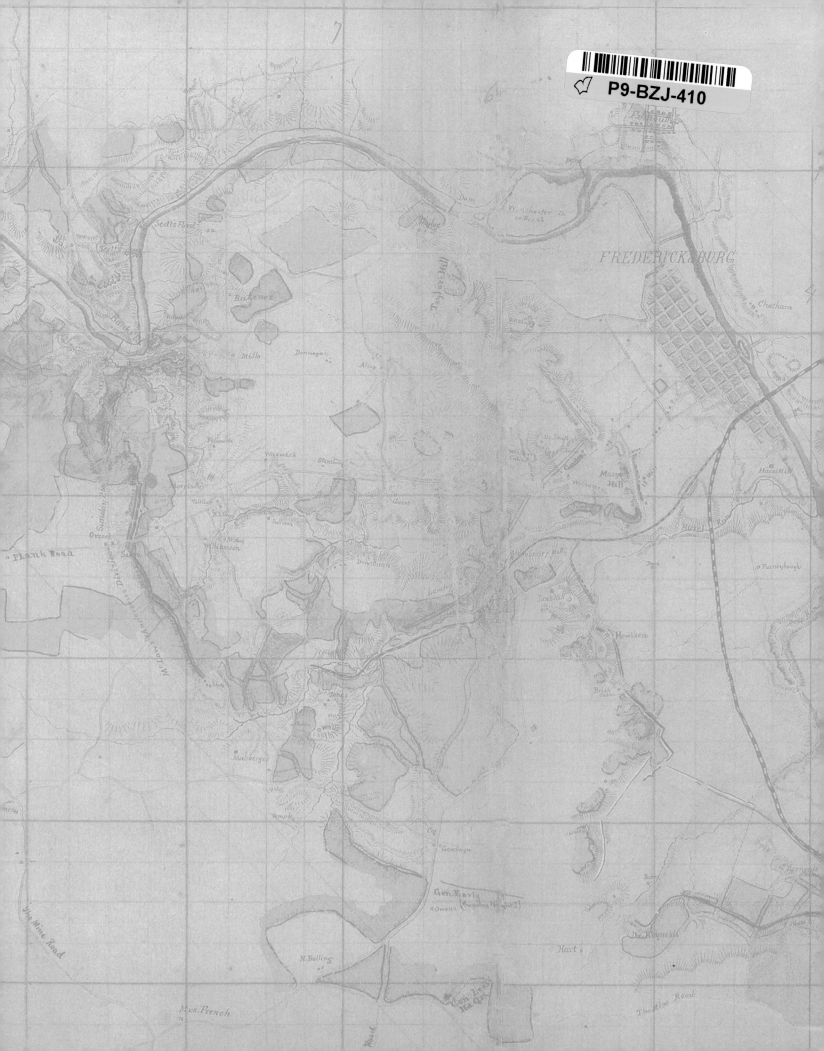

FREDERICKSBURG

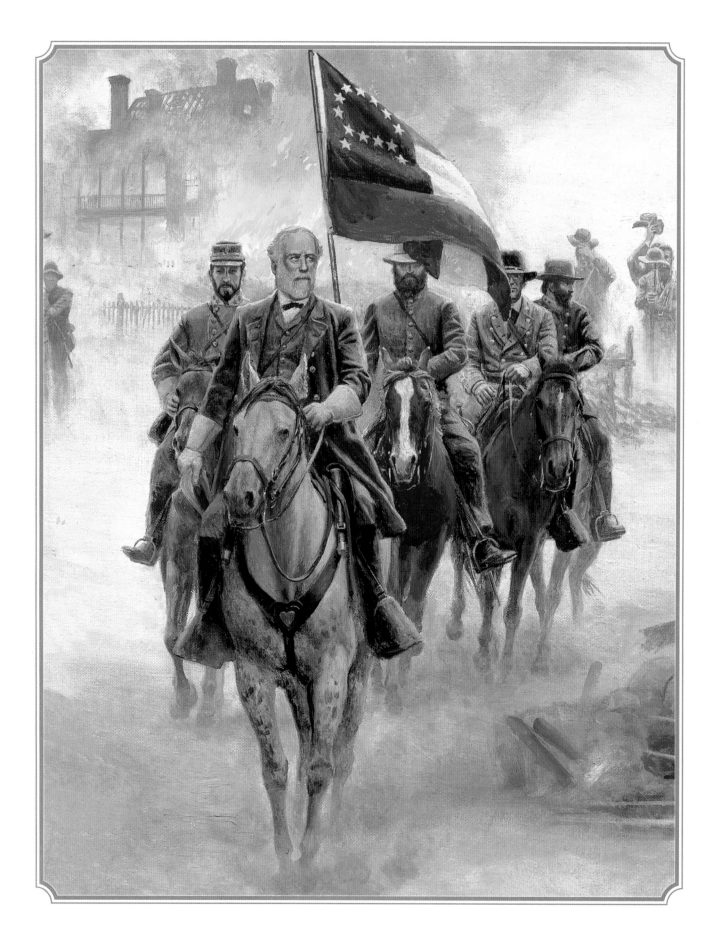

COMPANION HISTORY TO THE MAJOR MOTION PICTURE

GODS AND GENERALS

★ ★ ★

THE PAINTINGS OF MORT KÜNSTLER

Text by James I. Robertson, Jr.

Foreword by Ron Maxwell

Based on the novel by Jeff Shaara

THE GREENWICH WORKSHOP PRESS

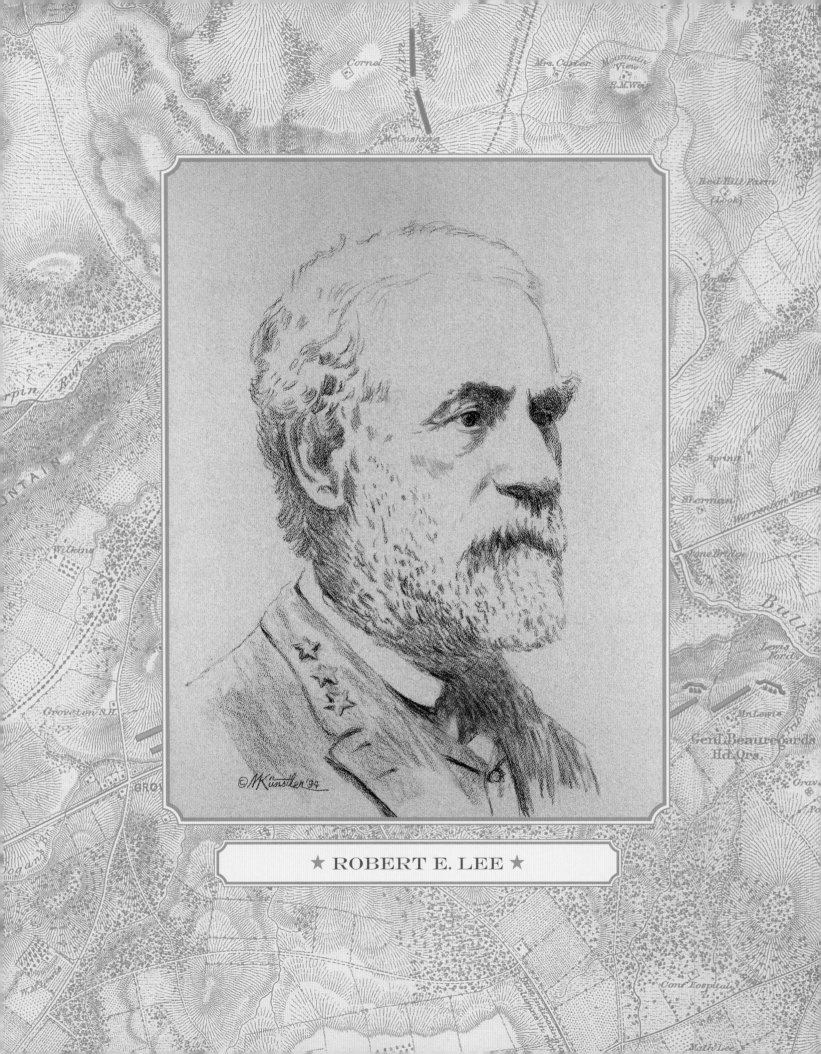

★ ROBERT E. LEE ★

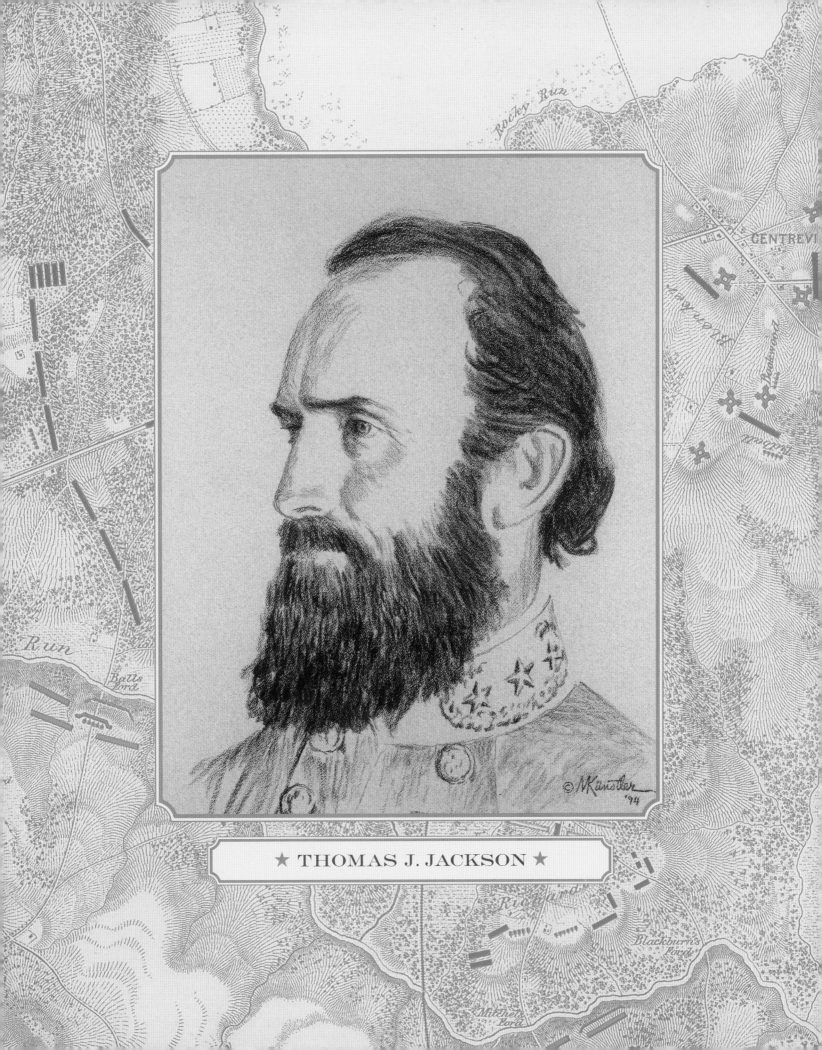

★ THOMAS J. JACKSON ★

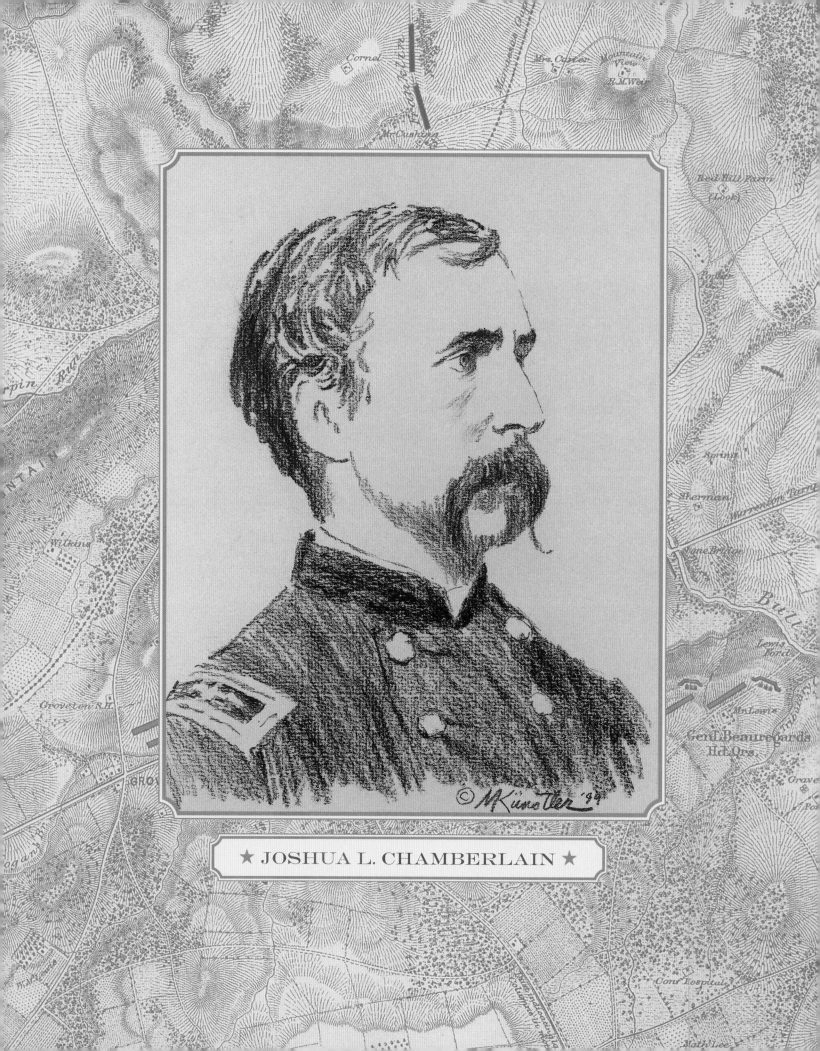

★ JOSHUA L. CHAMBERLAIN ★

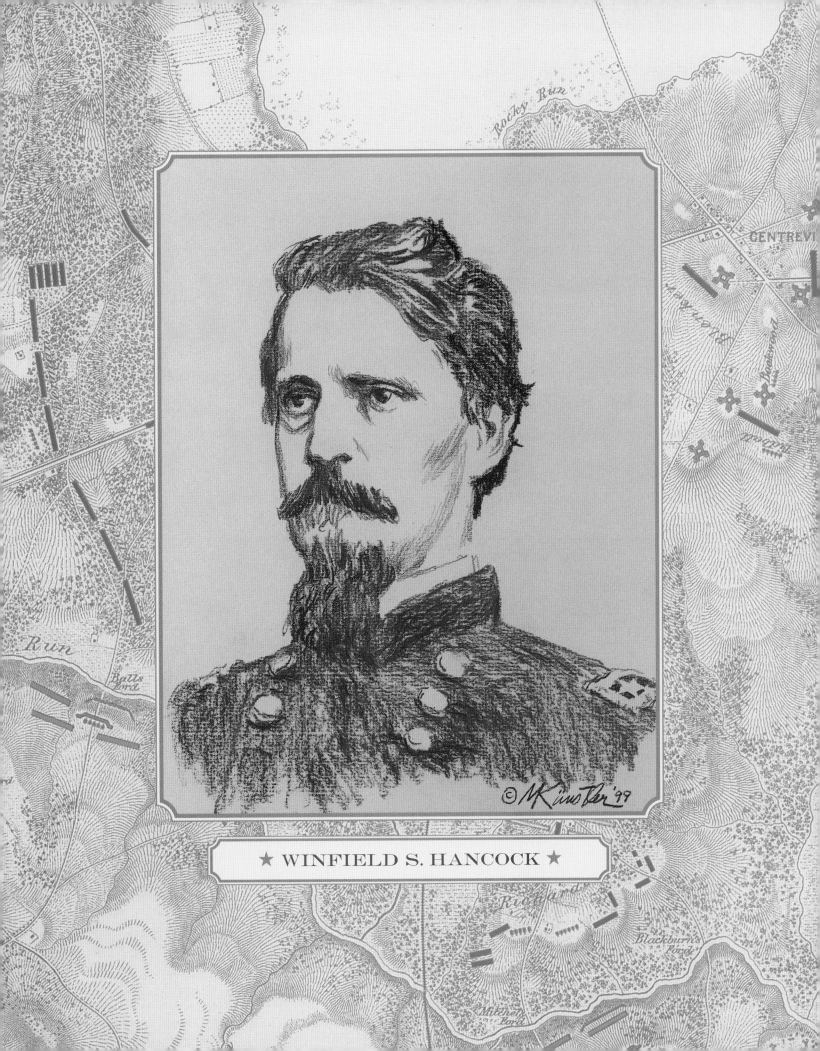

★ WINFIELD S. HANCOCK ★

All maps courtesy of the The Library of Congress, Geography and Map Division

Published by The Greenwich Workshop Press
One Greenwich Place
P.O. Box 875
Shelton, Connecticut 06484
www.greenwichworkshop.com

Produced by Lionheart Books Ltd.
5105 Peachtree Industrial Blvd.
Atlanta, Georgia 30341

Designed by Michael Reagan

Library of Congress Cataloging-in-Publication Data
Robertson, James I. Jr.
Gods and Generals: The Paintings of Mort Künstler / text by James I. Robertson, Jr.
p. cm.
ISBN 0-86713-084-9 (alk. paper)
1. United States--History--Civil War, 1861-1865--Campaigns. 2. United States--History--Civil War, 1861-1865--Campaigns--Pictorial works. 3. Gettysburg Campaign, 1863. 4. Gettysburg Campaign, 1863--Pictorial works. 5. Generals--Confederate States of America--Biography. 6. Generals--United States--Biography. 7. Lee, Robert E. (Robert Edward), 1807-1870. 8. Jackson, Stonewall, 1824-1863. 9. Hancock, Winfield Scott, 1824-1886. 10. Chamberlain, Joshua Lawrence, 1828-1914. I. Title.
E470 .R635 2002
973.7'349--dc21
2002071414

Jacket front: *With a Rebel Yell*, © 2002 Mort Künstler, Inc.

First Printing 2002
1 2 3 4 5 6 7 8 9 — 07 06 05 04 03 02
Printed in China

Table of Contents

Acknowledgments Page 10

Foreword Page 13

Introduction Page 15

Paths to War Page 21

A Confederate Team Page 45

Leaders Become Heroes Page 69

Crossroads at Chancellorsville Page 107

Epilogue Page 126

The Paintings Page 137

Index Page 143

Acknowledgments

A book, like a painting, is never the work of just one individual. I am grateful for the contributions and encouragement of the many people who were involved in this work.

I am deeply thankful to my friend and colleague Dr. James I. Robertson, Jr., whose superb historical narrative so enhances this book. "Bud" is both a valued friend and a trusted mentor, whose broad knowledge of the American Civil War has inspired and enlightened me on repeated occasions. It has been a privilege to work with him on this book, our third collaboration.

It was a unique honor for me to be selected as the official artist for the motion picture *Gods and Generals*. I met screenwriter-director, Ron Maxwell, when I produced the companion book for the film *Gettysburg*, and I have been an admirer of his work ever since. He is both an artist and a historian. With *Gettysburg*, he created the most authentic Civil War motion picture ever produced, and also crafted a graceful, unforgettable cinematic drama. I am confident that *Gods and Generals* will be viewed with equal and growing appreciation. I salute Jeff Shaara for the extraordinary talent which he brought to the novel on which the motion picture is based. Thanks are also due to Ted Turner and Ted Turner Pictures for their assistance on this project.

My sincere appreciation to Michael Reagan of Lionheart Books and Scott Usher of The Greenwich Workshop Press for their original vision for this book. Their enthusiasm and expertise were invaluable.

I remain grateful to my good friend and advisor, Richard Lynch, President of New York's Hammer Galleries. It is a distinct honor for me to have Hammer Galleries represent my original artworks, and I will always be thankful to Howard Shaw, Vice President and the rest of the staff at Hammer for the positive impact they have had on my work.

This book would not have been possible without the help of my daughter, Jane Künstler Broffman. During the many months it took to compile the book, her daily advice, expertise and creative input were truly appreciated.

I am also thankful to Civil War author-historian Rod Gragg, my good friend and colleague, whose vast array of knowledge, wisdom and guidance has been invaluable over the years.

I am grateful to other historians as well—too many to name here—who have generously shared with me their knowledge and research and have made my work so much better through their contributions. My gratitude is also extended to the countless people around the nation who have written me over recent years to provide encouragement and suggestions—and who have acquired my artworks, prints, books and other products. Their positive influence on my work cannot be overstated.

Thanks, too, are due to Chris Brooks, of American Spirit Publishing, the exclusive publisher of my limited edition fine art prints. I appreciate his friendship and knowledgeable counsel.

And, I want to express humble and sincere appreciation to those here at my studio. How can I begin to thank Paula McEvoy and Lissette Portillo of Künstler Enterprises for all they do to assist me in my work? I am grateful beyond words for their devoted and selfless service and their matchless expertise.

Finally I am so glad that once again I have the opportunity in print to thank my beautiful Deborah for her winsome ways, wise counsel, exceptional patience—and for being the love of my life.

—*Mort Künstler*
Oyster Bay, New York

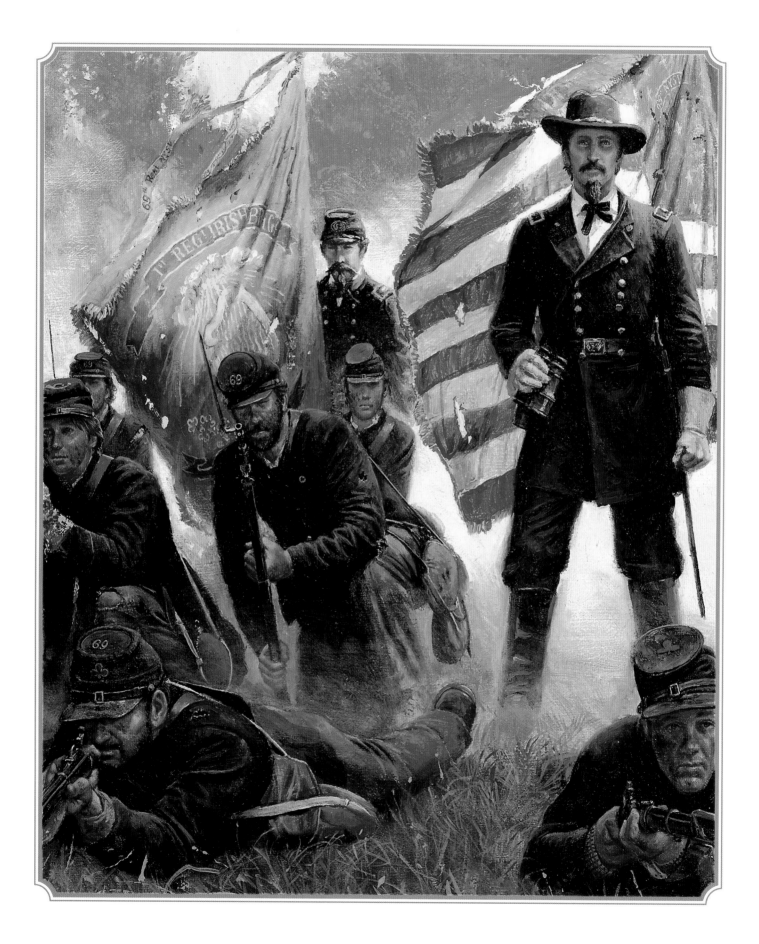

Foreword

Perhaps the most powerful aspect of the motion picture *Gods and Generals* is the fact that the story is true. The principal events depicted in the film—and the deeds of its main characters—are dramatic, emotionally moving, and, in many instances, simply unforgettable. Those would be powerful elements in any work of fiction, but especially so in *Gods and Generals* because the key elements are rooted in history—our history. Jeff Shaara's best-selling novel, like his father's famous work, *Killer Angels*, is the result of meticulous research on the American Civil War.

The film *Gods and Generals* is an adaptation of the novel of the same name, on which it is based. And in both cases, the Shaaras—father and son—skillfully crafted classic fiction from genuine history. As the director and scriptwriter of *Gods and Generals*, I wanted to complement the authenticity of the motion picture by developing an official history of the era in which the film and the novel are set. This was done successfully with the film *Gettysburg* through an accompanying nonfiction book, *Gettysburg: The Paintings of Mort Künstler*, which was the official companion history to the motion picture. That book proved to be immensely popular, and we anticipate a comparable demand for an official companion history to *Gods and Generals*.

Selecting an artist and a historian for the companion history was one of the easiest decisions of the entire *Gods and Generals* project. I knew immediately that this would be a Mort Künstler book. His work on the *Gettysburg* volume was exceptional, and we wanted the same standards for *Gods and Generals*. He is America's premier Civil War artist, and his artwork is both historically authentic and emotionally powerful. He is the perfect choice as the official artist of *Gods and Generals*. An equally famous Civil War authority, Dr. James I. Robertson, Jr., known to scholars and students of the war as the dean of Civil War historians, was one of the principal historical consultants of the film and is author of the book's narrative. What a remarkable combination—the artwork of Mort Künstler and the words of Dr. Robertson.

Gods and Generals: The Paintings of Mort Künstler is a classic companion to the motion picture *Gods and Generals*. As a work of history, it is broader in scope than the novel or the motion picture. It places the characters and events of *Gods and Generals* within the full context of the war, and serves admirably as the stage on which the novel and the film unfold. It is also a fitting tribute to the Americans of the Civil War—Northerners and Southerners, soldiers and sailors, white and black—who bequeathed to us a lasting legacy of courage and sacrifice.

—Ron Maxwell

Introduction

Forty years ago, well-known writer Walker Percy made this observation: "The truth of it is, I think, that the whole country ... is just beginning to see the Civil War whole and entire for the first time. The thing was too big and too bloody, too full of suffering and hatred, too closely knit into the fabric of our meaning as a people, to be held off and looked at—until now. It is like a man walking away from a mountain. The bigger it is, the farther he's got to go before he can see it. Then one day he looks back and there it is, this colossal thing lying across his past."

That mountain has grown enormously in the past four decades. Today the Civil War has become almost a national pastime. Books and articles appear at an average of more than one a day. Television documentaries, weekly radio programs, monthly meetings of 125 Civil War Round Tables scattered across the country, lectures, book-signings, battle reenactments, exhibits, commemorations, celebrations, dedications—all are now regular ingredients in American life. One thing guaranteed to draw a crowd is the occasional big-screen movie with a Civil War setting.

The mighty struggle of the 1860s established personal habits in America as no other historical event has ever done. From the Civil War came pairs of shoes, home delivery of mail, a national motto, the Medal of Honor, the Pledge of Allegiance, paper money, standard time, canned goods, and Santa Claus, just for starters. On a higher level, the war eliminated slavery from our society and established federalism in our politics.

A major reason for the war's ongoing popularity lies with the individuals who had leading roles. History should be the most exciting of all subjects since it is about the most intriguing of all creatures: human beings. The challenges they faced, the way in which they were met, and the endless recital of the progress of mankind are themes that have no equal.

This explains why biography is the most popular form of historical writing, especially in a democracy where the candidates are more numerous. The procession of fascinating Civil War figures is well-nigh

endless. Jeff Shaara selected four prominent officers for the leads in his novel *Gods and Generals*. Those same four men are central characters in the movie adaptation of the novel. In like vein, Robert E. Lee, Thomas J. Jackson, Winfield S. Hancock, and Joshua L. Chamberlain dominate this presentation.

The contents here generally follow the novel. From the coming of civil war in April, 1861, the narrative moves through battles in the Eastern theater of operation. Highlighted is the fighting at First Manassas, Antietam, Fredericksburg, and Chancellorsville.

Lee and Jackson are most prominent here because they towered over all other field commanders in the first two years of the Civil War. Whether campaigning independently or in tandem, those two generals formed an unmatched partnership that kept Union efforts in the East constantly bloodied and off-balance. Jackson's death in 1863, followed by Confederate defeat at Gettysburg, reversed fortunes in the Virginia theater. Without a principal lieutenant of Jackson's stature, Lee waged a heroic but futile resistance in the second half of the war.

The formative period from 1861to1863 is the setting here. Lee, Jackson, Hancock, and Chamberlain all laid the foundations for their military reputations in those first two years of warfare. Their careers grew as the struggle broadened and became more all-consuming.

Great men rise in time of need. In art and in prose, this book is the story of four such leaders.

—James I. Robertson, Jr.

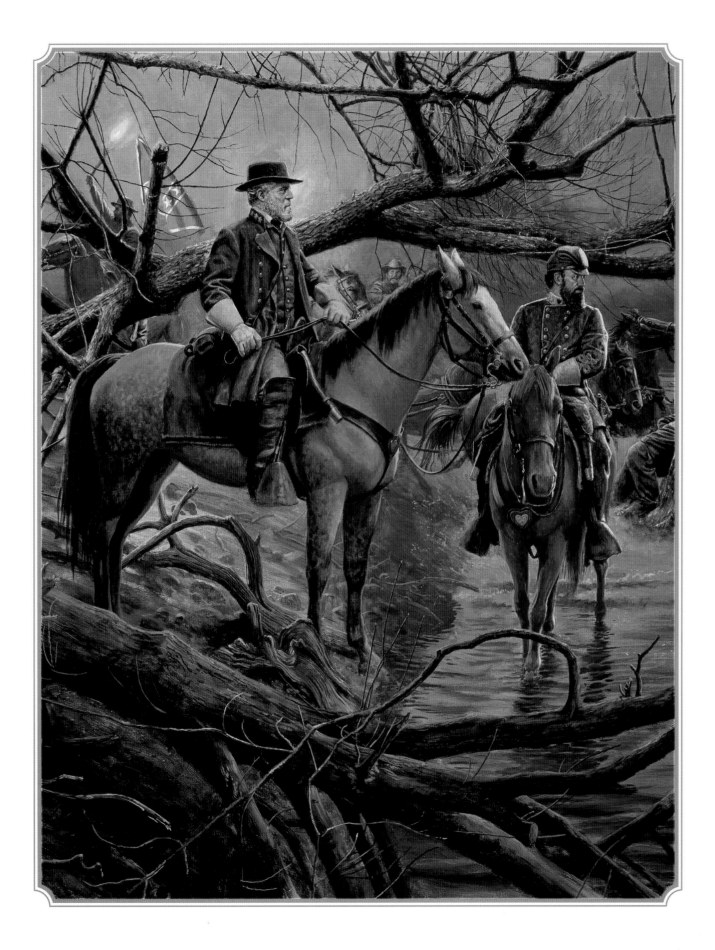

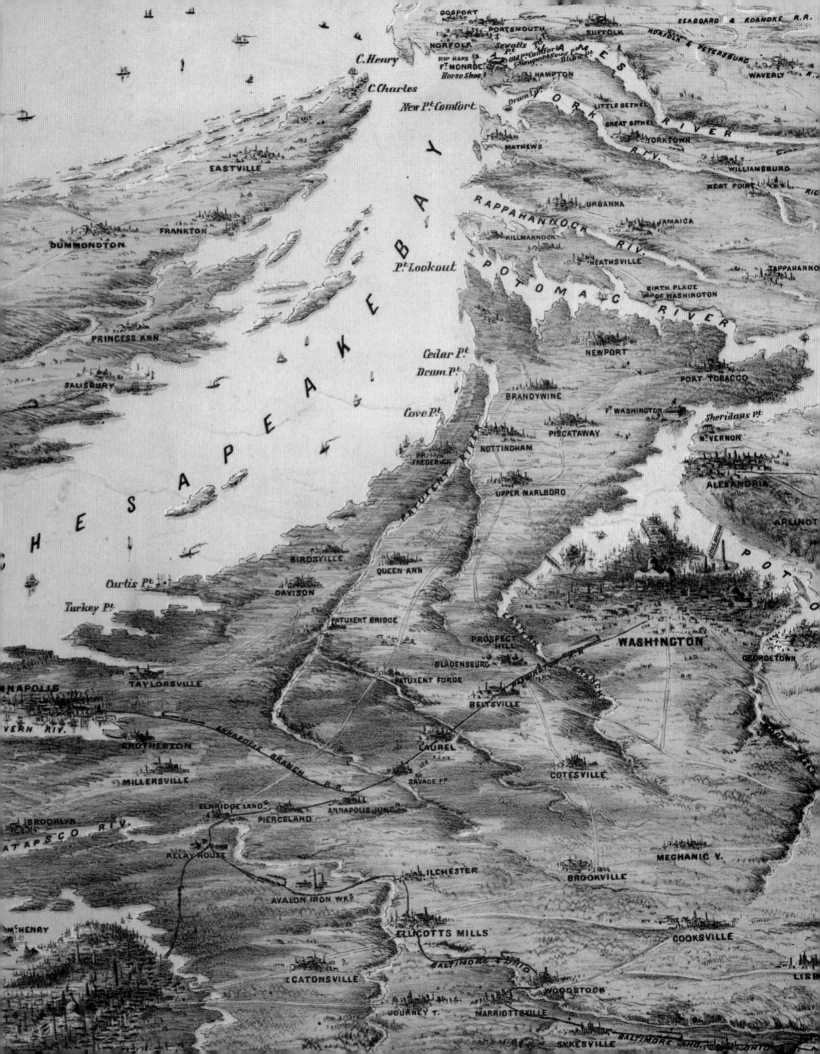

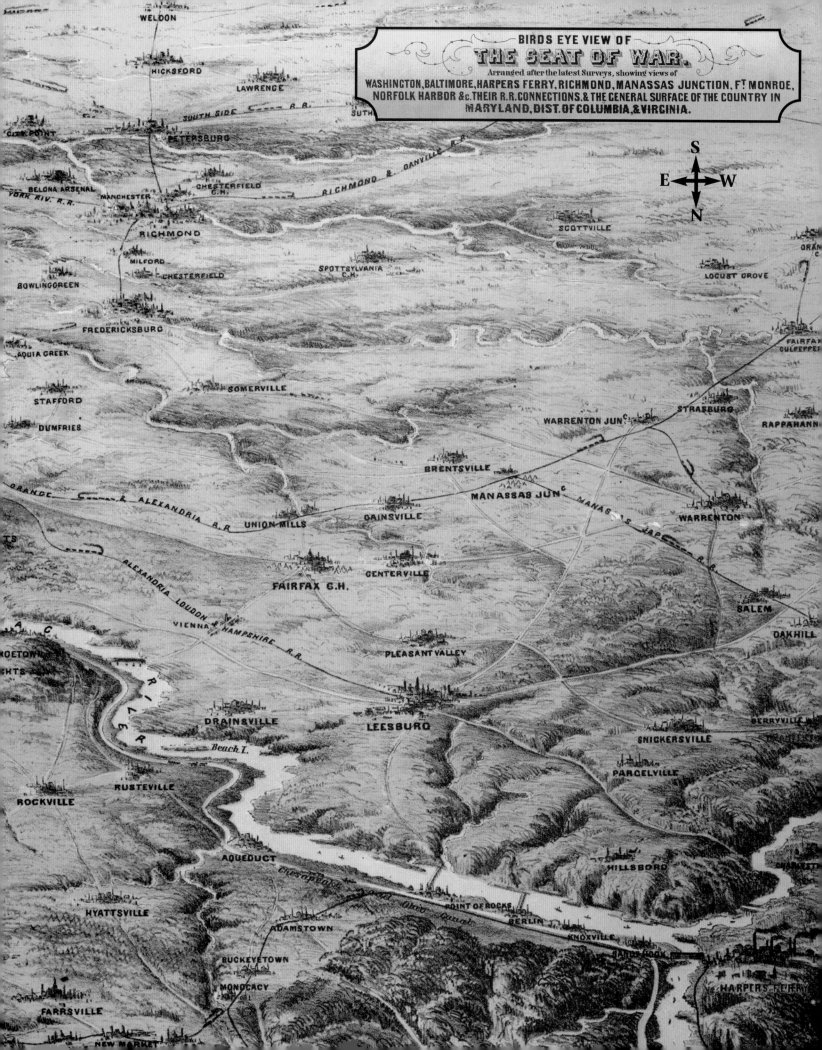

BIRDS EYE VIEW OF
THE SEAT OF WAR.
Arranged after the latest Surveys, showing views of
WASHINGTON, BALTIMORE, HARPERS FERRY, RICHMOND, MANASSAS JUNCTION, F.T. MONROE,
NORFOLK HARBOR &c. THEIR R.R. CONNECTIONS, & THE GENERAL SURFACE OF THE COUNTRY IN
MARYLAND, DIST. OF COLUMBIA, & VIRGINIA.

PATHS TO WAR

In 1861, ripped asunder by an unendurable tension, the young United States broke in half. Two countries emerged between Canada and Mexico. Emotions were at such fever pitch that the likelihood existed of even more divisions. The opening battles gave shocking evidence to all, that if the nation were to be put back together again, it would have to be done at the cost of a long and bloody conflict. The dreams and expectations of what had been a growing America were now on hold.

Four years of war followed—four years of incalculable suffering, indescribable horror, and depthless heartache—four years of trauma that shook the foundations of America as nothing else had come remotely close to doing. From the battlefields and the burial places came a new and more strongly unified nation. That is why the first 75 years of American history are a lead-in to the Civil War, and why that war has become a springboard for everything that has happened since.

The Civil War also reaffirmed for all time to come that when a national crisis emerges, America's common folk will rise majestically to the challenge. Just as the struggle of the 1860s produced heroes, legends, and memories, just as it bequeathed a host of legacies that still mark daily life, the Civil War likewise was an event that uncovered a score of extraordinary field commanders. ★ ★ ★

WAR CAME WITH THE APRIL 12-13, 1861, BOMBARDMENT OF FORT SUMTER, SOUTH CAROLINA. THE SMALL UNION GARRISON WAS HOPELESSLY OUTNUMBERED. CONFEDERATES FIRED 4,000 SHELLS IN A THIRTY-THREE-HOUR PERIOD. UNION EFFORTS WERE CONFINED TO A SINGLE-GUN REPLY HERE AND THERE.

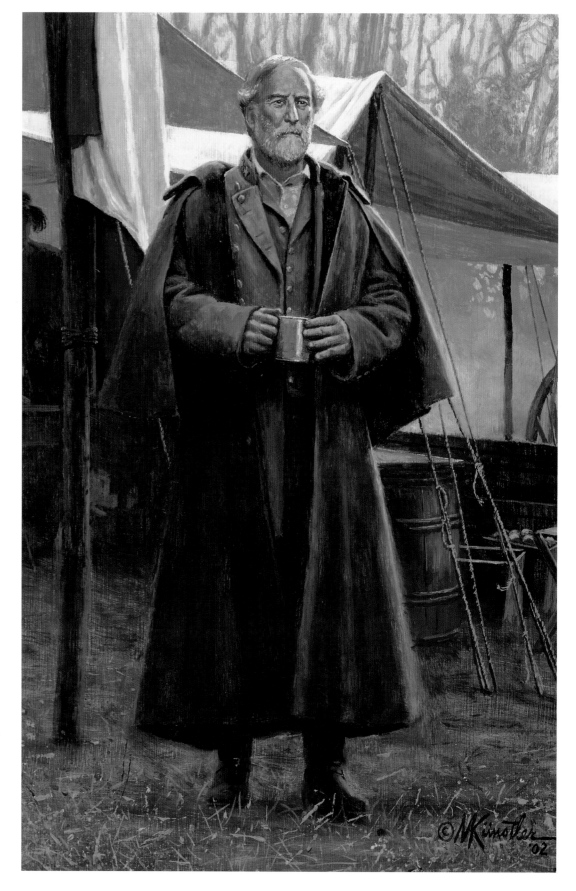

THE MOST IMPRESSIVE-
LOOKING MAN IN THE
ARMY, WAS HOW GEN-
ERAL WINFIELD SCOTT
DESCRIBED LEE. A MAS-
SIVE TORSO MADE LEE
APPEAR LARGER THAN
HE ACTUALLY WAS. TO
HIS CONFEDERATE SOL-
DIERS, HE WAS AFFEC-
TIONATELY KNOWN AS
"MARSE ROBERT."

American military leadership on a grand scale originated in the great contest between Union and Confederacy.

Four representatives from that group attained high acclaim in their lifetimes and thereafter. They came from strikingly different locales and backgrounds. Robert E. Lee and Thomas J. Jackson were products of the extremes of Virginia society. Winfield S. Hancock and Joshua L. Chamberlain likewise had their differences. The former came from good stock in the Mid-Atlantic region, while the latter's roots were in New England's yeoman class.

Two of the four were trained and experienced soldiers. Two were on active duty when the Civil War began; the other two were college professors. Two cast their lot with the Confederacy, while the other two pledged their services to the Union. Not one ever met the other three. Yet despite their disparities, the members of this quartet came to personify the Confederacy, the Union, and, to a large extent, the war whose course they did much to direct.

Lee was the oldest and most distinguished of the four in the prewar period. The Lee family and colonial Virginia were synonymous terms. John Adams remarked that the Lees included more men of merit than any other family in America. Robert's father, Henry "Light Horse Harry" Lee, was a hero in the American Revolution. Two kinsmen of the father were signers of the Declaration of Independence.

Robert Edward Lee was born in January, 1807, at Stratford, the ancestral mansion alongside the Potomac River. The father's peacetime indiscretions left the family all but destitute. George Washington became young Robert's role model and may have been the influence behind the lad's early decision to become a soldier. Lee entered the U.S. Military Academy in 1825 and proved an exemplary cadet. Easily absorbing the demands of the West Point curriculum, Lee graduated second in his class, held the highest cadet rank, and had a spotless record in conduct.

Even as a young officer, Lee looked like a soldier. He stood five feet, eleven inches tall, was a compact 170 pounds, had wavy black hair, brown eyes, and even features. Dignity, tact, piety, and a quiet confidence were leading characteristics of the man. Lee was one who always commanded respect by his mere presence.

Even as a young officer, Lee looked like a soldier. He stood five feet, eleven inches tall, was a compact 170 pounds, had wavy black hair, brown eyes, and even features. Dignity, tact, piety, and a quiet confidence were leading characteristics of the man. Lee was one who always commanded respect by his mere presence.

A brilliant career as an army engineer followed. Lee worked on several coastal fortifications, and he was most responsible in preventing the Mississippi River from cutting a new channel and leaving the city of St. Louis literally high and dry. His 1831 marriage to Mary Custis, daughter of an adopted son of George Washington, produced seven children. Two sons would become generals in the Civil War.

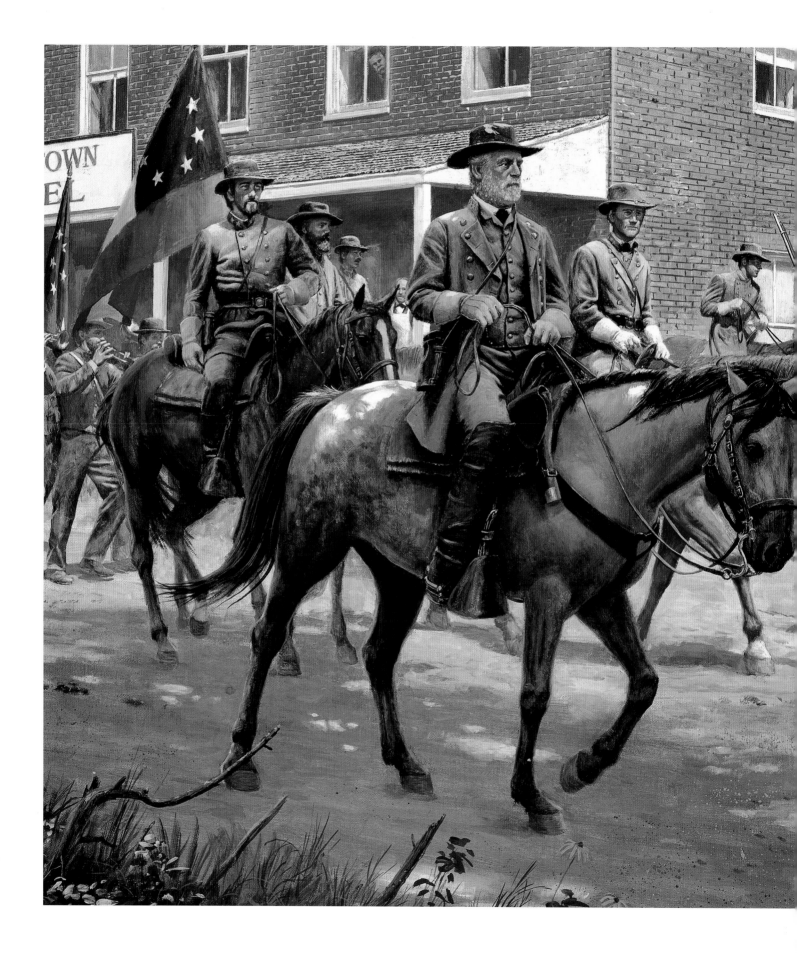

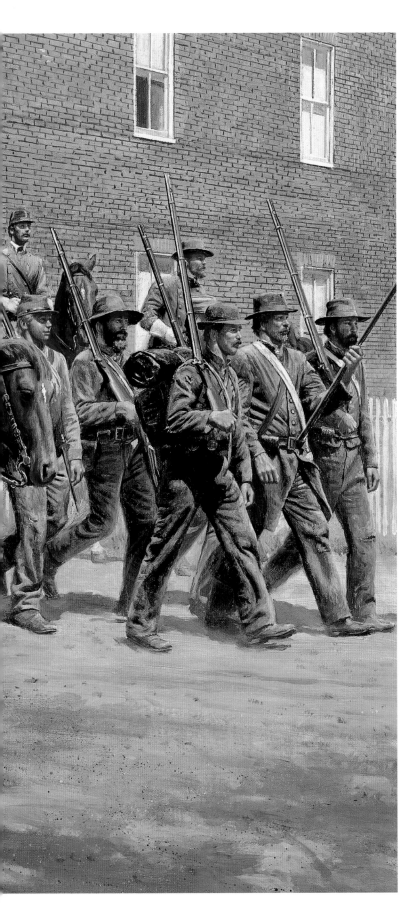

Military fame first came to Lee in the Mexican War. He served on General-in-Chief Winfield Scott's staff and became a member of Scott's "inner circle" of advisers. Lee displayed conspicuous gallantry at Cerro Gordo and the climactic engagement at Chapultepec. Scott, who was never lavish with praise, declared that "American success in Mexico was largely due to the skill, valor, and undaunted courage of Robert E. Lee."

Lee served a brief tour as superintendent at West Point before assignment as second-in-command of one of the Army's elite units, the Second Cavalry. In 1859 he was on protracted furlough at his Arlington mansion near Washington when John Brown and his militant abolitionists raided Harpers Ferry, Virginia. Lee led a detachment of Marines (the only military force then available) that put down the uprising with efficiency and a minimum of bloodshed.

By 1861, Lee had given over 30 years to the military. His love of country was as unchallenged as his devotion to duty. Yet he was a Virginian. The Old Dominion had existed for 180 years before the creation of the United States. The secession crisis following the presidential election of Abraham Lincoln gave Lee cause for worry. "If the bond of the Union can only be maintained by the sword and the bayonet, instead of brotherly love and friendship," he wrote a daughter after the secession of South Carolina, then the Union "will lose

⟅⟆ ★★★ ⟅⟆

LATE IN THE SUMMER OF 1863, A GEORGIA SOLDIER OBSERVED: "GENERAL LEE IS THE BEST RIDER I EVER SAW. HE WAS MOUNTED ON A FINE GRAY HORSE. I CAN LOOK AT HIM WITH HIS GRAY HAIR AND BEARD ONLY WITH FEELINGS OF AWE AND ALMOST DEVOTION."

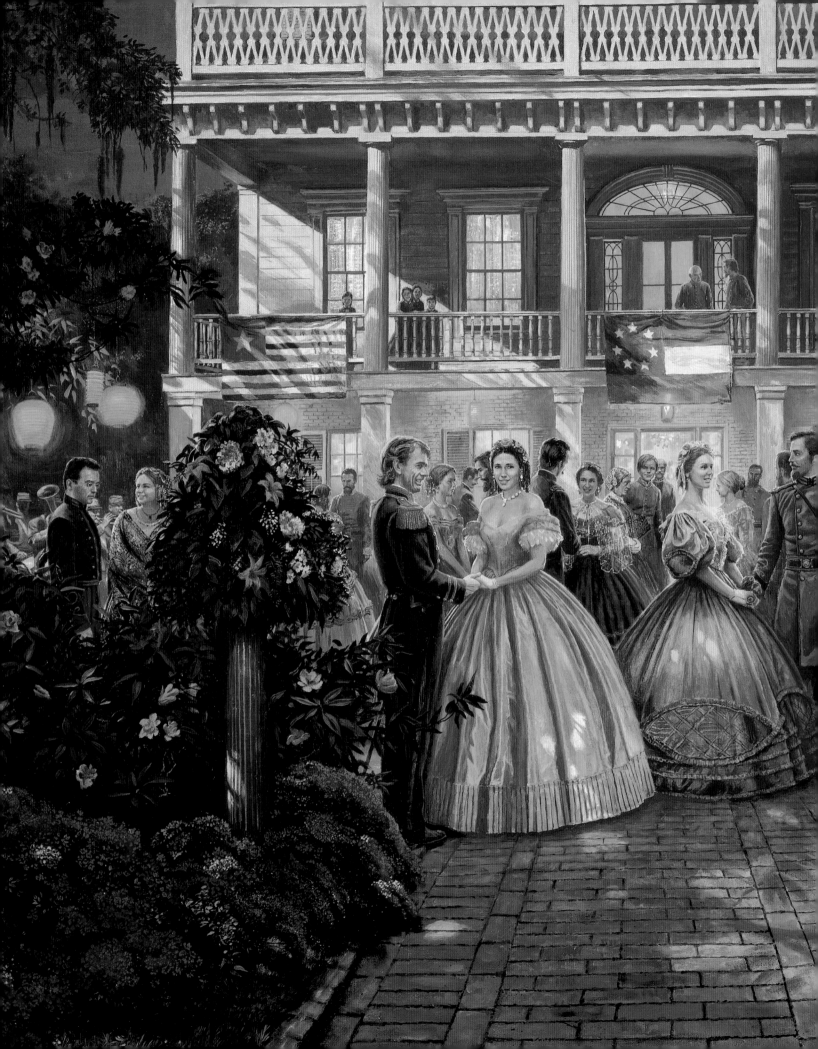

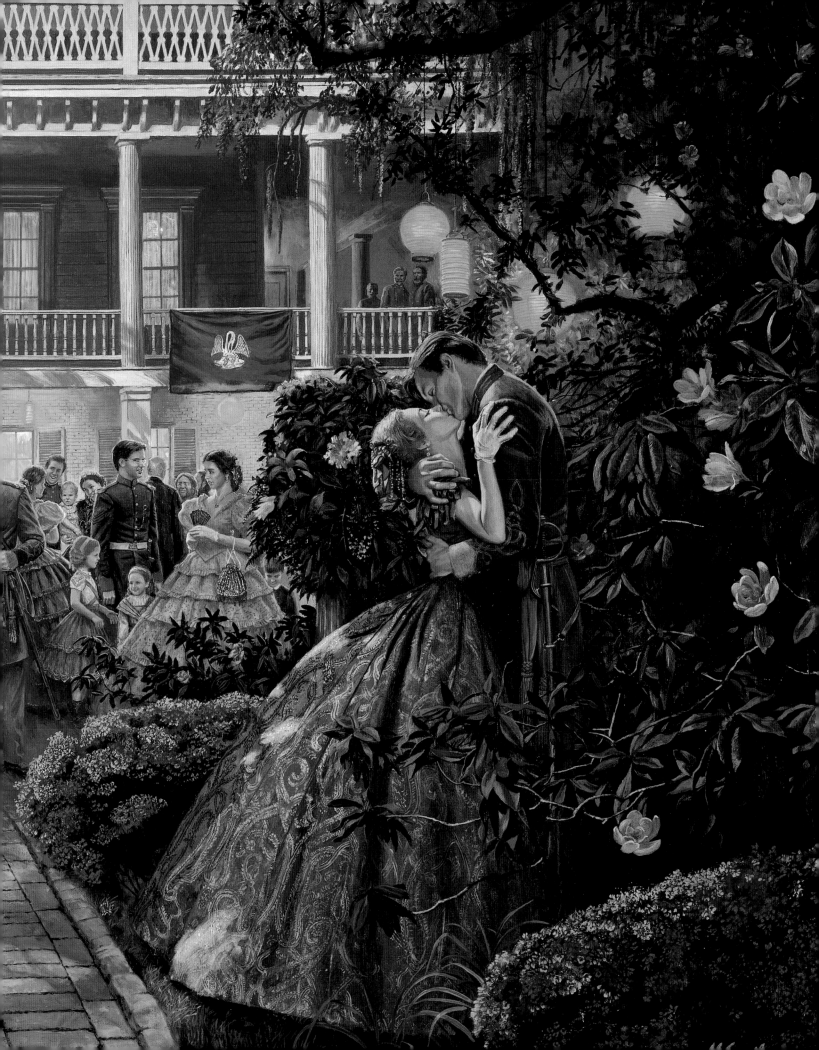

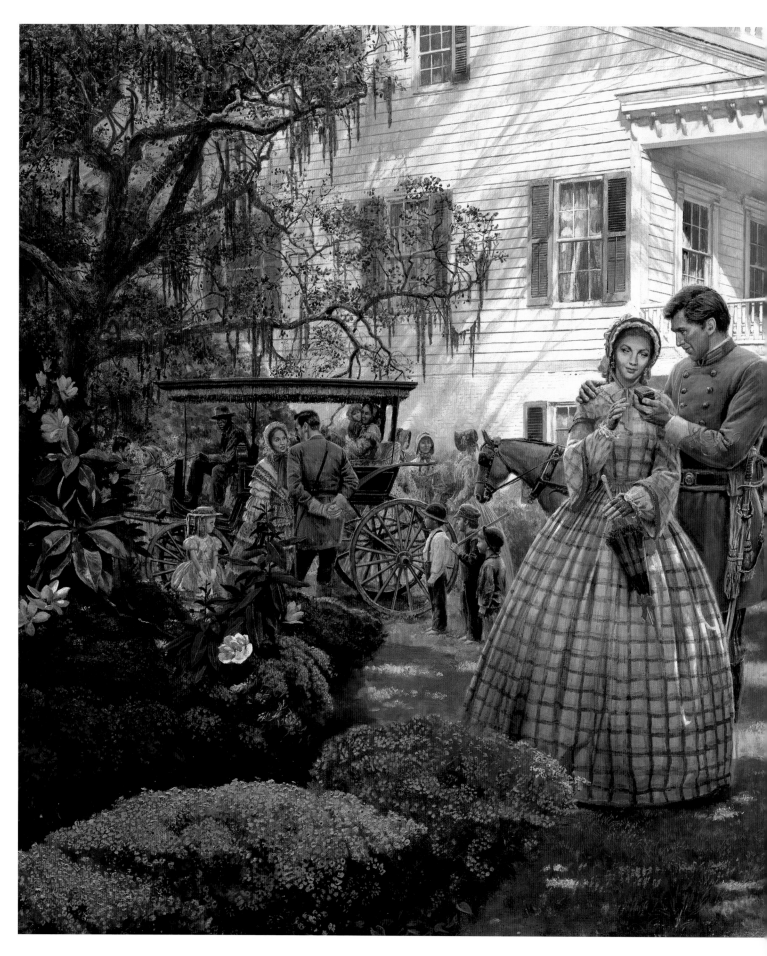

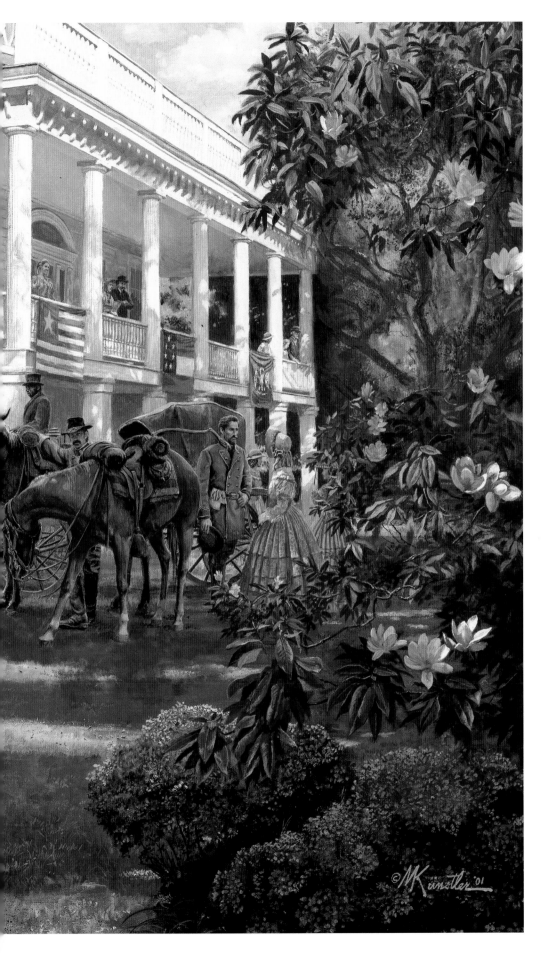

◦◦◦ ★ ◦◦◦

Previous pages, LEAVING THE UNION IN 1860—1861 SEEMED FOR MANY SOUTHERN STATES A RELEASE FROM FIFTEEN YEARS OF TENSION AND ARGUMENT. LIGHTHEARTED SPIRITS PREVAILED AT THIS LOUISIANA PLANTATION "SECESSION BALL." ROMANCE BLOSSOMED BY MOONLIGHT.

THE MORNING AFTER THE "SECESSION BALL," DESPITE THE WARM SUNLIGHT, A GLOOMY ATMOSPHERE HAD DESCENDED OVER THE REVELERS. IT WAS TIME TO SAY GOODBYE: THE SOLDIER LEAVING FOR WAR, HIS SWEETHEART LEFT TO WORRY.

all interest in me…. I can, however, do nothing but trust to the wisdom and patriotism of the nation and to the overruling providence of a merciful God." Lee determined to wait and watch events unfold.

A second man had also put his trust in this crisis in "a merciful God."

Seventeen years younger than Lee, Thomas Jonathan Jackson had been born in January, 1824, in the mountain wilderness of northwestern Virginia. He endured a childhood so sad that he preferred not to mention it. Jackson's father died when he was two; his mother gave him away when he was seven. Although Tom grew up on a family estate at Jackson's Mill, his foster parent was an uncle to whom love, religion, and education were unwanted virtues. Eleven years of loneliness marked Jackson's formative years.

Jackson's father died when he was two; his mother gave him away when he was seven. Although Tom grew up on a family estate at Jackson's Mill, his foster parent was an uncle to whom love, religion, and education were unwanted virtues. Eleven years of loneliness marked Jackson's formative years.

In 1842, he managed to secure a last-minute appointment to West Point. Jackson was ill-prepared for the demands imposed by what then was the finest engineering school in America. However, he was also aware that the military academy offered probably the only chance for advancement he would ever have. Jackson put every fiber of his being into his studies.

Persistence and determination brought success. Jackson graduated seventeenth in a class of fifty-nine. His high standing brought him assignment to the artillery. Jackson went directly from college into the Mexican War. Three brevet promotions for bravery in action made him the most decorated member of his West Point class. The postwar years consisted of dull, routine duty at various posts. In 1851, Jackson accepted an offer to become professor of natural and experimental philosophy, as well as artillery instructor, at the Virginia Military Institute.

Situated at Lexington in the southern end of the Shenandoah Valley, the little academy was only 12 years old. It had 100 cadets and a half-dozen faculty. Yet it offered Jackson an opportunity not only to return to Virginia but to be back amid the beloved Allegheny Mountains of his youth. He left the Army and moved to Lexington with more enthusiasm than experience for the professorship that would fill ten years of his life.

The twenty-seven-year-old Jackson was impressive-looking. He stood a full six feet tall, weighed 175 pounds, was solidly built, with large blue eyes, a high forehead, and huge sideburns that curved almost to his mouth. In other respects, unfortunately, Jackson left much to be desired.

An empty childhood had produced an introverted, reticent, and shy adult. Jackson was uncomfortable in civilian society, knew little of the art of conversation, and had difficulty making friends. Because of several physical

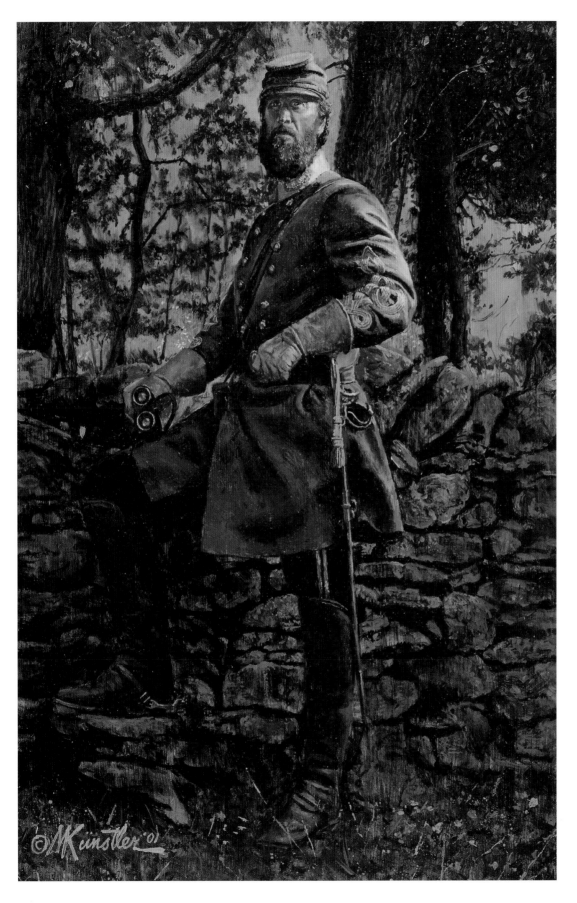

Thomas Jackson was an Old Testament warrior. He always believed in aggressive action. If successful in an attack, he taught, pursue the enemy relentlessly. Destruction, rather than mere defeat, of a foe ends a war more quickly.

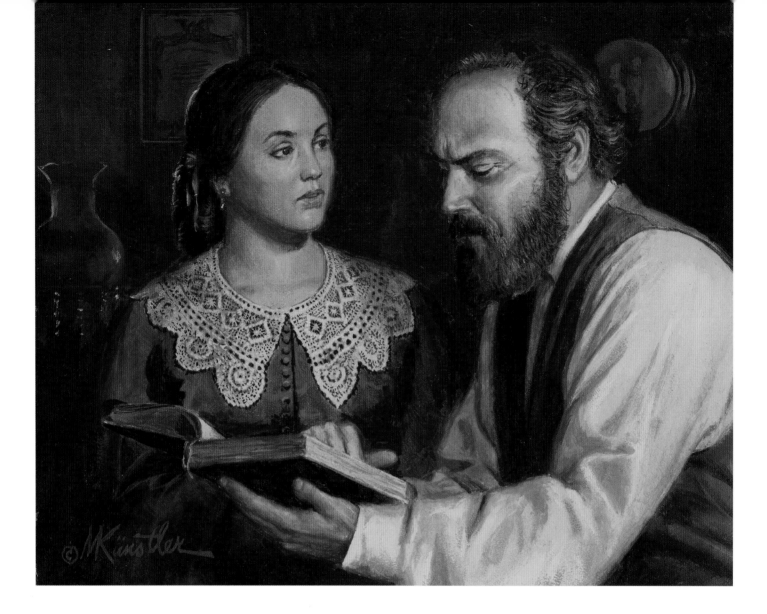

BETWEEN JACKSON AND HIS TWO WIVES (SECOND WIFE MARY ANNA MORRISON IS PICTURED HERE) THERE WAS DEEP LOVE, MUTUAL UNDERSTANDING, AND AN ABIDING FAITH THAT INCLUDED DAILY DEVOTIONALS FROM THE BIBLE.

⚜ ★★★ ⚜

ailments (both real and imagined), he followed a monastic diet and engaged in sometimes bizarre physical exercises that got him labeled as the "town character." His rigid demands as a teacher brought him such uncomplimentary nicknames as "Tom Fool" and "Old Blue Light." One cadet thought him "the worst teacher that God ever made." Another student dismissed him as being "crazy as damnation."

Jackson labored hard to overcome these many eccentricities. He read extensively on manners and good breeding, developed a book of maxims that became his guide to good conduct, and made increasing efforts to acquire friends. He married twice in the 1850s. His first wife, the former Elinor Junkin, died in childbirth only fourteen months after their wedding. Three years later, Jackson married Mary Anna Morrison. That union lasted six years until the general's death.

Both wives were daughters of Presbyterian ministers and college presidents. Both were outgoing and cordial, which brought Jackson closer into the mainstream of Lexington society. Even his teaching improved with time.

It was at the outset of the Lexington years that the always-religious Jackson sought a home in the Lexington Presbyterian Church. He promptly became one of the most devout Calvinists of his age. Jackson sought solace in constant prayer and ongoing strength in an unbending faith. He attended every service at the church. He organized two Sunday school classes: one was for the young men of the congregation, the other was an afternoon class for slaves and freedmen in the Lexington area. Such a gathering was in violation of a Virginia law that forbade blacks from gathering in public. Jackson's faith was so consuming that it is the

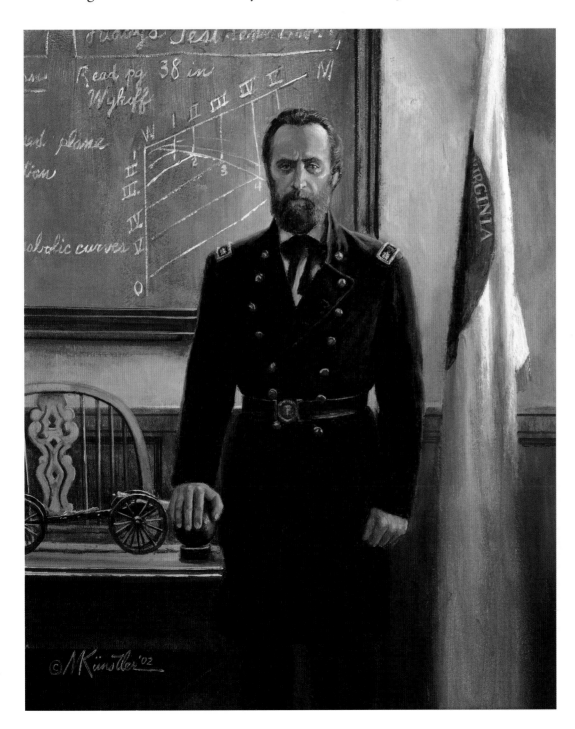

NEVER A GOOD TEACHER, MAJ. JACKSON BROUGHT TO THE CLASSROOM A PLODDING INTENSITY THAT FEW OF HIS VMI CADETS COULD GRASP. YET IN TIME, RIDICULE TURNED TO RESPECT. ONE CADET WHO LATER BECAME A BRIGADE COMMANDER UNDER JACKSON TERMED THE PROFESSOR "WONDERFULLY ECCENTRIC."

key to understanding him both as a man and as a soldier.

Six weeks after Col. Lee had quelled John Brown's raid, Maj. Jackson and the VMI corps of cadets stood guard at the execution of the convicted abolitionist. These are the only two instances where Lee, Jackson, Hancock, or Chamberlain was directly involved with an event leading directly to the Civil War.

Jackson had always had a firm allegiance to the Union. On the other hand, he was a Virginian, a Democrat, and a states' rights adherent who did not believe that the federal government had the authority to coerce a state by force. Still, Jackson voiced what for him was a typical opinion on the growing issue of secession. "Why should Christians be disturbed about the dissolution of the Union? It can come only by God's permission, and will only be permitted if for His people's good."

Winfield Scott Hancock was only a month younger than Jackson. Born in February, 1824, in the hamlet of Montgomery Square, northwest of Philadelphia, Hancock was one of twin boys. His father was successively a schoolteacher and lawyer. Hancock entered West Point in 1840. He was only sixteen and looked even younger.

Hancock applied himself well enough to graduate, although he stood only eighteenth in a twenty-five man class. Such low standing got him posted to the infantry. While the young lieutenant saw limited service in the Mexican War, he did receive a slight wound and a citation for gallantry at Chapultepec. For a decade thereafter, his principal duty was quartermaster of the Sixth Infantry. In 1849, a West Point friend, Don Carlos Buell, introduced Hancock to Almira Russell, daughter of a St. Louis merchant. The couple married a few months later. They had two children, neither of whom outlived their parents.

Throughout the 1850s, Hancock had duty assignments in Florida, Kansas, and Utah. Hancock finally settled down in Los Angeles as chief quartermaster for the southern military district of California. After fourteen years out of West Point, he was only a captain. Like Lee, Hancock was soldier-like in appearance. Tall, muscular, with light brown, straight hair, a mustache, and a tuft on his chin, he had blue eyes, a firm jaw, and what one observer called "a very mobile, emotional countenance."

Hancock's closest friends at the California garrison were Southerners: Albert Sidney Johnston, Lewis Armistead, Henry Heth, and Simon B. Buckner. All of the officers closely watched the events of spring, 1861. In answer to a query about his sentiments, Hancock

> *Hancock's closest friends at the California garrison were Southerners: Albert Sidney Johnston, Lewis Armistead, Henry Heth, and Simon B. Buckner.... In answer to a query about his sentiments, Hancock replied: "My politics are of a practical kind: the integrity of my country, the supremacy of the federal government, and an honorable peace, or none at all."*

WINFIELD HANCOCK WAS
AS STRIKING AND AS GRE-
GARIOUS A GENERAL AS
THE ARMY OF THE PO-
TOMAC EVER HAD. A
NEWSPAPER REPORTER
THOUGHT HIM "BRAVE AS
JULIUS CAESAR, AND
ALWAYS READY TO OBEY …
FIGHTING ORDERS."

He went from modest New England professor to inspiring Union general. Joshua Chamberlain felt, as did millions of other participants, that the Civil War was the greatest event of their lives.

replied: "My politics are of a practical kind: the integrity of my country, the supremacy of the federal government, and an honorable peace, or none at all."

By background, Joshua Lawrence Chamberlain was the least likely of the four future generals to become a war hero. A combination of solid strength and common sense were his foundations. Born in September, 1828, in Brewer, Maine, he was the oldest of five children in a fairly well-to-do family. A dominating father ruled over the household; when one of the children would confess to not knowing how to perform a task, the father would sternly say: "Do it, that's how!" Such became, Chamberlain declared, his "order of life."

He had a busy and happy childhood. School lessons and farm chores occupied his days. A stammering speech impediment early in life made him somewhat of a loner who lacked self-assurance and self-assertion when around strangers. As was the case with Jackson, Chamberlain preferred being by himself.

In the early teenage years, Chamberlain attended a nearby military school. French was a compulsory subject. It proved to be the first of nine foreign languages that he would master over the years.

The father wanted him to go to West Point; the mother wanted him to enter the ministry.

The father wanted him to go to West Point; the mother wanted him to enter the ministry. Chamberlain wanted neither. He felt that both the military and the clergy "bound a man by rule and precedents and petty despotisms, and swamped his personality." So he delayed making a decision by entering Bowdoin College.

Chamberlain wanted neither. He felt that both the military and the clergy "bound a man by rule and precedents and petty despotisms, and swamped his personality." So he delayed making a decision by entering Bowdoin College. It was a typical liberal arts institution that stressed classical languages and mathematics.

Chamberlain's introverted nature made it difficult for him to make friends in the early college years. When classmates began calling him "Jack," Chamberlain was pleased because he considered it a sign that they liked him. Much of his college time he spent in a long courtship with Fanny Adams, the adopted daughter of a local minister.

In Chamberlain's senior year at Bowdoin, he applied for admission to Bangor Theological Seminary. He and Fanny agreed to delay their marriage until he completed the three years of postgraduate study. A week after his graduation in 1855, Chamberlain was awarded an M.A. degree from Bowdoin for the religious courses he had taken. He joined the faculty there in the autumn and married Fanny in December. By 1860, Chamberlain was chair of the Department of Modern Languages and contemplating two years hence a promised leave of absence to study in Europe.

He, too, was physically striking. Unusually tall at five feet, eleven inches, Chamberlain was slim, with a wide forehead, brown hair, and

enormous mustache, which he grew during the summer of 1862. He was graceful and erect, possessed a sonorous voice, and had a remarkable presence in academic, as well as social, circles. Although trained to be a minister of the Gospel, he would in time show a surprising aptitude for the military.

In mid-April, 1861, a rapid sequence of events led to war. Confederate guns at Charleston, S.C., bombarded Union-held Fort Sumter and forced its garrison to surrender. Lincoln responded by calling on loyal states for 75,000 volunteers to put down the insurrection. That intent to employ federal coercion led Virginia and three other Upper South states to leave the Union and join the seven states already comprising the Confederate States of America.

Now it was time for individuals to choose sides. The first, and seemingly most difficult, decision fell on Lee. "I shall never bear arms against the Union," he stated early in April, "but it may be necessary for me to carry a musket in defence of my native state, Virginia." Four days after the fall of Fort Sumter, Lee received a summons to the home of Francis Preston Blair, Sr. This elder statesman was acting as Lincoln's representative. A large Federal army was being formed, Blair said, and the President had authorized him to tender command of the force to Lee.

The Virginian's ancestral obligations were all-powerful. "I declined the offer," he said later, "stating as candidly and as courteously as I could, that though opposed to secessions and deprecating war, I could take no part in an invasion of the Southern States."

Bidding farewell to Blair, Lee went to see his superior and mentor. General Winfield Scott felt crushed at the news his fellow Virginian brought. "Lee, you have made the greatest mistake of your life, but I feared it would be so," Scott exclaimed.

Lee's resignation from the Army ended with a statement he made often that month of April: "Save in defence of my native state, I never

★ ★ ★

BEHIND THE BROODING MELANCHOLY AND PATIENT UNDERSTANDING THAT MARKED ABRAHAM LINCOLN WAS ALSO A TOUGH RESOLVE AND A COMPLETE DEVOTION TO THE UNION. HIS ENTIRE FOUR YEARS AS PRESIDENT WERE SPENT IN A NEVER-CEASING EFFORT TO RESTORE UNITY TO THE YOUNG AMERICAN NATION.

THE HOUR FOR DECISION CAME FOR COL. ROBERT E. LEE, U.S. ARMY. HIS BELOVED VIRGINIA HAD SECEDED, AND HE WAS ABOUT TO BE OFFERED COMMAND OF THE ARMY TO FORCE THE STATE BACK IN THE UNION. BIRTHRIGHT AND PATRIOTISM, HONOR AND DUTY SEEMED IN CONFLICT.

again desire to draw my sword." He traveled to Richmond where, on April 23, he appeared before Virginia's secession convention and accepted command of the Old Dominion's military and naval forces.

Jackson likewise offered his services to his native state. He had sensed the atmosphere of war sweeping across Virginia; he saw the enthusiasm and anger in the faces of cadets in his classes. As Jackson viewed the situation, the national catastrophe was a trial ordained by God to test the faith of believers. That side which most followed God's commandments would emerge triumphant in the war. Christian faith and the Confederate cause were, for Jackson, one and the same.

Governor John Letcher desperately needed drillmasters for the thousands of recruits flocking to Richmond. He ordered the VMI corps of cadets at once to the capital. As the senior officer on duty, Major Jackson would lead the marching column. At midday on April 21, Jackson knelt in prayer with his wife. "His voice was so choked with emotion," Mary Anna Jackson recalled, "that he could scarcely utter the words."

Jackson then rode to the Institute, took his place at the head of the column, and led the cadets out of Lexington. He never saw his adopted hometown again.

On the West Coast, a half-dozen Southern officers prepared to head home and serve the Confederacy. One was Winfield Hancock's

⚜ ★ ★ ★ ⚜

ON A BRIGHT SUNDAY, PROFESSOR JACKSON ABANDONED HIS CLASSROOM TO LEAD THE VMI CADETS TO DRILLMASTER DUTIES IN RICHMOND. THE WAVING WHITE FLAG OF THE INSTITUTE REFLECTED THE GAIETY OF THE OCCASION—A GAIETY THAT WOULD PROVE SHORT-LIVED.

closest friend, Lewis Armistead of Virginia. At a farewell party, emotions ran high. Armistead walked up and tearfully embraced Hancock. The Virginian then presented his friend with a new U.S. Army major's uniform for which Armistead would have no use. Hancock meanwhile had received orders to report to Washington for duty in the major military theater.

Chamberlain did not answer his country's initial call. For one thing, his domineering father bitterly opposed the war. The young professor was probably among those who envisioned a short contest. Further, Bowdoin College was not a bastion of either abolitionism or active unionism. In 1858, it had conferred an honorary degree on U.S. Sen. Jefferson Davis of Mississippi. Chamberlain was also aware that the college might withdraw his two-year leave of absence if it thought he had plans to go rushing into battle. The events of 1861, Chamberlain wrote, "took possession of every heart." Yet his was an exception.

Chamberlain's action was a delay, not a decision. As he observed: "Fighting and destruction are terrible, but are sometimes agencies of heavenly rather than hellish powers. In the privations and sufferings endured, as well as in the strenuous action of battle, some of the highest qualities of manhood are called forth—courage, self-command, sacrifice of self for the sake of something held higher." For participants, he added, war is "a test of character; it makes bad men worse and good men better."

✦ ★ ★ ★ ✦

Chamberlain joined the Bowdoin College faculty as an instructor in rhetoric. By 1861 the accomplished linguist and charismatic professor occupied the chair of modern European languages.

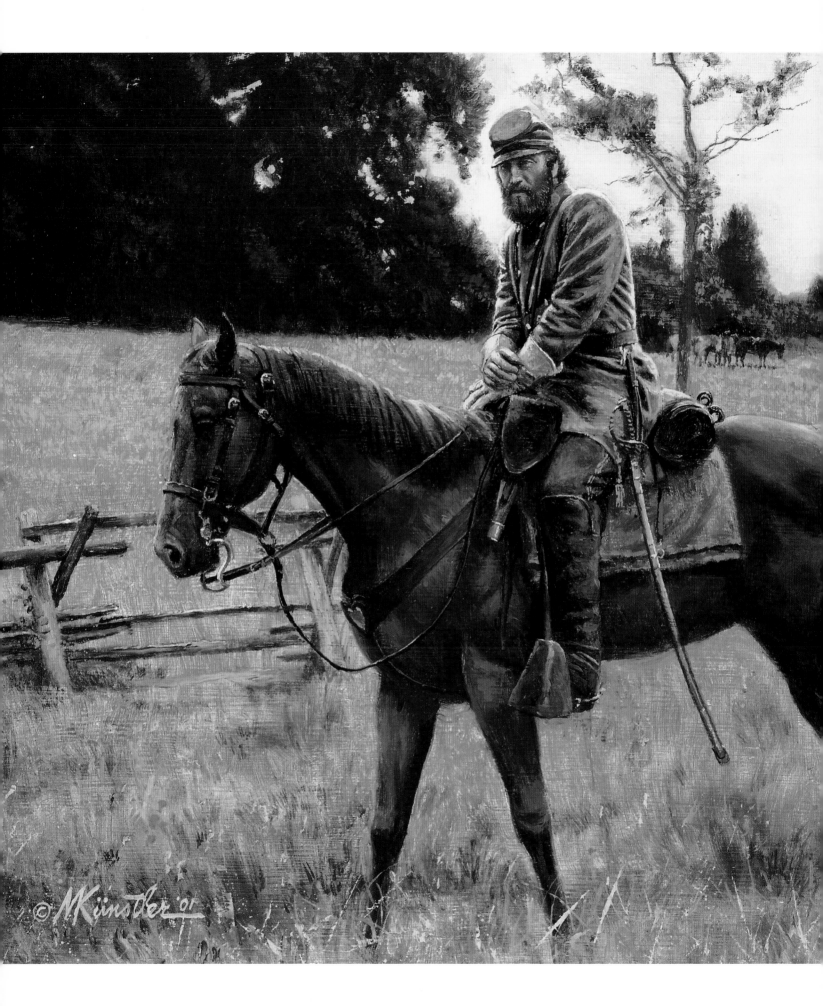

A CONFEDERATE TEAM

During the first year of the Civil War in the Virginia theater, the man who dominated thinking on both sides was the silent, pious professor from VMI. It was as if the sectional conflict awakened a spark in the latent Thomas J. Jackson. Whatever the cause, his star flashed across the sky and cast a brilliant light that would dominate much of the war for its first two years.

Colonel Jackson's first assignment was to command the Confederacy's northernmost defense, Harpers Ferry. The village where the Potomac and Shenandoah Rivers joined also stood alongside the Baltimore and Ohio Railroad and the Chesapeake and Ohio Canal. Jackson not only turned the old post into a strong fort that served as a rendezvous camp for recruits arriving almost daily, he also strengthened Harpers Ferry's defense of the lower (northern) end of the agriculturally rich Shenandoah Valley.

It was during the Harpers Ferry assignment that Jackson secured the services of Jim Lewis, a middle-aged Lexington slave who would be his servant throughout the two years in the field. Jackson at that time also acquired "Little Sorrel." The horse became his favorite mount, as well as one of the most famous horses in American military history.

In late spring, Jackson received promotion to brigadier general. Under his new command were five Virginia infantry regiments from the Valley area. Initially known as the First Brigade of Virginia, the unit, under Jackson's watchful and

<div align="center">〜🐚★★★🐚〜</div>

WHILE IN COMMAND AT HARPERS FERRY, JACKSON PURCHASED A SMALL HORSE THAT HE INTENDED TO GIVE TO HIS WIFE. YET WHEN HE FIRST MOUNTED THE ANIMAL FOR A TEST-RIDE, A BONDING TOOK PLACE. "LITTLE SORREL" AND "OLD JACK" WERE INSEPARABLE THEREAFTER.

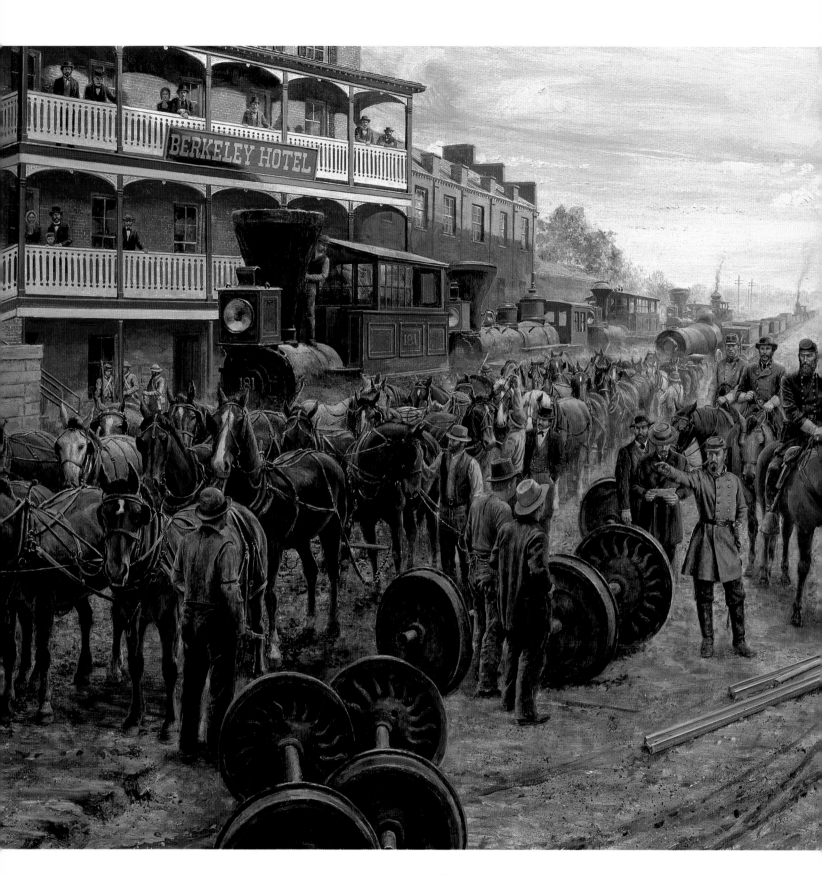

For the first time in warfare, railroads became a major factor in the 1860s. Jackson saw the value of rail lines early. In mid-June, 1861, he oversaw the dismantling of 13 captured locomotives at Martinsburg for a partially overland transfer to Richmond.

BERKELEY HOTEL

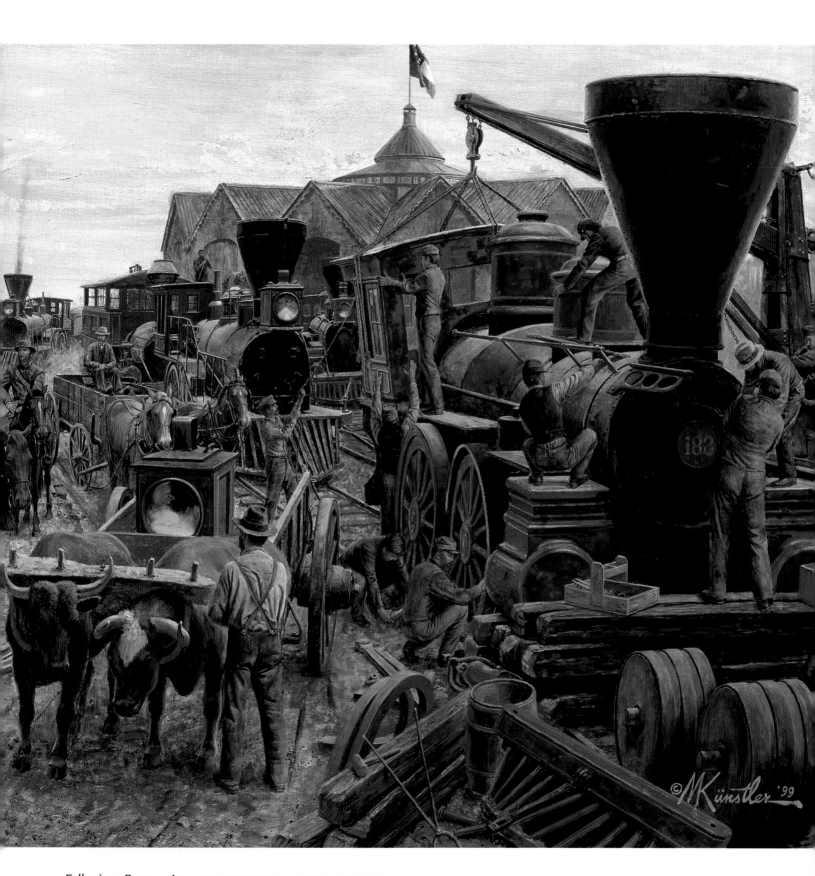

Following Pages, AN UNFORGETTABLE SIGHT GREETED WINCHESTER CITIZENS AS FORTY-HORSE TEAMS PULLED SECTIONS OF LOCOMOTIVES THROUGH THE DOWNTOWN EN ROUTE TO A RAILHEAD AT STRASBURG. THIS ACCOMPLISHMENT WAS ONE OF THE ENGINEERING WONDERS OF THE WAR.

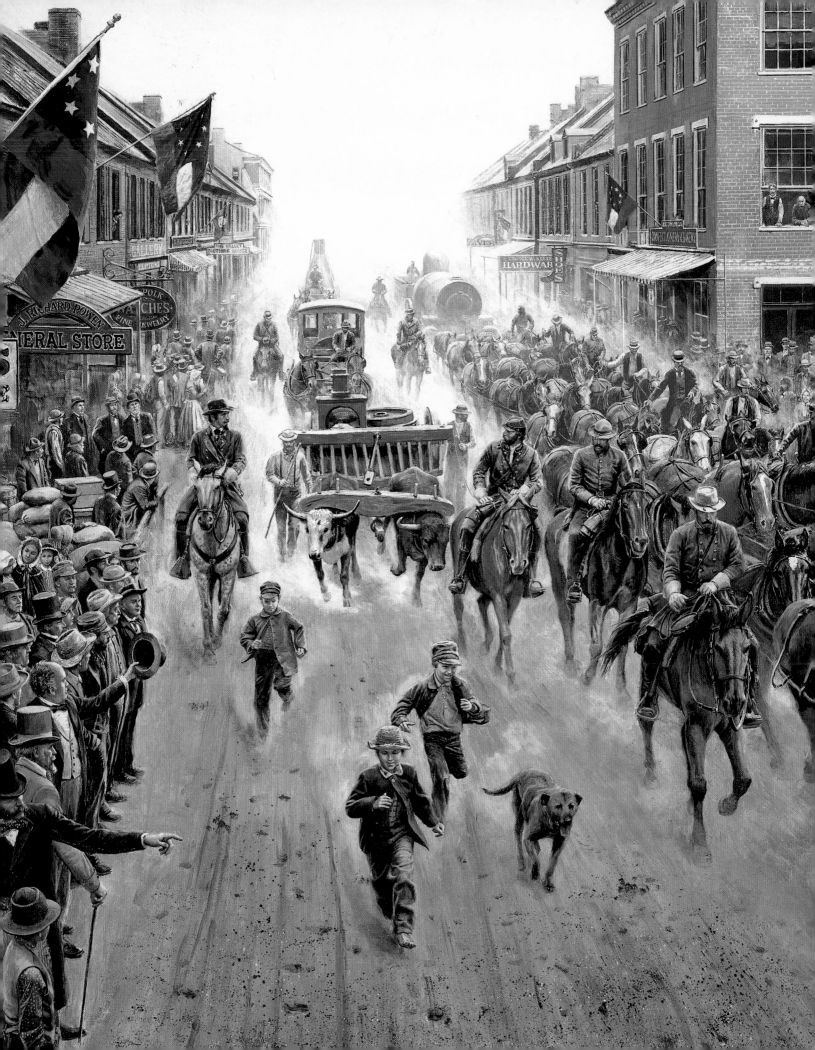

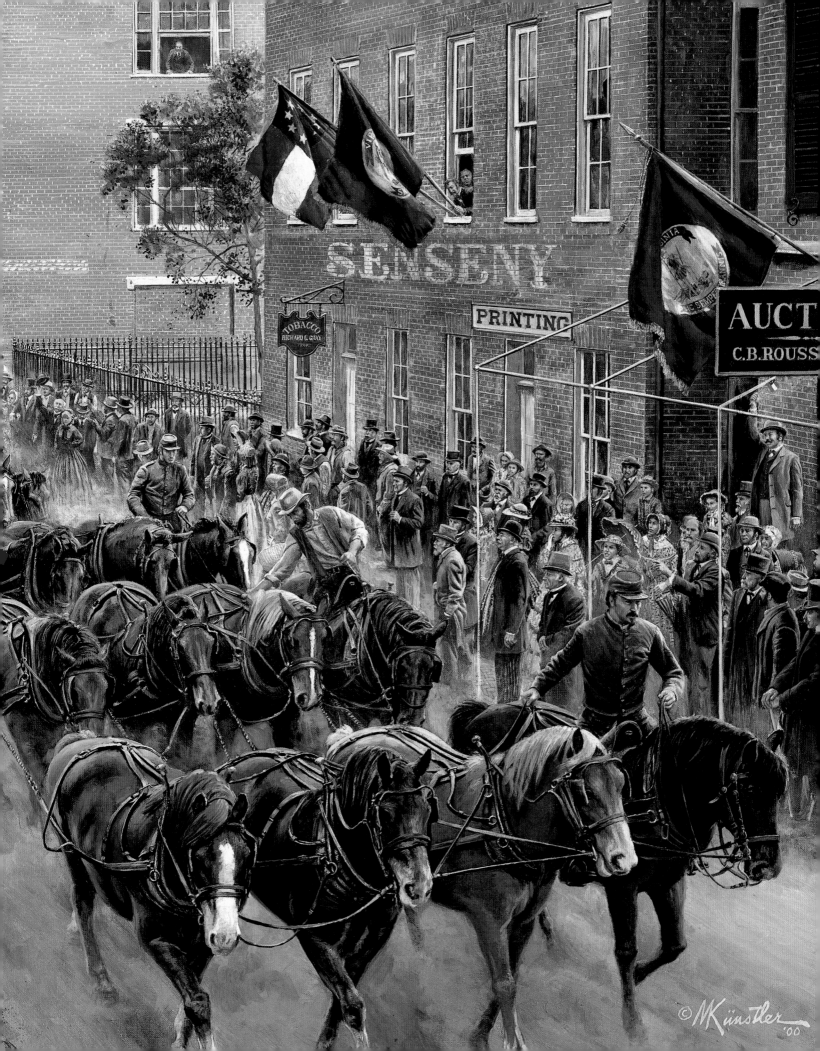

demanding eye, became exceptionally well-disciplined. That proved providential for the South a few weeks later.

General Robert E. Lee, meanwhile, had done well in organizing and overseeing the training of a large fighting force. Responsible for defending a state 240 miles long and more than 600 miles in width, Lee would have had great difficulty in his new job had Virginia not possessed a well-developed militia. Troops from other Southern states rushed to Richmond and the defense of the Confederate capital. By mid-July, some 12,000 soldiers were in position guarding the north end of the Shenandoah Valley while 22,000 Confederates were protecting Manassas Junction, where the two principal railroads in northern Virginia came together.

Northern newspapers and politicians clamored for action to end what was perceived as a one-battle war. An untested field commander, General Irvin McDowell, led 35,000 equally green troops toward Manassas. Jackson's brigade and other Southern units marched from the Valley to reinforce Confederates posted along Bull Run at Manassas. On Sunday, July 21, McDowell launched his attacks.

This opening major battle of the Civil War was basically a collision between two armed mobs. However, the bloodshed through the day, and the panic near day's end, awakened the people to the realities of war.

Both sides spent the morning shifting elements under fire here and there. Jackson got

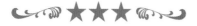

THIS WARTIME MAP DEPICTS MANASSAS JUNCTION ON THE LEFT AND THE JULY 21, 1861, BATTLEFIELD ON EITHER SIDE OF NEARBY BULL RUN. THE STREAM WAS NOT AS WIDE AS SHOWN.

MAP
OF THE
SEAT OF WAR
SHOWING THE BATTLES OF
JULY 18TH & 21ST 1861.

his brigade posted behind the crest of Henry House Hill, an eminence that commanded the Confederate left—the sector McDowell was attempting to break. Federals fought their way through the first line of defenders and began advancing up Henry House Hill in anticipation of victory. Jackson calmly advanced his regiments to the hilltop. General Barnard Bee saw the movement and shouted to his faltering South Carolina troops: "Look, men! There stands Jackson like a stone wall! Rally behind the Virginians!" Bee fell, mortally wounded a few moments later, but his words gave birth to the most famous nickname in American military history.

Stonewall Jackson's line advanced and fell back throughout the afternoon's fighting. Yet the line never broke. The arrival of fresh Confederate reinforcements eventually sent the Federals in a pell-mell retreat to Washington. Jackson begged to give pursuit and seize the Northern capital, but the Confederates were as exhausted and confused in victory as the Federals were in defeat. Nevertheless, at Manassas the South won the day and found a hero.

Throughout the summer and early autumn, while Jackson and his Stonewall Brigade were part of the northern Virginia defensive line,

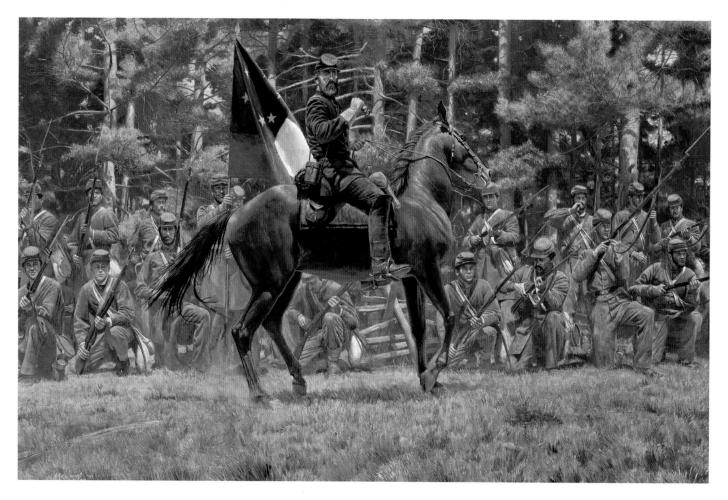

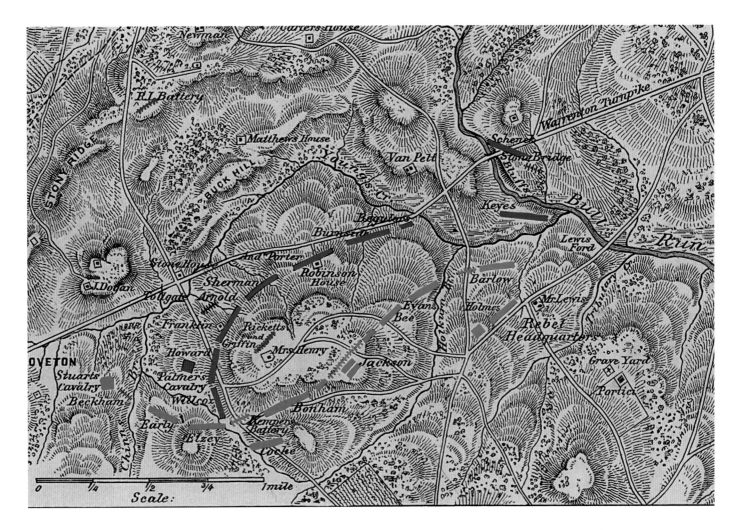

THIS MANASSAS MAP SHOWS JACKSON'S BRIGADE NOT ONLY MANNED THE VITAL LEFT-CENTER OF THE CONFEDERATE LINES; IT WAS ALSO ATOP HENRY HOUSE HILL, THE DOMINANT HIGH GROUND ON THE BATTLEFIELD. GENERAL BEE, WHOSE BRIGADE WAS ON JACKSON'S RIGHT, WAS THE MAN WHO SHOUTED THE NICKNAME BY WHICH JACKSON WAS KNOWN THENCEFORTH.

★ ★ ★

Lee was undergoing a long battle with frustration. Appointed to the rank of full general in the Confederacy, Lee did not get the field command he badly wanted. He became instead military adviser and troubleshooter for President Jefferson Davis.

His first duty was to superintend military operations in western Virginia, an area not only mountainous and overwhelmingly Unionist in sentiment, but also a theater where three Confederate generals were spending more time arguing among themselves than in driving back steadily advancing Union forces. Lee spent three months trying to bring a semblance of order out of widespread chaos. Not even his tact and strategic mind could turn the

campaign around. On October 24, a majority of voters in the region elected to withdraw from the state of Virginia. Lee returned to Richmond, his hair having turned gray from the experience, his reputation damaged, and ridiculed in public circles as "Granny Lee."

Davis then dispatched Lee to inspect the defenses along the Atlantic coast of South Carolina, Georgia, and Florida. Lee found once-navigable rivers obstructed, forts in need

of repairs, and earthworks insufficient. The engineering skills of Lee sprang forth. In four months he vastly improved all defenses by employing every able-bodied man (regardless of social class) to help in the digging and the strengthening of earthworks and cannon emplacements. Yet he departed for Richmond with a second unflattering nickname, the "King of Spades."

Lee's yearning for field command persisted. While it did, "Stonewall" Jackson was making history in the Shenandoah Valley.

In October, 1861, Jackson had been promoted to major general and placed in charge of the great Valley of Virginia. His dual responsibilities were to protect the region against Union intrusion and to prevent Federals in the Valley and to the east at Fredericksburg from reinforcing General George B. McClellan's huge army then beginning an offensive against Richmond. Jackson spent most of the winter months slowly building up his force to just under 4,000 men. It was certainly not an imposing army, but it was large enough, and sufficiently well-led to do damage. In mid-March, 1862, with Lee's endorsement, Jackson unleashed a campaign a Federal officer termed "that succession of movements which ended in the complete derangement of the Union plans in Virginia."

To understand the complicated Valley Campaign requires an understanding of the

✦✦✦

general who masterminded it. Jackson was a no-nonsense commander who paid little heed to tradition. The only way a weaker force such as his own could destroy a stronger one, he believed, was by swift and unexpected attacks. Alacrity and audacity were his tools of war. Never do what the enemy expects. Keep your opponent continually off-guard. Create a sense of superiority, always ask God's blessings, have faith in your soldiers, and success will result.

On March 23, Jackson stopped a Union withdrawal from the Valley with an attack at Kernstown on the outskirts of Winchester. A month later, Jackson was strengthening and fine-tuning his command when Lee (acting in essence as chief-of-staff for operations in Virginia) suggested that Jackson attack Federal forces in the Valley in an effort at least to cripple McClellan's grand offensive against Richmond. What followed over the next six weeks was a masterpiece of strategy and tactics.

Three Union armies from three different directions were moving leisurely to engage Jackson. The Confederates were outnumbered more than three to one. Jackson then combined secrecy, intuition, boldness, knowledge of terrain, mobility, concentration of force, and surprise with textbook perfection. An aide to General Richard S. Ewell, Jackson's second-in-command, wrote his mother in the middle of the campaign: "Our old chief, Jackson, is the very man to put in the Valley of Virginia, for

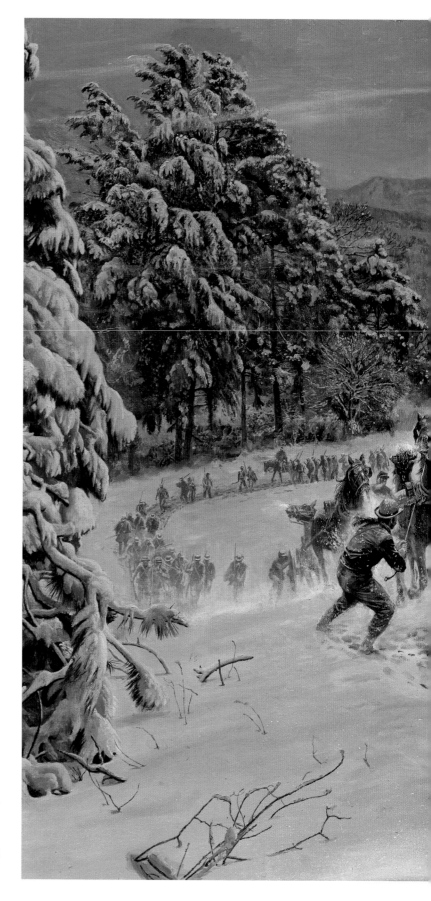

⚜ ★ ★ ★ ⚜

JACKSON WATCHES HIS TROOPS STRUGGLE THROUGH WINTRY ELEMENTS DURING THE JANUARY, 1862, ROMNEY CAMPAIGN. ONE CONFEDERATE SPOKE FOR MANY WHEN HE WROTE: "I RECKON OLD STONEWALL KNOWS WHAT IS BEST, I DON'T THINK HE WOULD MARCH US SO HARD UNLESS IT WAS NECESSARY."

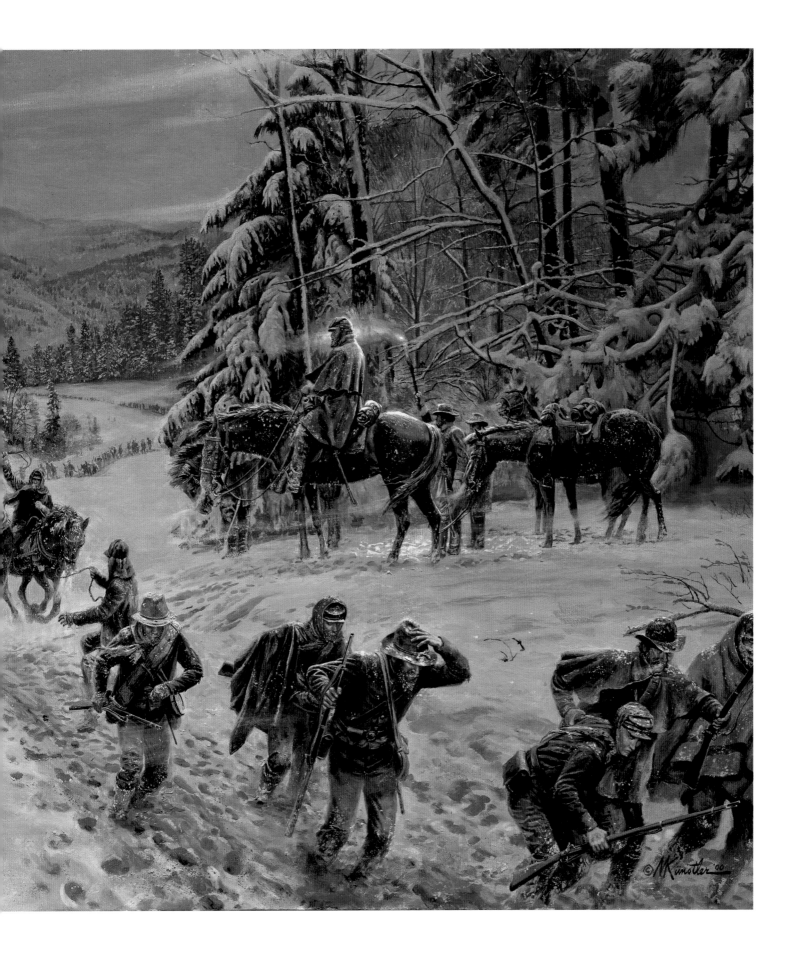

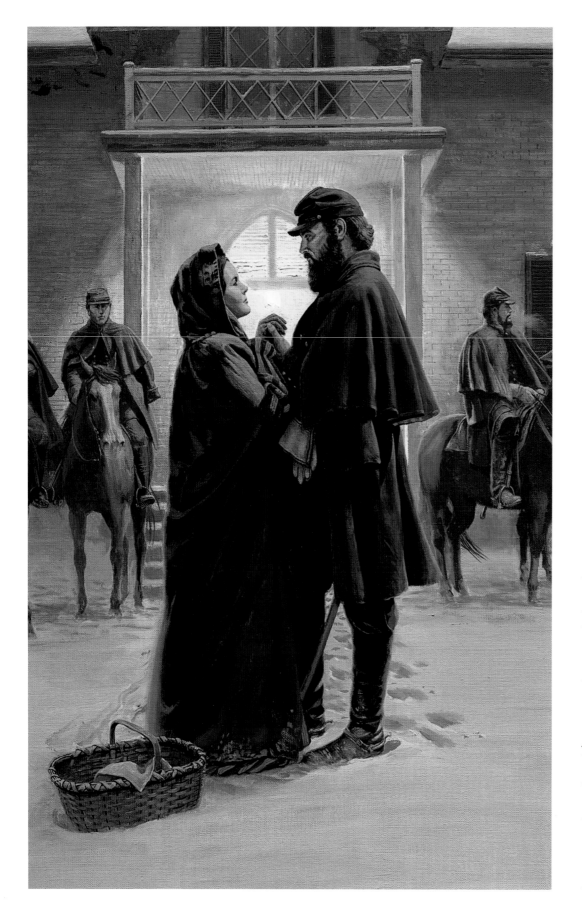

MARY ANNA JACKSON GAVE HER HUSBAND SIX OF THE HAPPIEST YEARS HE EVER KNEW. SHE SPENT THE WINTER OF 1861—1862 WITH HIM IN WINCHESTER, VA. HERE JACKSON BIDS HER GOODBYE AS HE PREPARES TO BEGIN HIS FAMOUS SHENANDOAH VALLEY CAMPAIGN.

JACKSON MAY HAVE HAD THE FINEST STAFF OF ANY GENERAL IN THE CIVIL WAR. FOR HIS "INNER FAMILY," HE SELECTED MEN WHO POSSESSED HIGH MORAL CHARACTER, STRICT PUNCTUALITY, AND A DEVOTION TO DUTY THAT APPROXIMATED HIS OWN.

he believes altogether in its importance, and it would be hard to convince him that the axis of the world does not stick out somewhere between Winchester and Lexington."

Between May 8 and June 9, Jackson marched his men 400 miles, swept down on Federal detachments like an avalanche, won five battles, captured as many Federal soldiers as he had in his command, and seized tons of badly needed arms and supplies, while clearing the Valley of all Union threats. At the end of the campaign, a Pennsylvania private, in a letter home, voiced the frustrations of Union authorities. "I guess our General found it was no use to try and catch Jackson for he marched his men on half rations as far in one day as we could in two and a half." Further, Jackson's actions led Abraham Lincoln to withhold a full Union corps from McClellan for the protection of the Northern capital. Jackson had all but turned the Civil War upside down in Virginia.

That second spring of the war, the Southern people were desperate for victories. Jackson appeared out of nowhere with those victories. Overnight he became the most heralded general in the Confederacy. His brilliance as a soldier

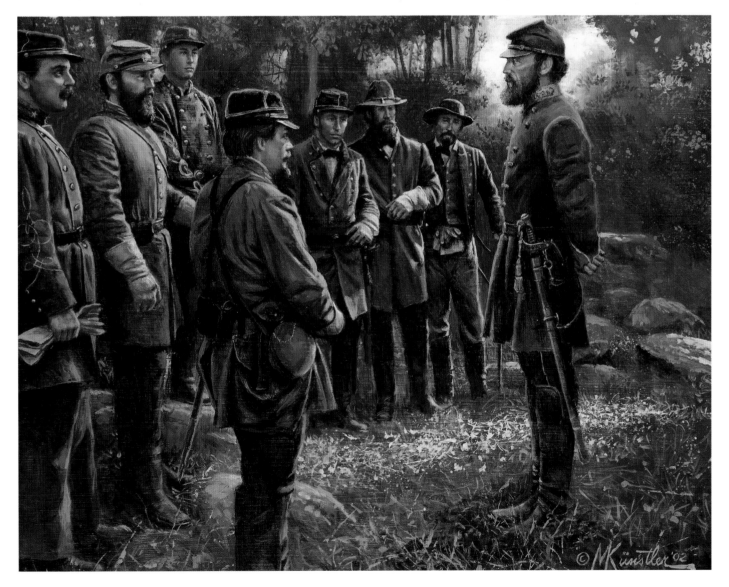

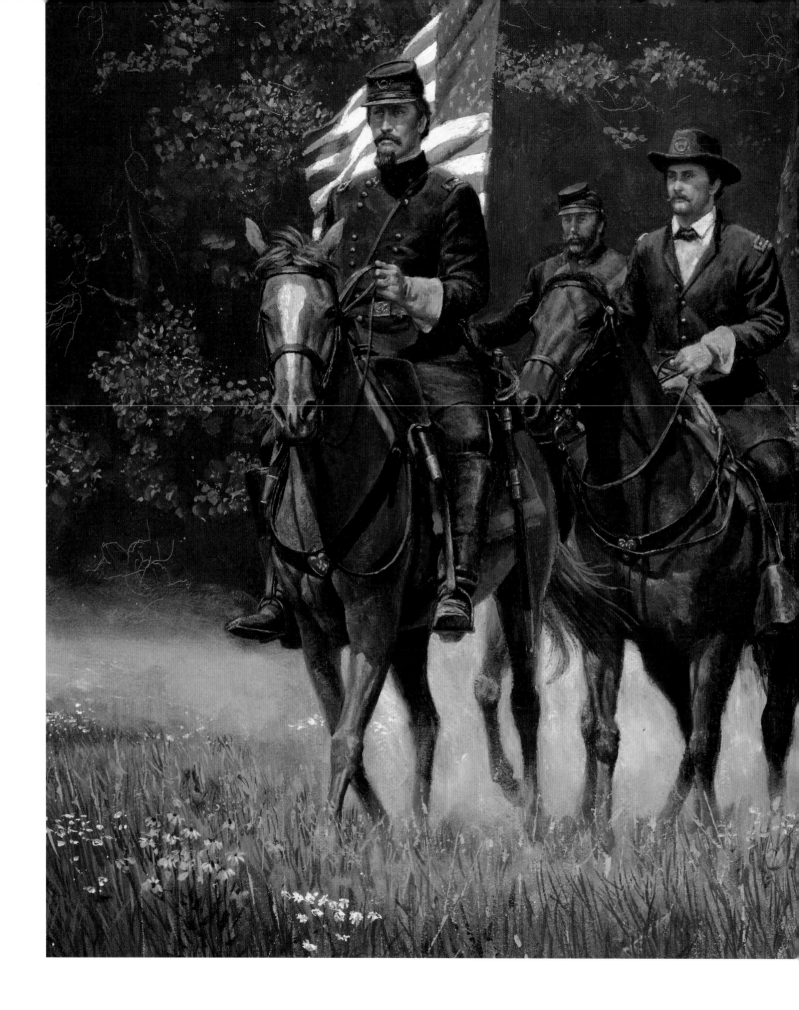

and his piety as a man made him the perfect soldier for the beleaguered Southern nation.

While Jackson was conducting his still-studied campaign in the Valley, McClellan and his massive Army of the Potomac were inching westward up the Virginia peninsula toward Richmond. One of the Union brigades in that advance was under the command of Winfield Scott Hancock. The Pennsylvanian had reached Washington in September, 1861, with the hope of getting free of assignments in the Quartermaster Department. He was a good soldier, and he knew it. All he needed was a chance to show it. That opportunity came from his old friend, McClellan. Hancock was promoted in one jump from captain in the Regular Army to brigadier general of volunteers.

He proved a stern but fair disciplinarian, a man of action who both looked and acted like a soldier. Among his characteristics was one of the most sulfuric vocabularies in all the Union armies. Fame came in his first engagement: the May 5 rearguard action on the peninsula at Williamsburg. Hancock's brigade advanced around the enemy flank and routed a Confederate force sent to dislodge him.

Although the battle of Williamsburg was basically a draw, Hancock and his men had scored a clear victory. An exhilarated McClellan exclaimed: "Hancock was superb yesterday!" Thereafter, throughout the

⤞⟡ ★ ★ ★ ⟡⤝

THE TERM "FIGHTING GENERAL" WOULD APTLY APPLY TO HANCOCK. "HE IS MAGNIFICENT IN APPEARANCE, LORDLY, BUT CORDIAL," A MEMBER OF HIS STAFF WROTE. HANCOCK DIFFERED "FROM OTHER OFFICERS I HAVE SERVED WITH IN BEING ALWAYS IN SIGHT DURING ACTION."

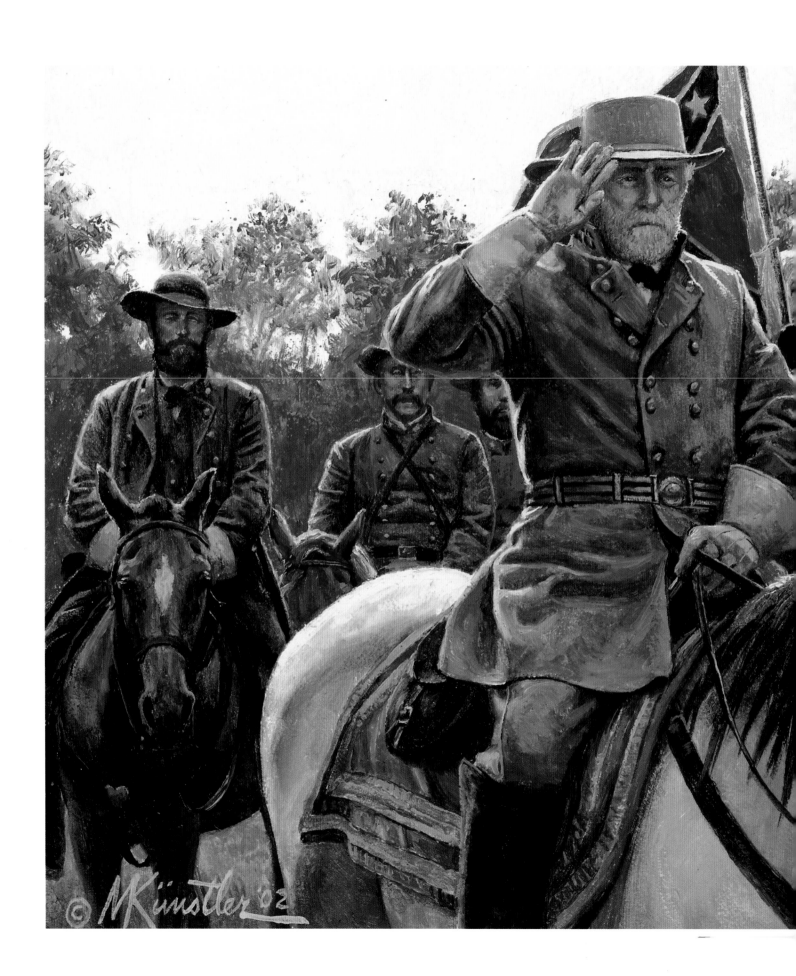

Union, the victor at Williamsburg was known as "Hancock the Superb."

McClellan got his army to within nine miles of the Confederate capital. The rain-swollen Chickahominy River blocked his advance. Confederate General Joseph Johnston used the opportunity to hurl the bulk of his forces against two isolated Union corps south of the Chickahominy. Assaults during this two-day Battle of Seven Pines were uncoordinated, tardy, and unsuccessful. Yet they did bring the cautious McClellan's offensive to a permanent halt.

Late in the afternoon of the second day's action, Johnston fell seriously wounded. The following day, President Davis named Lee to take command of the South's premier force, the Army of Northern Virginia. Historians still argue whether putting Lee in charge of one army was as important as keeping him at the seat of government and taking advantage of his incisive mind and strategic guidance. Yet field command was what Lee wanted, and he more than lived up to the trust placed in him by Davis.

Lee should have been thinking of defense when he took command of the Confederate army, but he was not. He immediately began planning an attack. Within three weeks, the Confederates launched a sudden, unexpected counteroffensive. Lee's actions were dramatic and careful. Thanks to his ever-vigilant

★★★

WITH THE EXCEPTION OF LINCOLN, NO INDIVIDUAL WAS MORE FAMILIAR TO MORE PEOPLE THAN LEE. A VIRGINIA ARTILLERYMAN EXPLAINED WHY. "HE WAS OF ALL MEN MOST ATTRACTIVE TO US, YET BY NO MEANS MOST APPROACHABLE. WE LOVED HIM MUCH, BUT WE REVERED HIM MOST."

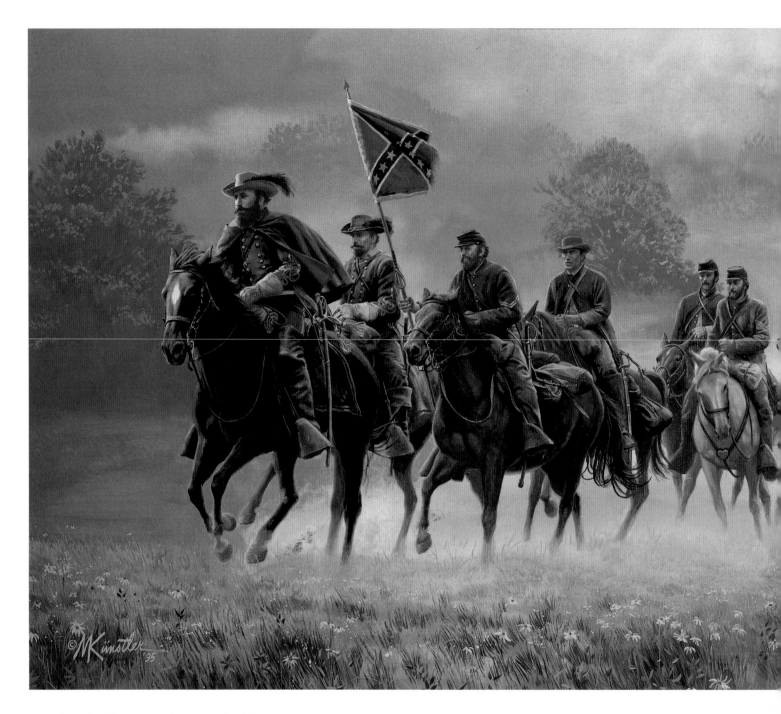

cavalry chief, General J.E.B. "Jeb" Stuart, Lee discovered that McClellan's northern flank was "in the air"—it was neither anchored on a strong terrain feature nor "refused" by being curved back to form a defensive perimeter.

Armed with that knowledge, Lee left a third of his army facing the bulk of McClellan's forces in front of Richmond. The rest of the Southern army concentrated against McClellan's vulnerable flank. Further, Lee ordered Jackson and his men to march east from the Valley and swing around the end of McClellan's line as the second part of a two-pronged Confederate assault. Destroying the Union right would expose McClellan's supply lines back to the Pamunkey River and leave the Union general

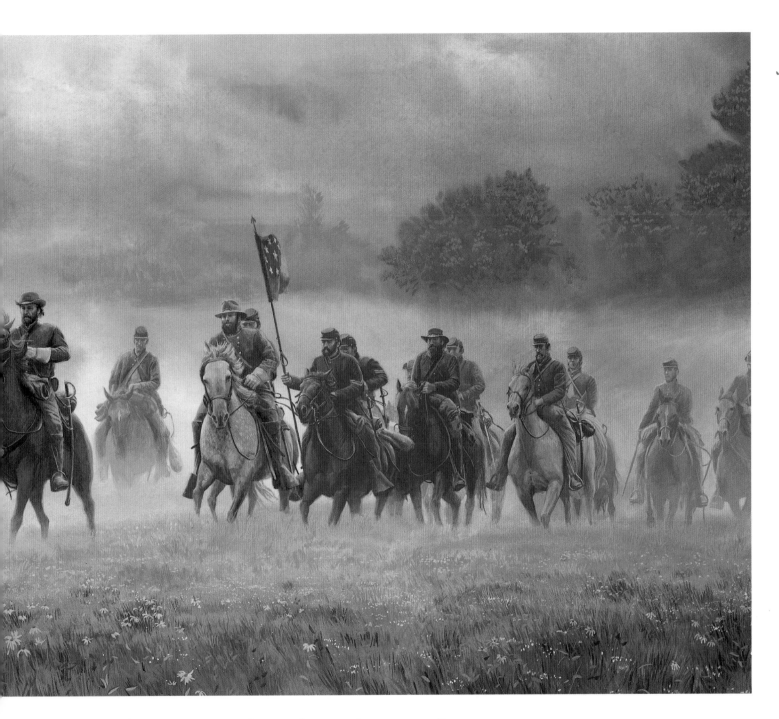

with nowhere to go except due south toward the James River.

What followed was the first all-out offensive by the Army of Northern Virginia; it was Lee's first endeavor as an army commander. The strategy was complicated and called for pinpoint execution by all elements in two army segments: Lee's and Jackson's. It was a situation

★ ★ ★

made for mistakes. Each of the major actors made them as things went wrong from the start. Jackson was tardy as well as lethargic from

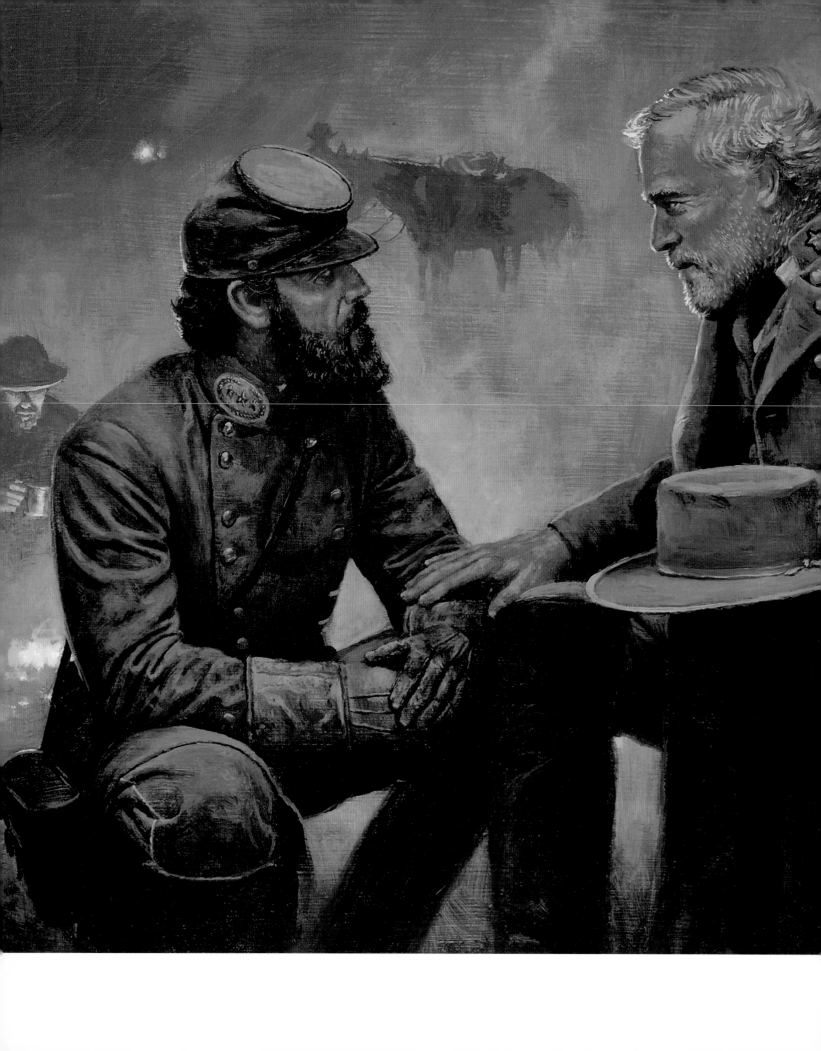

mental and physical exhaustion. Lee did not yet have the experienced command over his brigades that gave necessary timing and cohesion to his attacks. Across the way, McClellan barely kept control of his own forces.

On June 26, the Seven Days Campaign opened with an ill-conceived attack on the Federals at Mechanicsville. Fighting at Gaines' Mill consumed the next day and brought Lee and Jackson their only victory in the campaign. Lee drove hard to destroy the Union army, but he met defeats at Savage Station (June 29), Glendale (June 30), and Malvern Hill (July 1). Winfield Hancock saw only limited action in a sharp but brief June 28 fight at Golding's Farm.

Lee suffered more casualties than his opponent. He failed in all but one of his attacks. Yet his boldness sent the largest army the Western Hemisphere had ever seen scurrying to the protection of Union gunboats in the James River. For the moment, Richmond was safe.

Starting with the Seven Days Campaign, a military partnership between Lee and Jackson began. The two men shared the same preference for offense and the same determination to succeed in battle. Lee came to trust Jackson explicitly, to give him suggestions when he was giving orders to others. Jackson never had more respect for anyone than he had for Lee. An aide observed that Jackson regarded Lee "with mingled love and admiration. To excite such feelings in a man like Jackson, it was necessary that Lee should be not only a soldier of the first order of genius, but also a good and pious man. It was in these lights that Jackson regarded his commander, and from first to last his confidence in and admiration for him never wavered."

No two military commanders ever had more confidence in each other, or performed more magnificently together, than Jackson and Lee. What the latter planned, the former executed. For ten months they brought unbounded hope to the beleaguered Confederacy.

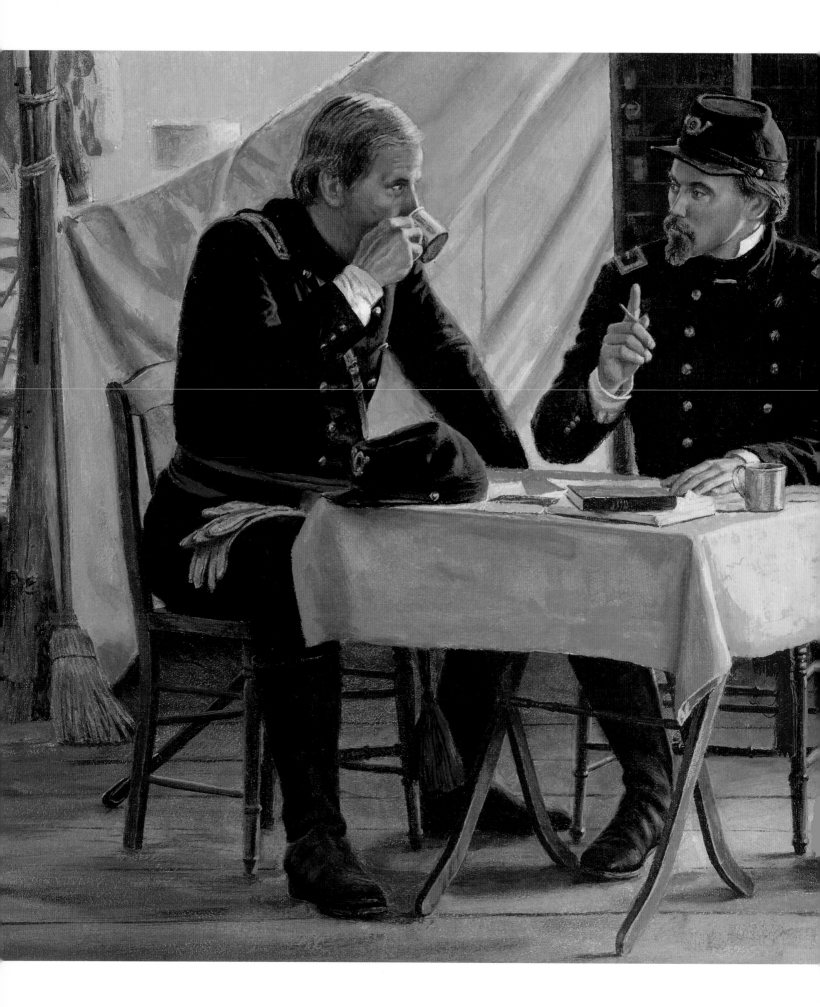

LEADERS BECOME HEROES

Joshua Chamberlain became increasingly anxious as 1861 became 1862. The Civil War did not end with one battle, as so many people expected. Bowdoin College students left for war in a steady stream. Chamberlain was opposed to both the institution of slavery and the principle of secession. His conscience burned at doing nothing for the Union cause.

In the summer of 1862, President Lincoln issued a call for 300,000 new volunteers to bring the struggle "to a speedy and satisfactory conclusion." That was the final impetus for the Maine professor. The thirty-three-year-old Chamberlain visited Governor Israel Washburn and tendered his services. Washburn offered him the colonelcy of one of the new regiments being formed. Chamberlain declined: he was too inexperienced in military affairs. A week later, Chamberlain accepted appointment as lieutenant colonel of the Twentieth Maine. Bowdoin College officials reluctantly endorsed Chamberlain's entrance into the army.

His first duty was to try to turn a mob of patriotic young men into soldiers. While Chamberlain was laboring at the task, the new regimental colonel came on duty. Adelbert Ames was seven years younger than Chamberlain. He was a high graduate in the West Point Class of 1861 and had been wounded in the opening battle at Bull Run. Ames took his first look at his command, shook his head, and pronounced it "a hell of a regiment."

Drill, drill, and more drill was Ames's means of creating a good regiment. In the process, he spent many nights in his

WHEN CHAMBERLAIN ENTERED THE ARMY AS LIEUTENANT COLONEL OF THE TWENTIETH MAINE, HE WAS EXTREMELY PLEASED TO HAVE COL. ADELBERT AMES AS HIS SUPERIOR. AMES WAS A FELLOW MAINER, REGULAR ARMY VETERAN, AND WOUNDED HERO FROM FIRST MANASSAS. THE TWO MEN BECAME INSTANT FRIENDS.

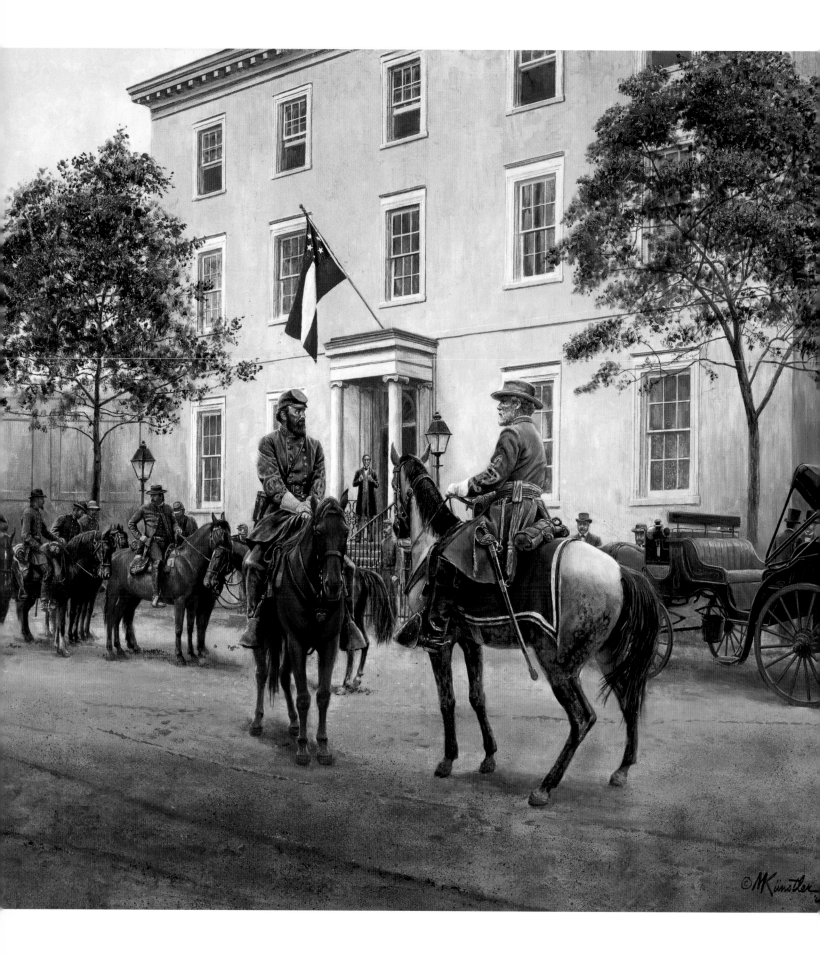

tent tutoring Chamberlain on military regulations, strategy, and tactics. The two officers quickly became close friends. Within a month after its formation, the Twentieth Maine arrived in Washington for assignment. It reached the Northern capital just as a beaten Union army was stumbling through the streets.

Robert E. Lee was then concluding one of the greatest turnarounds in military history. On June 1, Lee had taken command of a Southern army backed up to the gates of Richmond. The outlook for the Confederacy was as bleak as it could be. Nevertheless, Lee quickly reorganized his forces, brought "Stonewall" Jackson and his men from the Shenandoah Valley to Richmond, and then launched a daring counterattack. McClellan speedily retreated to the banks of the James River.

A second Union force then started toward Richmond through north-central Virginia. Lee boldly detached Jackson's brigades from McClellan's front and sent them to delay General John Pope's army as long as possible. Jackson checked Pope's advance at the August 9 Battle of Cedar Mountain. Lee, by then convinced that McClellan posed no further threat on Richmond, marched westward and linked anew with Jackson.

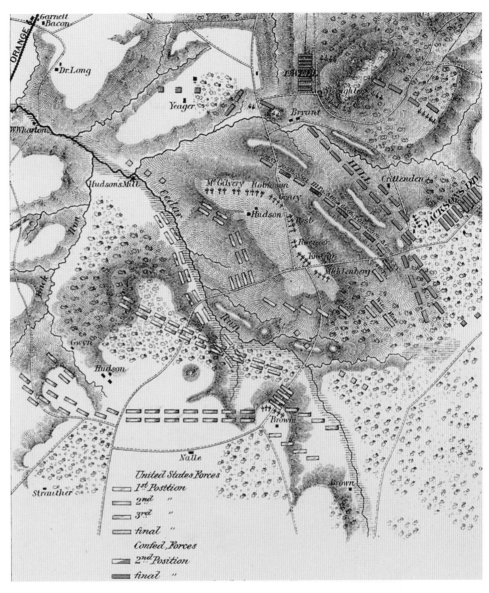

Above, THIS MAP SHOWS UNION AND CONFEDERATE POSITIONS DURING THE BATTLE OF CEDAR MOUNTAIN, AUGUST 9, 1862.

Left, ON SUNDAY, JULY 13, 1862, JACKSON AND LEE MET PRESIDENT DAVIS AT THE CONFEDERATE WHITE HOUSE IN RICHMOND. THERE THE DECISION WAS MADE TO DETACH JACKSON WITH A PORTION OF THE ARMY AND SEND HIM TO CONFRONT A NEW UNION THREAT IN NORTH-CENTRAL VIRGINIA.

⟿⟯ ★★★ ⟮⟿

The two generals devised a battle plan whereby Lee again split his army in half. Jackson's corps marched north and east on a wide flanking movement around Pope's right.

In two days, Jackson's "foot-cavalry" tramped 56 miles and seized Pope's major supply depot at Manassas Junction. Pope angrily turned around and went after Jackson. Lee went after Pope. Three days of fighting occurred in the Second Manassas (or Second Bull Run) Campaign. Pope's soldiers were exhausted from futile attacks when Confederates under Jackson and General James Longstreet assailed the Federals from two directions. Once again, a Union army fled the Bull Run arena.

In three months, Lee had changed the military picture from near-defeat to smashing success. Then, early in September, the Army of Northern Virginia waded across the Potomac River in an invasion of its own.

McClellan had returned to Washington. He gathered together the elements of his Army of the Potomac and began a cautious pursuit of Lee. Chamberlain's Twentieth Maine was now part of General Fitz John Porter's Fifth Corps. Winfield Hancock and his brigade were in General William B. Franklin's Sixth Corps. Both units were in reserve during most of the severe fighting of the September 14-17 Antietam Campaign.

★★★

IT WAS A DRAMATIC COUNCIL OF WAR, HELD AUGUST 24, 1862, ON A BARE HILLTOP OVERLOOKING THE CONFEDERATE ARMY ENCAMPMENT. LEE ASKED JACKSON TO EXECUTE A DANGEROUS, SWEEPING MARCH AROUND THE UNION ARMY'S FLANK. "I WILL BE MOVING WITHIN THE HOUR," JACKSON PROMPTLY REPLIED.

Following pages, FIVE DAYS AFTER THE HILLTOP CONFERENCE, JACKSON HAD DESTROYED THE UNION SUPPLY BASE AT MANASSAS JUNCTION AND WAS BETWEEN THE UNION ARMY AND WASHINGTON. WHEN LEE AND LONGSTREET ARRIVED ON THE SCENE, JACKSON POINTED OUT WHAT WOULD BECOME THE SECOND MANASSAS BATTLEFIELD.

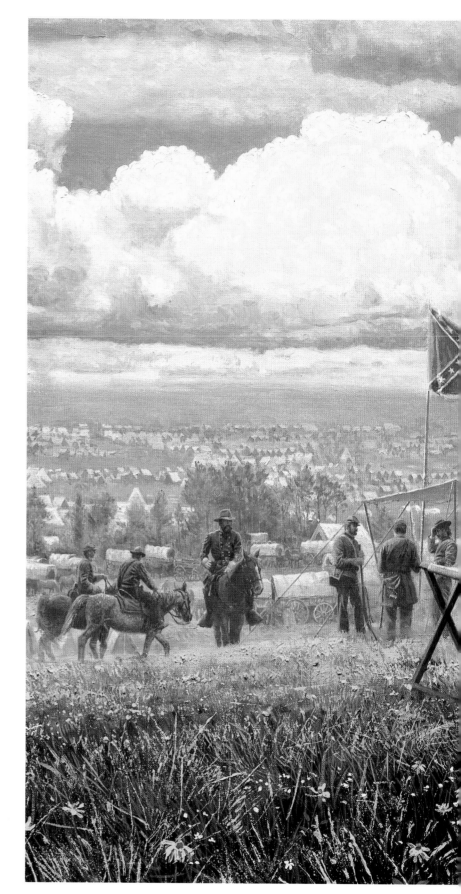

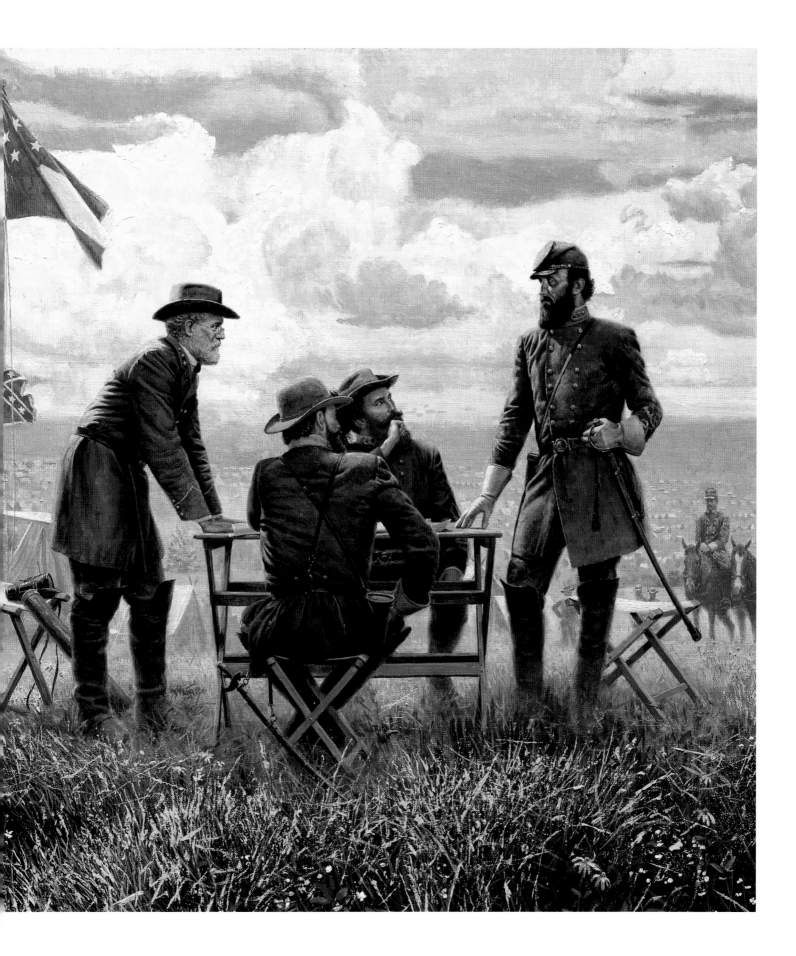

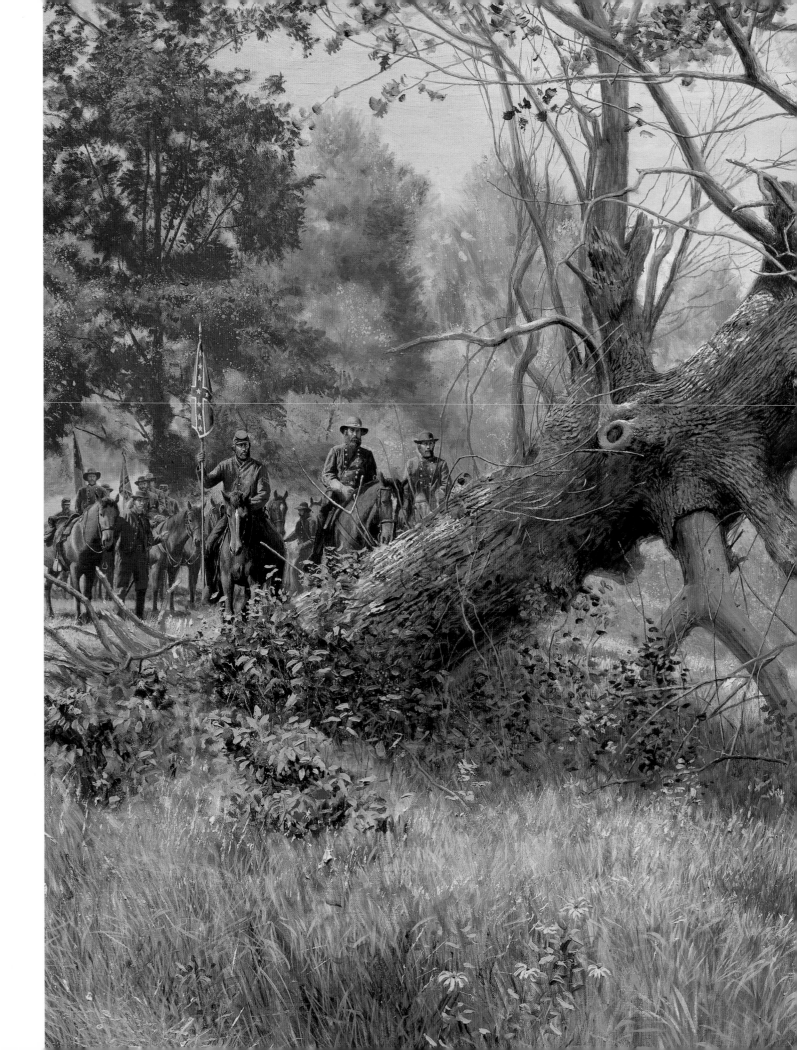

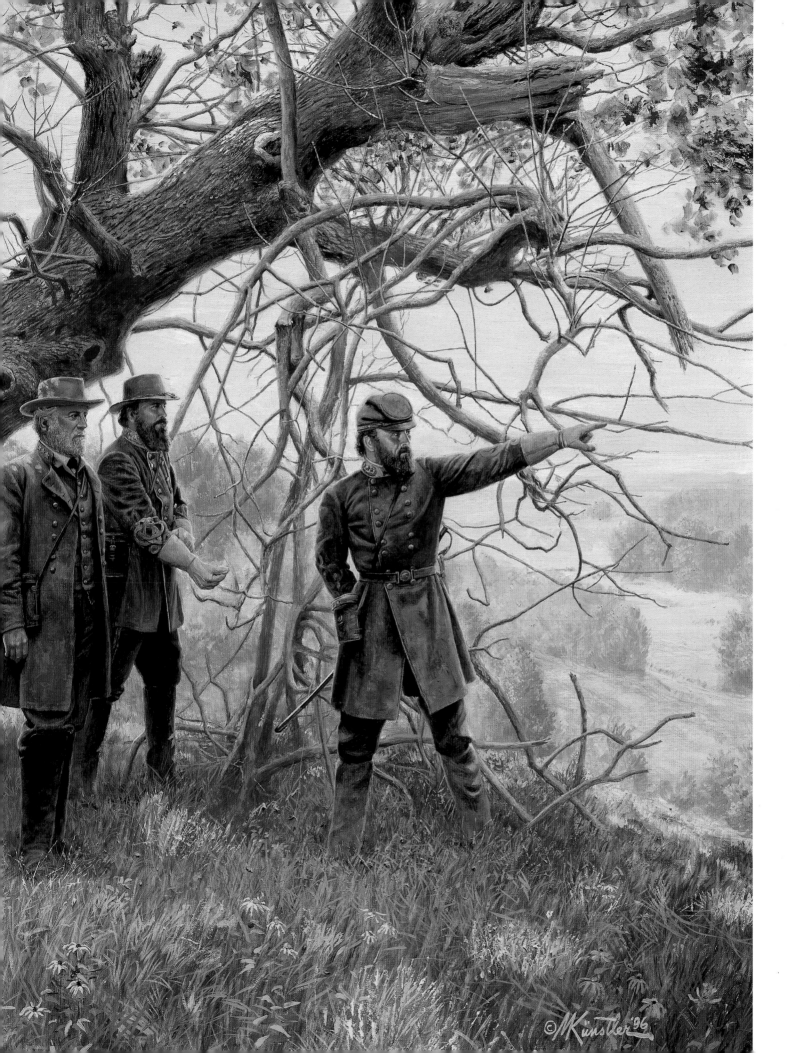

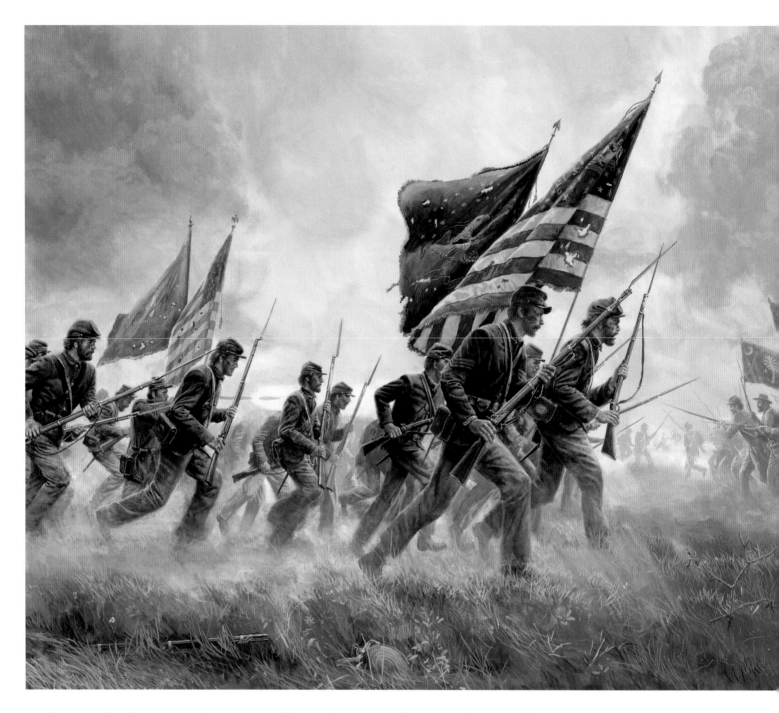

Lee marched unopposed to the road hub of Frederick in western Maryland. There he rested his army while obtaining up-to-date information. A large Union garrison at Harpers Ferry to the southwest had not retreated as expected. It posed a danger to Lee's communication lines as well as a possible retreat route into the Shenandoah Valley. So again Lee divided his forces in the face of larger enemy numbers.

Jackson and his brigades were sent to secure Harpers Ferry; Lee would march west across South Mountain to Hagerstown to await Jackson's return before proceeding north; a third Confederate force would guard the mountain passes and hopefully delay McClellan until the scattered segments of Lee's army could reunite.

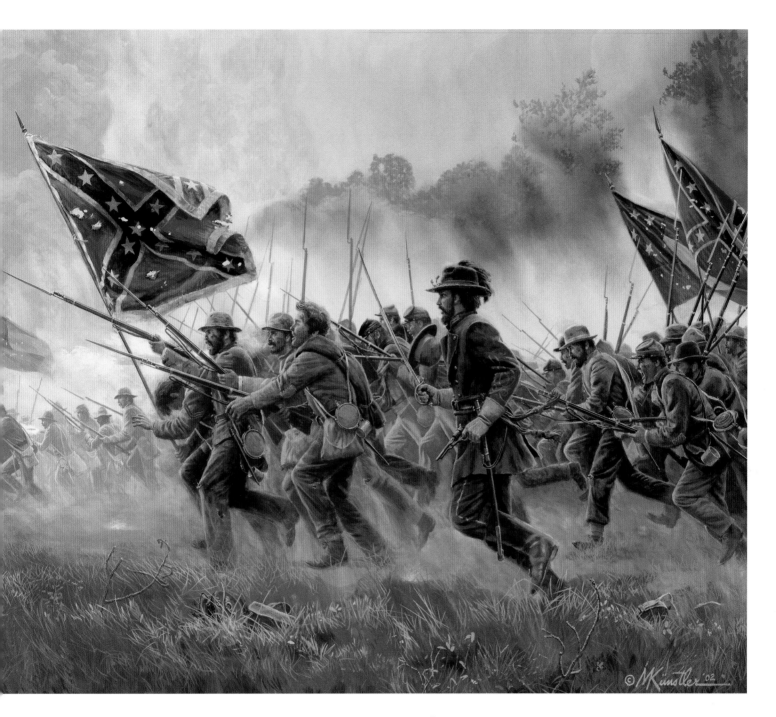

Throughout September 14, Union and Confederate soldiers fought for control of South Mountain. Meanwhile, Jackson was occupying the high ground surrounding Harpers Ferry. The next morning, his artillery began a systematic destruction of the Union garrison. White flags went up after a half-hour's bombardment. Lee then shifted his

BOTH SIDES SPOKE THE SAME LANGUAGE AND WORSHIPPED THE SAME GOD. BOTH SIDES FOUGHT FOR THE SAME THING: AMERICA, AS EACH SIDE INTERPRETED WHAT AMERICA SHOULD BE. IN SUCH A WAR, ONE SIDE WOULD HAVE TO CONQUER; THE OTHER WOULD HAVE TO BE CONQUERED.

★ ★ ★

men twelve miles south of Hagerstown to Sharpsburg to shorten the distance for a rendezvous with Jackson.

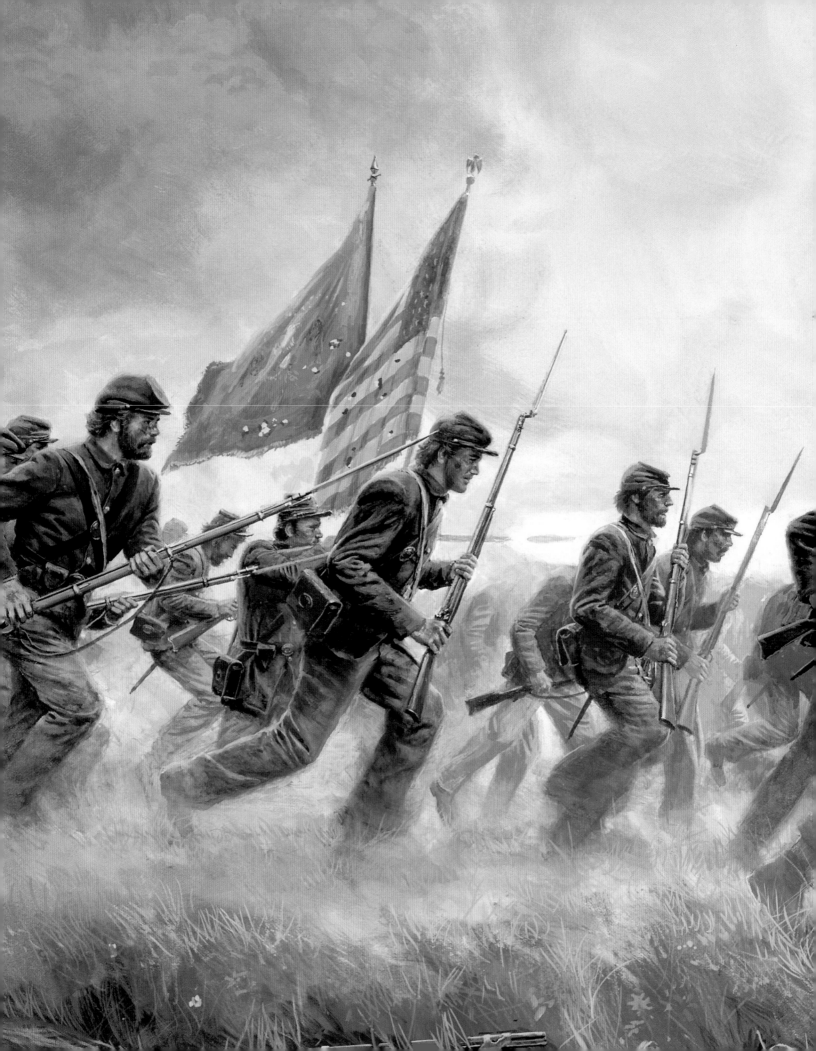

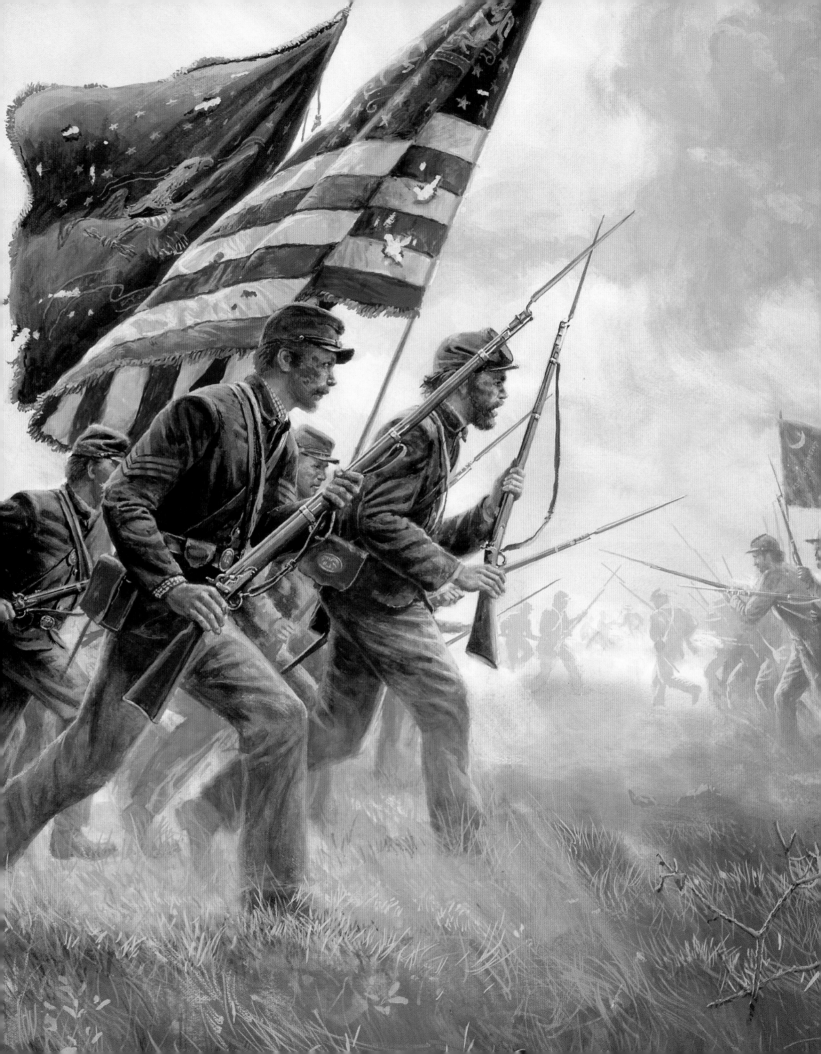

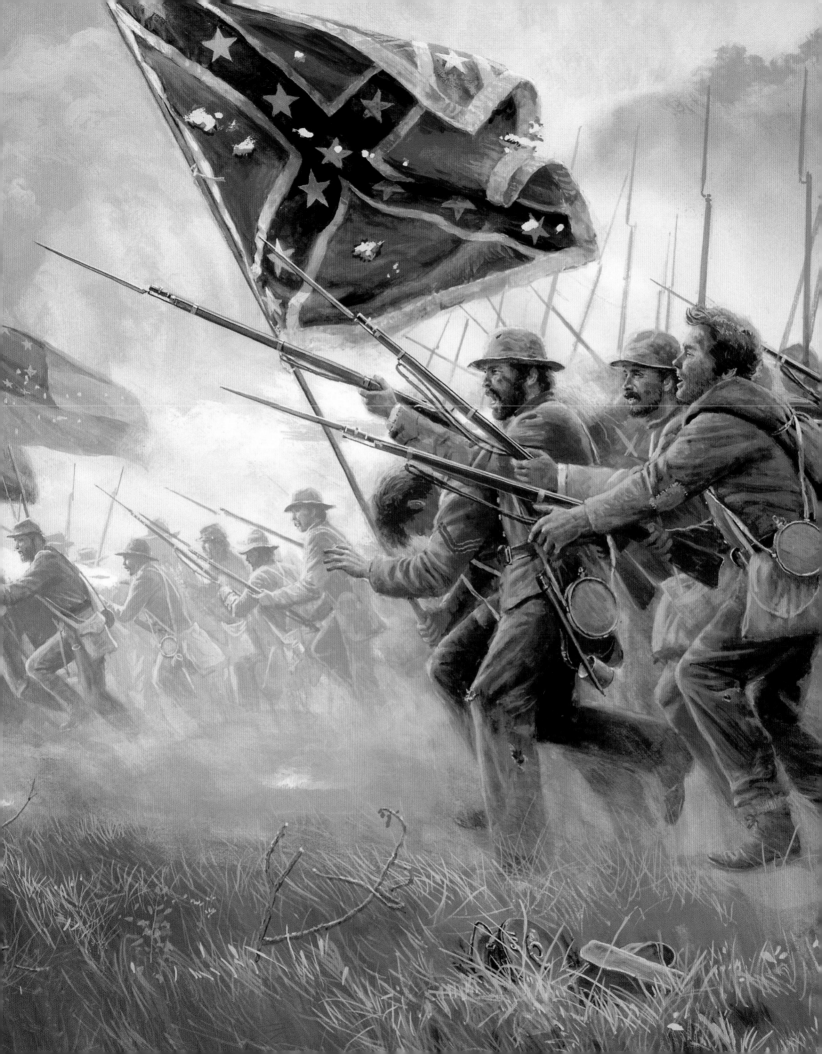

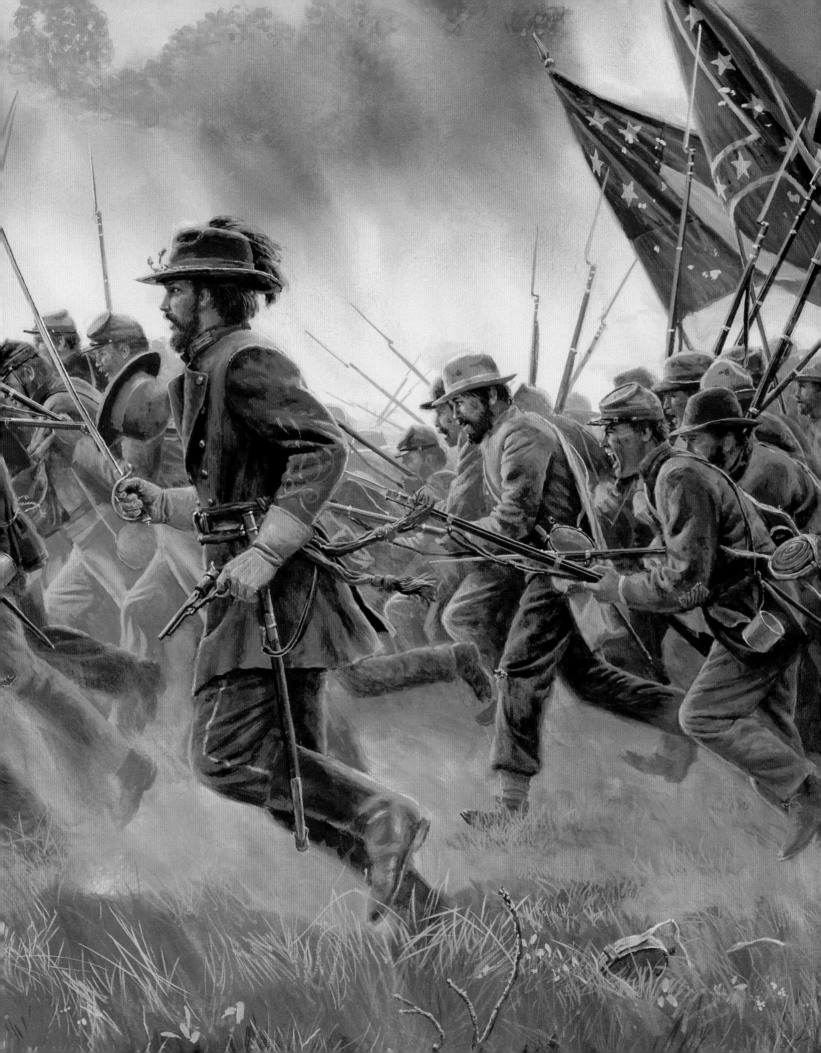

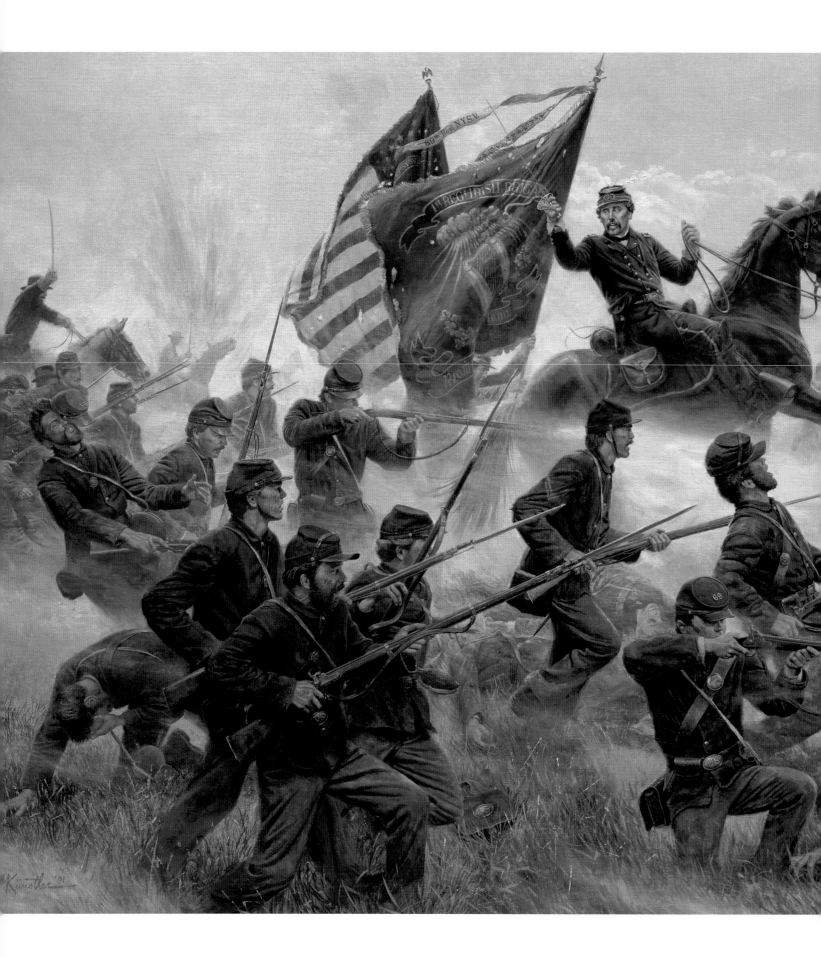

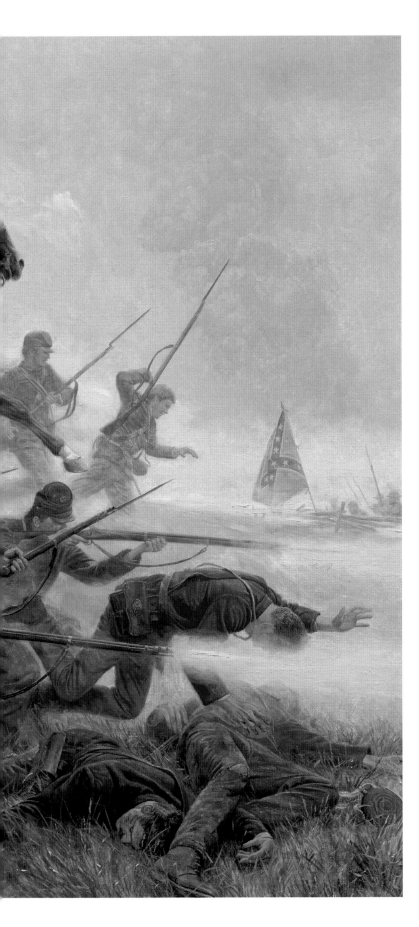

Even though McClellan had fallen beneficiary to a copy of Lee's orders detailing the division and movements of his army, the Union commander spent more of September 15-16 watching the Southern army come together than in trying to stop it.

Wednesday, September 17, became the bloodiest day in American history. The hamlet of Sharpsburg, with Antietam Creek meandering nearby, was the scene of a bloodbath still difficult to describe. For a full 13 hours, McClellan hammered Lee's position—but in stages: first attacking the Confederate left, then the center, and finally the right. Lee masterfully used inner lines of defense to shift soldiers from one sector to another. Men on both sides fought savagely, and died heroically.

Jackson's troops comprised the left of Lee's line. They received the first attacks just after dawn. In all, three Union corps assailed Jackson's ever-thinning lines over a three-hour period. That day Jackson and his men earned anew the title "Stonewall." Their lines bent, and bent some more, but never broke.

Union efforts against the middle of Lee's defenses consisted of one division after another charging down a hill against entrenched Southerners. Confederates posted in a sunken road beat back several assaults until losses and overwhelming Federal numbers forced them to abandon the road. It was so full of corpses that it has been known ever since as "Bloody Lane."

⟨✦ ★ ★ ★ ✦⟩

IRISH PATRIOT AND FUGITIVE THOMAS FRANCIS MEAGHER ORGANIZED A BRIGADE OF PREDOMINANTLY NEW YORK CATHOLICS. AT ANTIETAM, GREEN REGIMENTAL FLAGS WAVING, MEAGHER LED HIS MEN IN A COSTLY AND FAILED ATTEMPT TO DISLODGE CONFEDERATES MASSED IN THE NOW-FAMOUS "BLOODY LANE."

Fighting in the afternoon was on the Confederate right around Burnside's Bridge. Advancing Union soldiers actually broke through Lee's lines and seized high ground that overlooked Sharpsburg and blocked Lee's retreat. For a moment, McClellan was close to a decisive victory. Suddenly Confederate General A.P. Hill's division arrived from Harpers Ferry and slammed into the unprotected flank of the Union attackers. Federals abandoned the hill and fell back across Antietam Creek.

The battle ended with both sides about where they had been when it began. With twilight came the anguished cries of thousands of wounded men lying amid the dead. Over 4,800 soldiers had been killed; another 18,500 were injured—3,000 of them mortally. The one day's fighting at Sharpsburg produced more American casualties than the War of 1812, the Mexican War, and the Spanish-American War combined.

Lee had little choice but to return to Virginia. McClellan showed no inclination to press forward with the strong effort that

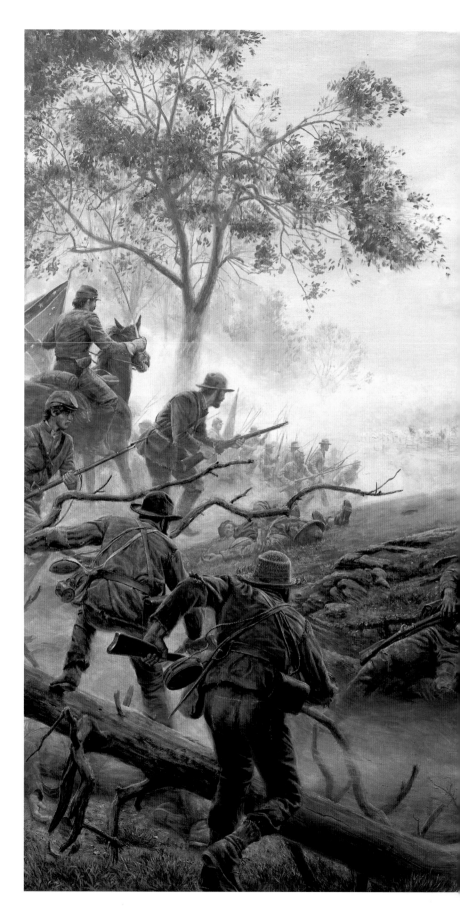

IN THREE HOURS OF VICIOUS FIGHTING AROUND THE DUNKER CHURCH AT ANTIETAM, JACKSON LOST ABOUT 40 PERCENT OF HIS COMMAND, KILLED OR WOUNDED. YET HIS LINES HELD. ONE CONFEDERATE DESCRIBED JACKSON AS "TRANSFIGURED WITH THE JOY OF BATTLE" AS HE ISSUED ORDERS "IN A QUIET WAY."

Following pages, WHEN A UNION DIVISION LEADER FELL DURING THE ASSAULTS ON "BLOODY LANE," MCCLELLAN DISPATCHED HANCOCK TO TAKE CHARGE OF THE DIVISION AND MAINTAIN THE FIGHT. YET BEFORE HANCOCK COULD LEAD A NEW ATTACK, HIS CORPS COMMANDER CANCELLED THE MOVEMENT IN ORDER TO AVERT FURTHER BLOODSHED.

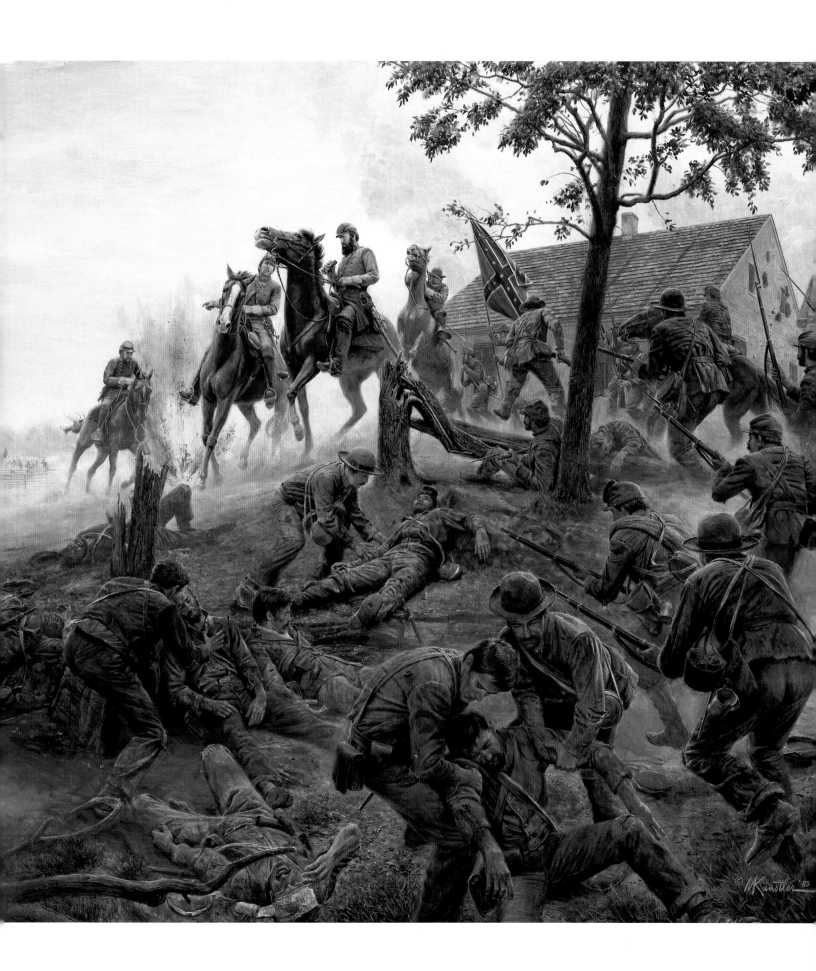

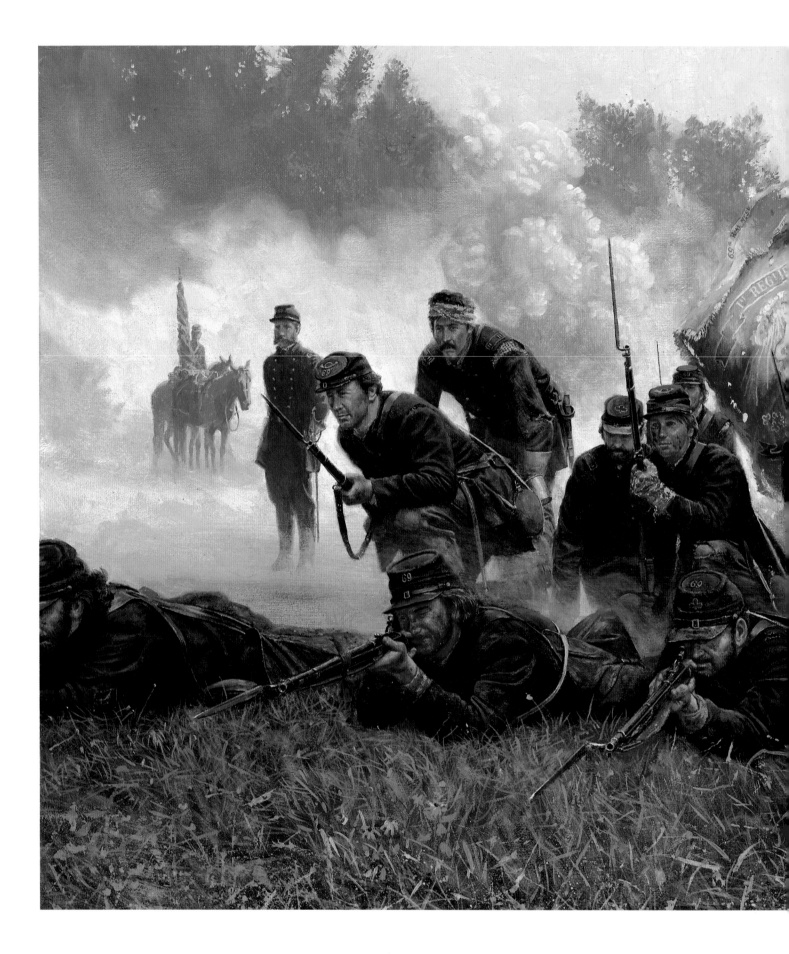

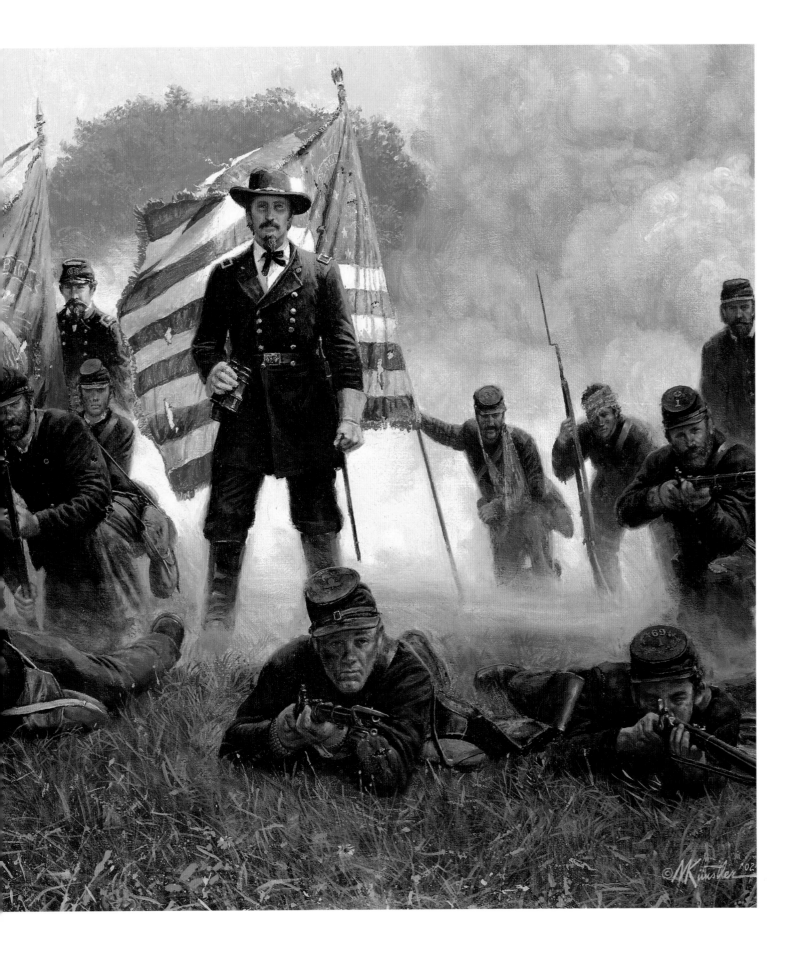

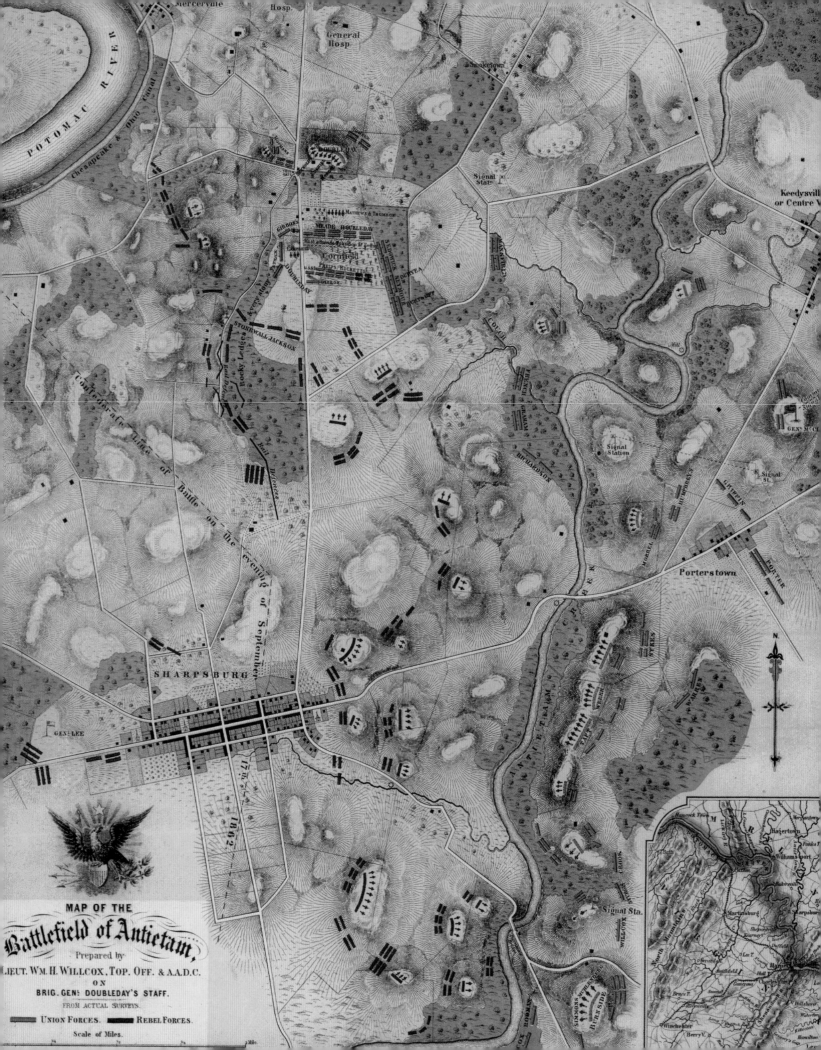

MAP OF THE
Battlefield of Antietam,
Prepared by
LIEUT. WM. H. WILLCOX, TOP. OFF. & A.A.D.C.
ON
BRIG. GEN: DOUBLEDAY'S STAFF.
FROM ACTUAL SURVEYS.
UNION FORCES. REBEL FORCES.
Scale of Miles.

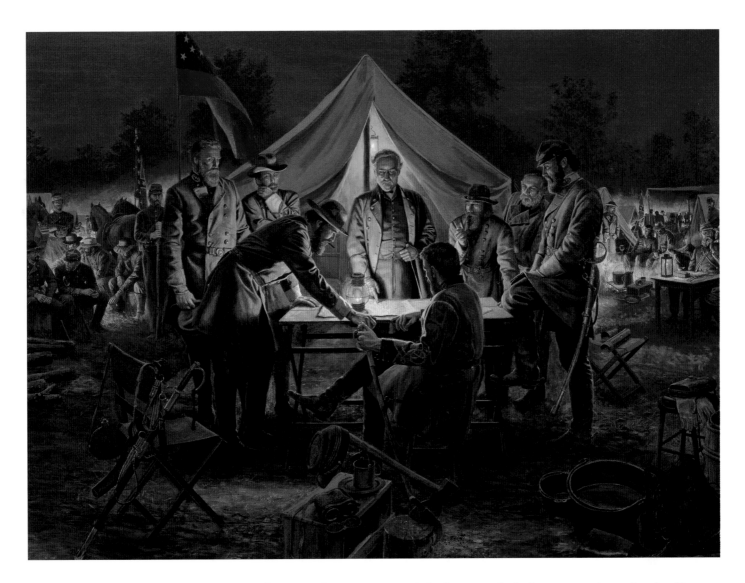

THE NIGHTS WERE A TENSE TIME FOLLOWING ANTIETAM. LEE MET WITH HIS PRINCIPAL LIEUTENANTS—LONGSTREET, JACKSON, A.P. HILL, AND OTHERS. TO REMAIN AND OFFER BATTLE ANEW OR TO RETREAT TO VIRGINIA WERE LEE'S OPTIONS. HE CHOSE BOTH, IN THAT ORDER.

Left, A UNION MILITARY CARTOGRAPHER PREPARED THIS BATTLE MAP OF ANTIETAM. JACKSON'S FIGHT IN THE WEST AND EAST WOODS IS CLEARLY VISIBLE IN THE UPPER LEFT-HAND QUADRANT, AS IS THE THIRD STAGE OF THE BAT-TLE—AROUND BURNSIDE'S BRIDGE—AT THE BOTTOM OF THE MAP.

Following pages, THROUGH THE WET NIGHT OF SEPTEMBER 18TH AND INTO THE MORNING OF THE 19TH, LEE'S MEN STRUG-GLED TO GET ARTILLERY, WAGONS, AND THEMSELVES ACROSS THE SWOLLEN POTOMAC RIVER. LEE FEARED AN ATTACK WHILE HIS ARMY WAS SO VULNERABLE, BUT NONE CAME.

★ ★ ★

might have ended the war, at least in the East. It remained for Abraham Lincoln to find victory in the stalemate at Antietam. On September 22, the Union president issued a preliminary Emancipation Proclamation. It declared that all slaves in states still in rebellion on January 1, 1863, "shall be then, thenceforward, and forever free."

With the stroke of a pen, Lincoln had broadened the Civil War from a contest to preserve the Union to a crusade to eliminate human bondage in America. Antietam was a turning point, for after September, 1862, the twin Northern goals were to stamp out a

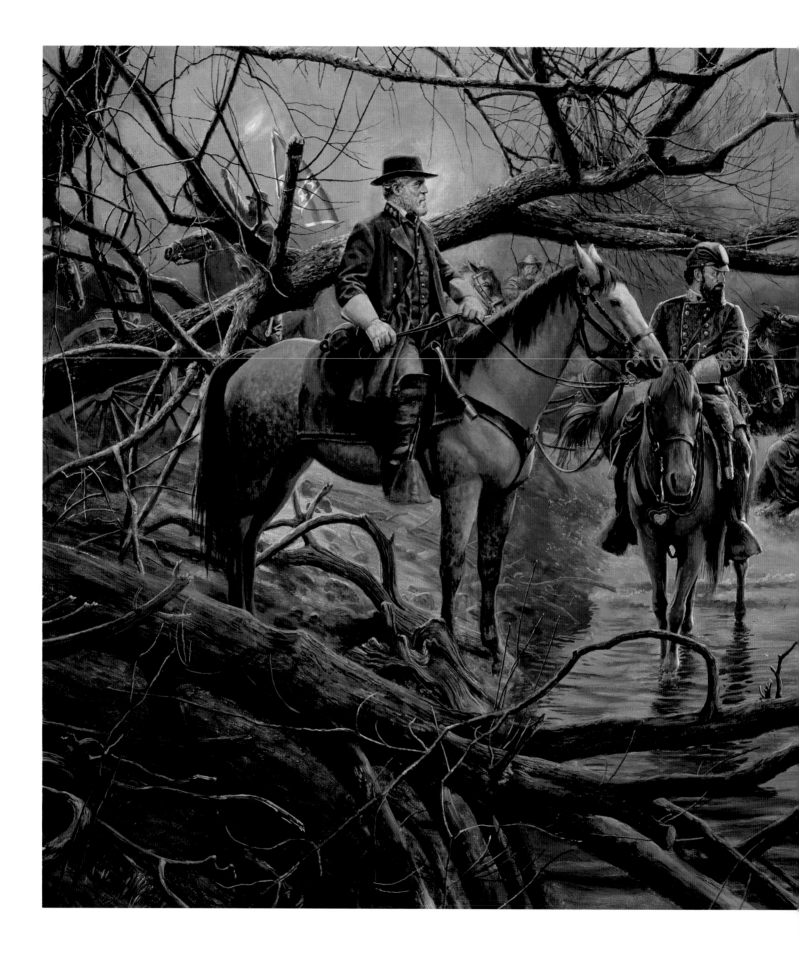

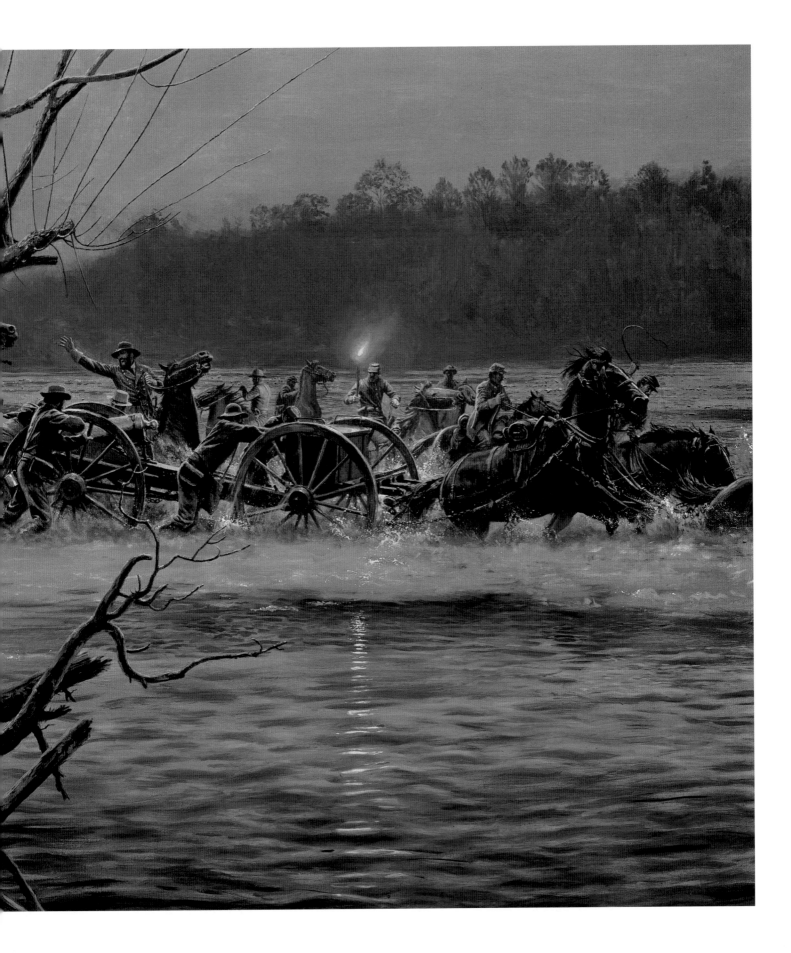

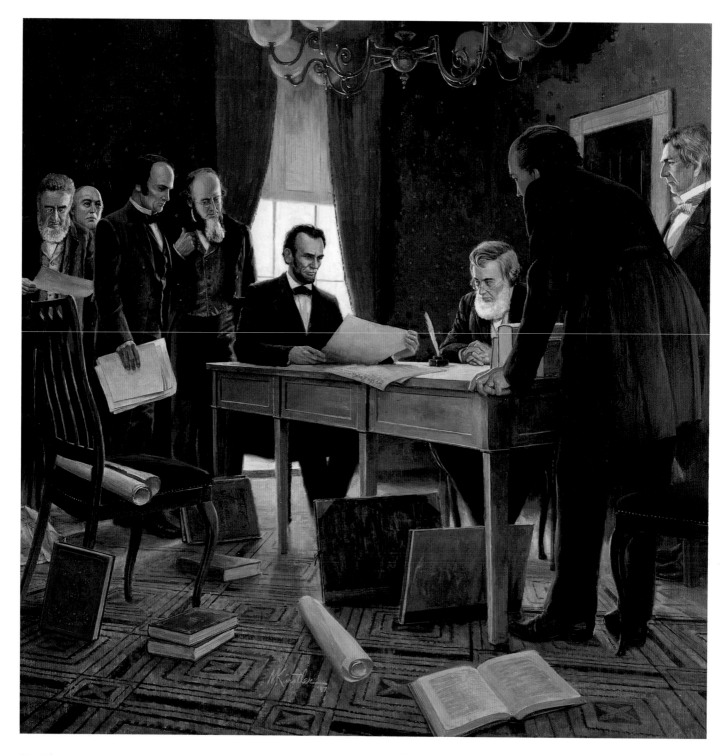

By September, 1862, Lincoln saw that the base of the war had to be broadened by a powerful new force. The issuance of the Emancipation Proclamation thus gave the North twin goals: to save the Union and to erase the word "slavery" from the American vocabulary.

⟳ ★ ★ ★ ⟲

political revolution while at the same time crafting a social revolution.

George McClellan could neither understand nor conduct a war of that magnitude. His removal from command of the Union army was inevitable. It came in November, two days after

the off-year elections passed and Lincoln's party had won solidly.

Lincoln chose General Ambrose E. Burnside of the Ninth Corps as McClellan's replacement. Stout and congenial, Burnside was a man who always tried to do his best. As fellow officers—and Burnside himself—knew, his best just never seemed quite good enough.

⚜ ★★★ ⚜

GEORGE B. MCCLELLAN WAS A BRILLIANT ORGANIZER, AND THE ARMY OF THE POTOMAC LOVED HIM. HOWEVER, A PENNSYLVANIA SOLDIER SPOKE FOR POSTERITY WITH THE COMMENT: "GRANT DID NOT KNOW HOW TO RETREAT; MCCLELLAN DID NOT KNOW HOW TO FIGHT."

The Rhode Islander was aware that he was expected to fight, and soon. Burnside's plan of battle against Lee in late autumn was well-organized and sound. With the opposing armies eyeing one another in northern Virginia, Burnside made a quick, secretive march eastward. His strategy was to cross the Rappahannock River at Fredericksburg, get behind Lee, and drive for Richmond to checkmate the king in this chess game of war.

All went well initially. Burnside stole a day on Lee. He reached Fredericksburg and saw the roads ahead clear of Confederate defenders.

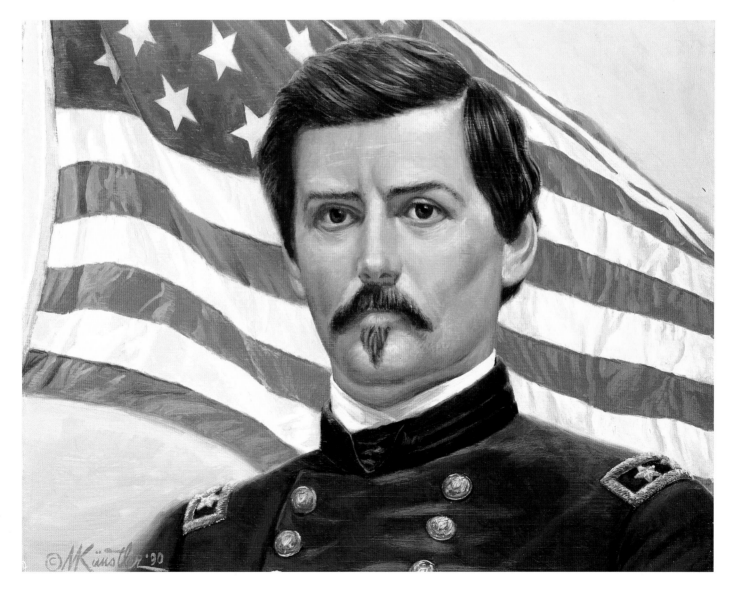

WAR OFTEN SPAWNS LOVE, FOR LONELINESS FILLS THE HEART AND EMOTIONS RUN HIGH. IN DOWNTOWN FREDERICKSBURG LATE IN NOVEMBER, 1862, A CONFEDERATE CAVALRY OFFICER BADE FAREWELL TO A YOUNG GIRL WHOSE EXPRESSION IS UNDERSTANDABLY A MIXTURE OF ATTACHMENT AND ANXIETY.

Left, CHAMBERLAIN EAGERLY ADAPTED TO ARMY LIFE AND ITS MANY RESPONSIBILITIES. HE HAD NO FEAR OF THE FUTURE. "MOST LIKELY I SHALL BE HIT SOMEWHERE SOMETIME," HE WROTE HOME, "BUT ALL 'MY TIMES ARE IN HIS HANDS,' AND I CAN NOT DIE WITHOUT HIS APPOINTING."

★ ★ ★

However, the pontoon bridges he had to have to cross the Rappahannock were nowhere in sight. Rather than alter his offensive plan, Burnside sat down to await the arrival of the pontoons. Doing so promptly removed the keys on which he had relied for success: secrecy and speed.

It took almost a month for the brigade materials to arrive from Washington. By then, Lee's Army of Northern Virginia was well-positioned west of town on a low ridge that extended in almost unbroken fashion for seven miles. It was the strongest line Lee had during the entire war. Confederates stood poised in rows along most of Lee's defensive works.

The center of Lee's line was a re-entrant angle that cut away from the Federals. Even Burnside saw the futility of trying to assault that cul-de-sac. He opted instead to launch assaults on December 13 against the shoulders of the re-entrant. A third of the Union army would move against Lee's right flank; the other two-thirds

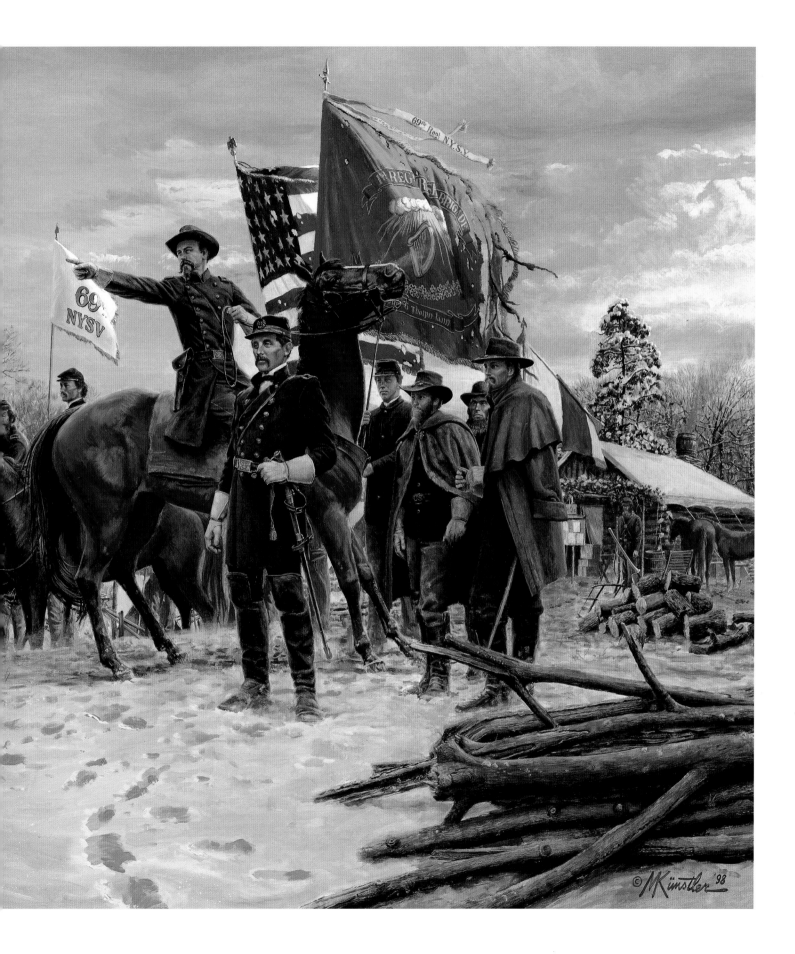

would attack directly out of Fredericksburg against a steep ridge known as Marye's Heights. This engagement marked the first time that Lee, Jackson, Hancock, and Chamberlain were all heavily involved in the same battle.

Jackson commanded Lee's right and, as at Antietam, took the first blows. "Old Jack," as his men affectionately called him, was upbeat that day. He had recently learned that his wife had given birth to a healthy daughter. For so long he had wanted to be a father. Now, at Fredericksburg, he held a seemingly impregnable position. A staff officer asked Jackson early in the morning of December 13 if he could hold his line against such numbers of Federals as were forming for the attack. Jackson replied: "Major, my men sometimes fail to take a position, but to defend one, never! I am glad the Yankees are coming!" Proud in fatherhood, confident of victory, the normally unpretentious Jackson was wearing a new uniform with the coat (a gift from General J.E.B. Stuart) trimmed in gold.

Artillery exchanges preceded an attack on Jackson by a lone Union division. Near noon, these Federals actually breached Jackson's center, but success was only momentary. Jackson's divisions delivered counterattacks from three directions. Union soldiers took heavier losses retreating than they did in advancing. Jackson and his Confederates spent the remainder of the

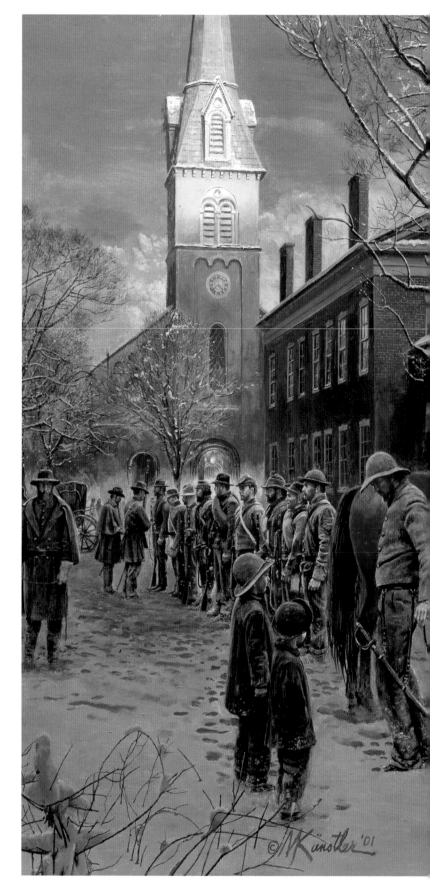

⚜ ★ ★ ★ ⚜

Previous Pages, On arriving at Fredericksburg, Thomas Meagher (standing) and his sixty-ninth New York surveyed Lee's battle lines across the Rappahannock River. The Irish Brigade lost 1,250 of 1,400 men in the ensuing struggle.

Lee maintained an advance guard in Fredericksburg until the eve of the great battle. Changing the pickets always brought civilians into the streets to watch and wonder. Church services continued as long as the war allowed.

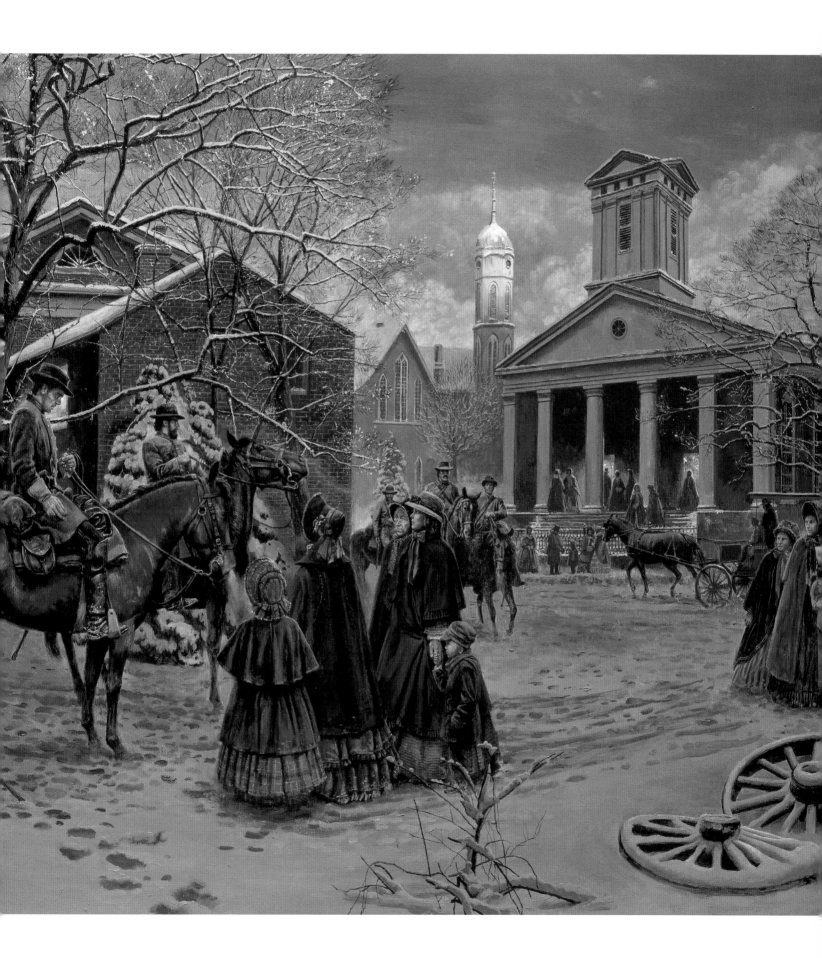

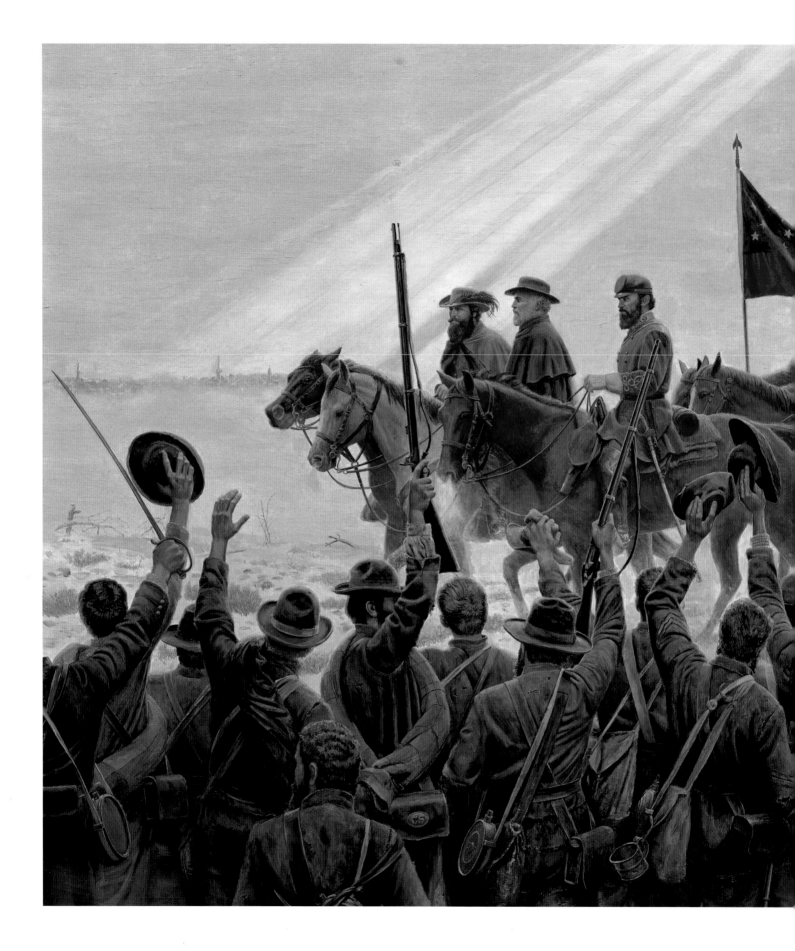

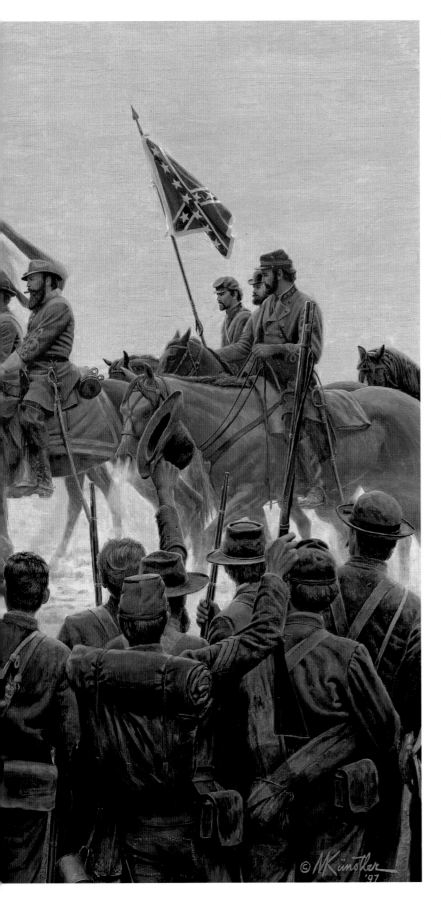

day watching the horrible slaughter taking place on their left.

The Union attacks there were never more than 1,000 yards wide. Each division had to emerge from town onto a wide, open plain. Those men not killed by point-blank artillery fire from atop Marye's Heights had to march to a stone wall at the base of the hill. Behind it was a sunken road. Wall and road extended for a quarter-mile. In the road were Southerners seven to nine ranks deep, enjoying ideal protection. Blue columns moving toward them elbow to elbow offered a target that simply could not be missed.

Just before the Union assaults against Marye's Heights began, Lee felt a moment of uncertainty at the sight of such a Federal host. He turned to corps commander James Longstreet and warned that the line might snap. Longstreet uttered a curse. "If every man in the Union army storms Marye's Heights," he said, "I will kill them all!" From start to end of the battle, not one Billy Yank got to within 100 yards of the stone wall.

It was not from lack of effort. Fourteen times the unimaginative Burnside ordered frontal attacks. As one assault failed, another began. Men scrambled over dead and wounded comrades as they tried to weather a hailstorm of gunfire but never could. The open plain quickly turned blue from Union soldiers. In places, the men lay in neat rows as

⟨✦✦✦⟩

IT WAS A RARE SIGHT TO SEE THE FOUR RANKING GENERALS OF THE ARMY OF NORTHERN VIRGINIA TOGETHER. CONFEDERATES CHEERED HEARTILY ON DECEMBER 12, 1862 WHEN STUART, LEE, JACKSON, AND LONGSTREET RODE ALONG THE LINES. THE SIGHT OF JACKSON IN AN ORNATE COAT WAS ENOUGH TO EVOKE HURRAHS.

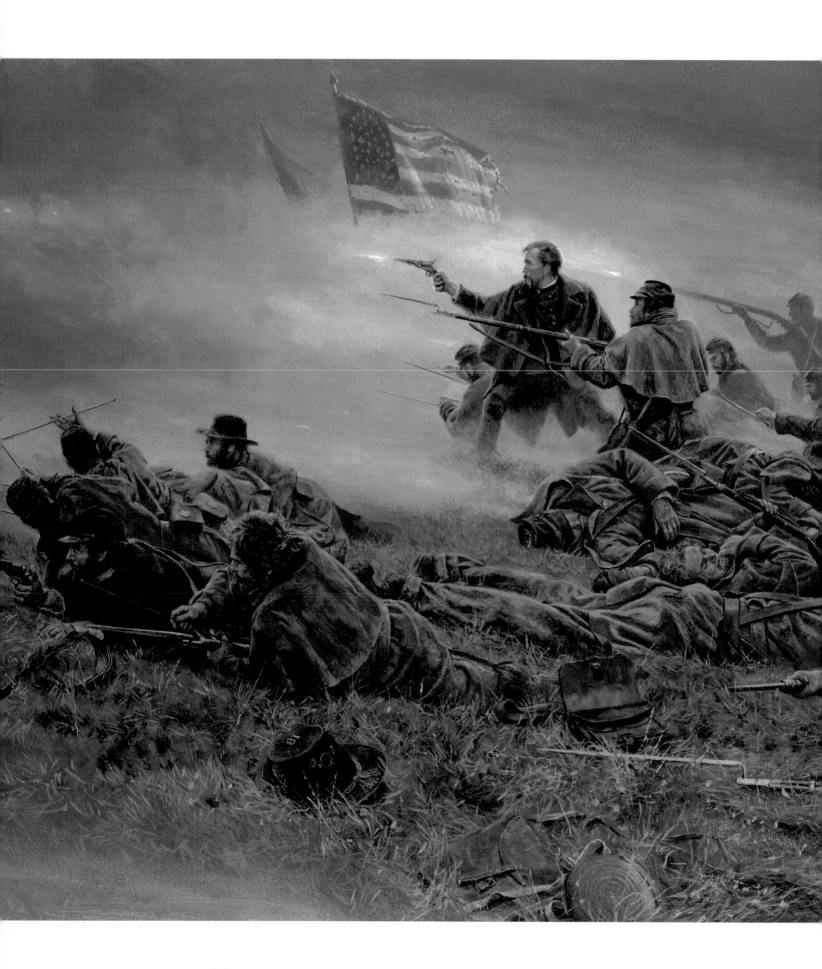

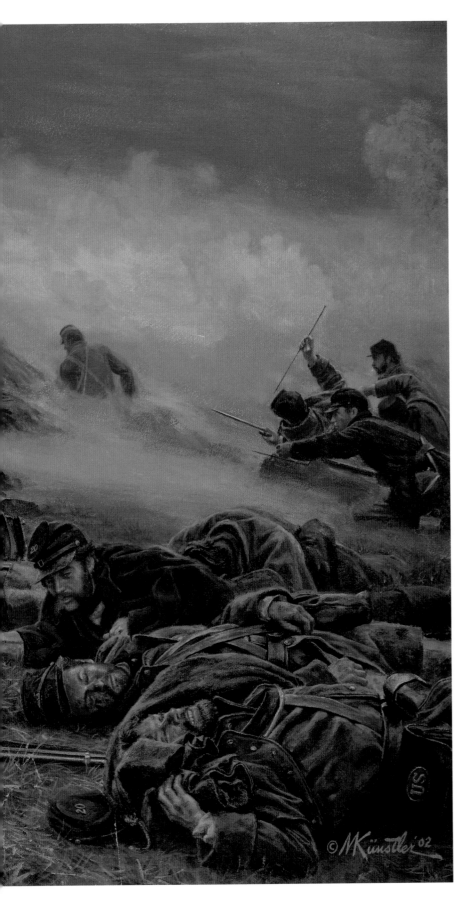

if some giant scythe had leveled them with one swipe.

Winfield Hancock, now a major general, led a division in one of the early assaults. The Pennsylvanian had proclaimed before the battle that the Marye's Heights sector could not be taken. This had produced a sharp exchange between Hancock and Burnside. Yet when ordered to charge, Hancock bravely led his brigades forward. The 5,000-man division suffered forty percent losses, including 156 officers. Confederate General George E. Pickett later declared: "I was with Lee's army from the beginning [and] I never saw anything that surpassed the charge made by Hancock and [Andrew] Humphreys at Fredericksburg." When the downcast Hancock reported his losses, he added: "These were veteran regiments, led by able and tried commanders, and I regret to say that their places cannot soon be filled."

Joshua Chamberlain and the Twentieth Maine were in one of the final attacks against Marye's Heights. The men picked their way through bodies as they moved across the open plain pockmarked now by shell holes. "We reached the final crest, before that all-commanding, countermanding stone wall," Chamberlain wrote. "Here we exchanged fierce volleys at every

⚜ ★★★ ⚜

FOR A NIGHT AND A DAY, CHAMBERLAIN AND HIS MEN LAY ON THE BATTLEFIELD AND USED DEAD BODIES FOR COVER. CHAMBERLAIN NEVER FORGOT THE CRIES OF THE WOUNDED: "A WAIL SO FAR AND DEEP AND WIDE...FLOWING TOGETHER INTO A KEY-NOTE WEIRD, UNEARTHLY, TERRIBLE TO HEAR AND BEAR."

disadvantage, until the muzzle-flame deepened the sunset red, and all was dark."

The Maine regiment spent a ghastly night pinned down by musketry on the battlefield, surrounded by the dead and dying, and huddling individually as biting winds swept across the field. Chamberlain got a measure of protection by lying between three dead Federals. "The regiment lay on the battlefield throughout daylight on December 14 before finally retiring to safety after dark...." A thoroughly fatigued Chamberlain met his corps commander, General Joseph Hooker, back near the edge of town. The colonel voiced complaints about the haphazard leadership displayed in the battle. Hooker angrily retorted: "God knows I did not put you in!"

An equally angry Chamberlain replied: "That was the trouble, General. You should have put us in. We were handed in piecemeal, on toasting-forks."

Burnside suffered 12,560 losses at Fredericksburg, in contrast to Lee's 5,200 casualties. The lopsided engagement was testimony to the valor that men can display and the price that patriots have to pay for displaying such valor. Robert E. Lee derived little pleasure from the butchery. At one point in the contest, Lee turned to Longstreet and observed sadly: "It is well that war is so terrible; else we should grow too fond of it."

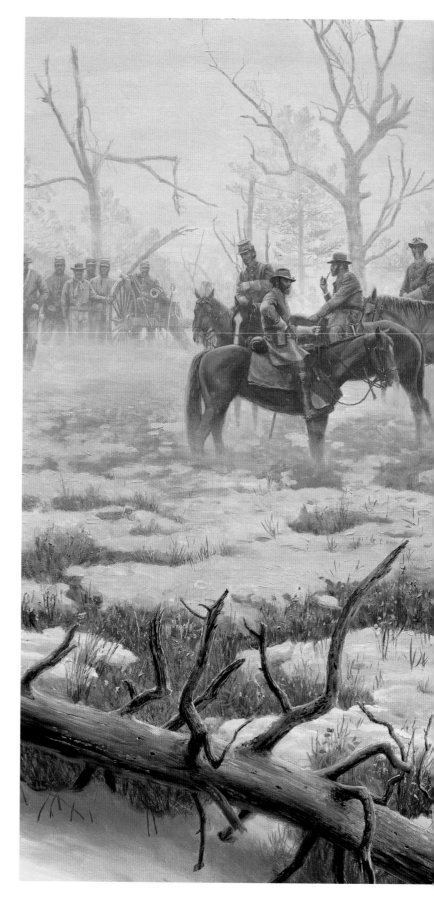

FROM THEIR VANTAGE POINT ATOP LEE'S HILL IN THE CENTER OF THE CONFEDERATE LINE, LEE AND LONGSTREET SOBERLY WATCHED THE ONE-SIDED BATTLE OF FREDERICKSBURG RUN ITS COURSE. IT WAS, SAID ONE JOHNNY REB, "LIKE BUTCHERING HOGS."

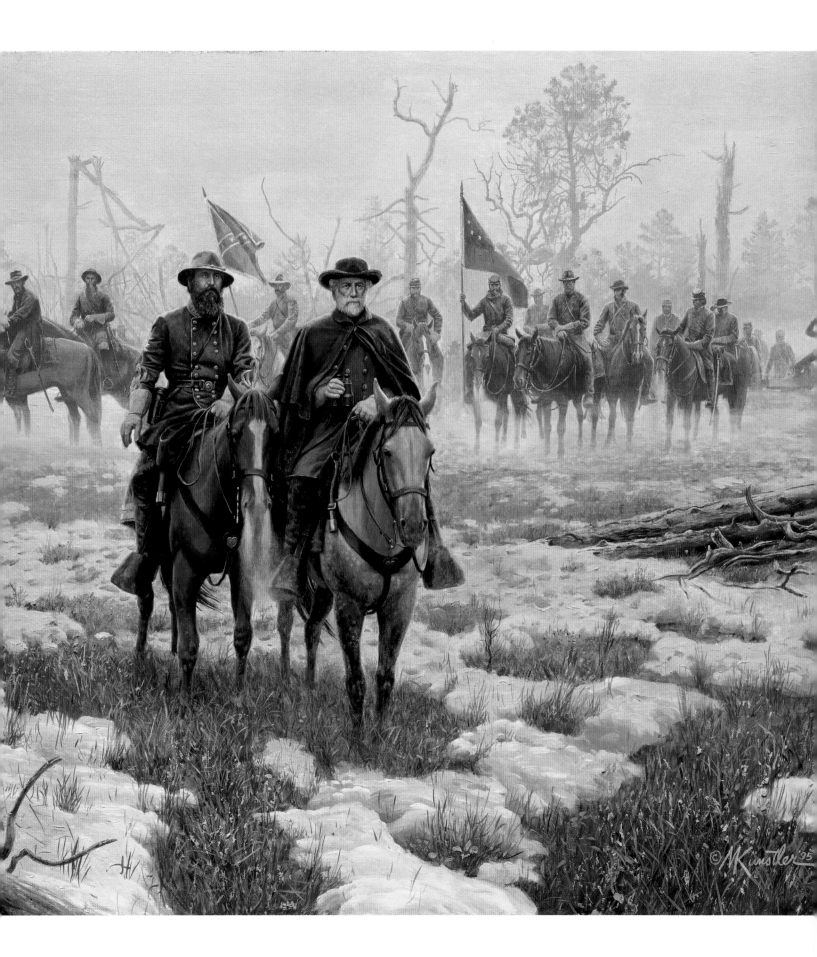

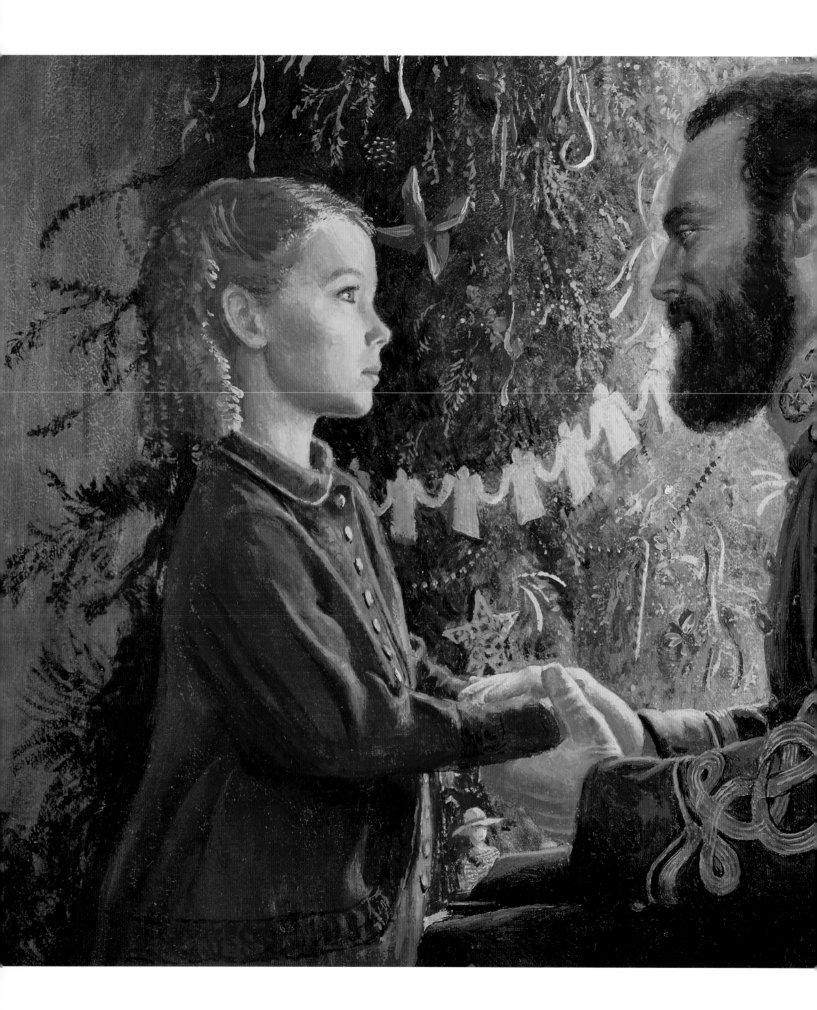

CROSSROADS AT CHANCELLORSVILLE

For Lee, the winter following Fredericksburg was sad. He had constant anxiety over the condition and future of his soldiers. He worried about his wife, crippled by arthritis, and his large family. On Christmas Day, 1862, he wrote Mrs. Lee: "What a cruel thing is war. To separate and destroy families and friends and mar the purest joys and happiness God has granted in this world."

Worst of all for Lee, he became seriously ill at winter's end. In all likelihood, the general suffered an attack of angina pectoris. After March, 1863, cardiovascular problems would occasionally impair his effectiveness.

Jackson fared better in those months of inactivity. He made his winter headquarters on the downriver estate of the Corbin family. Jackson oversaw the writing of battle reports, took the lead in promoting religious activity inside his corps, and became almost an adopted father to five-year-old Jane Corbin. The child visited Jackson's office daily. In the attention he gave her was the love and yearning he felt for the infant daughter he had not yet seen.

Suddenly Jane Corbin died of scarlet fever. Jackson's distress would have been longer in duration had not Mary Anna Jackson visited her husband with their daughter, Julia. For several days Jackson was as happy as he had ever been. Then the advance of the Union army called him to duty.

Hancock enjoyed a furlough early in the new year. He returned to his division and subjected it to rigorous drill for

✦✦✦

THE EMPTINESS OF HIS OWN CHILDHOOD IMPLANTED IN JACKSON AN OVERWHELMING LOVE FOR CHILDREN. DURING THE WINTER OF 1862–63, WITH HIS HEADQUARTERS AT THE CORBIN MANSION, THE GENERAL BECAME INFATUATED WITH YOUNG JANE CORBIN. SHE VISITED HIM EVERY AFTERNOON AND QUICKLY TURNED "THE FAITHFUL MAN OF WAR" INTO A PLAYMATE.

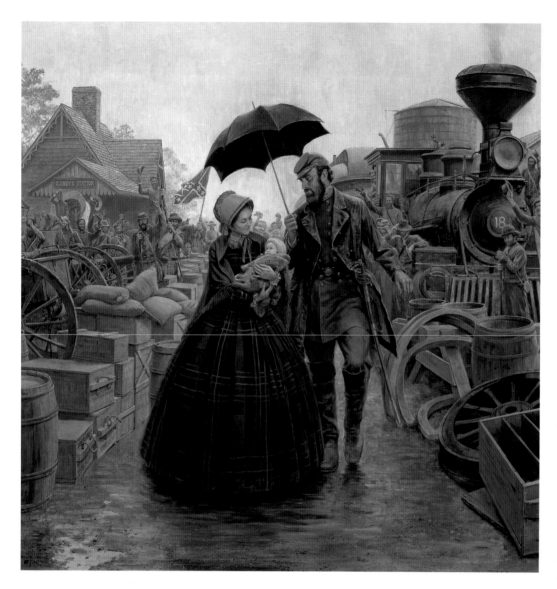

AMID AN APRIL SHOWER, ANNA JACKSON AND HER INFANT DAUGHTER ARRIVED AT GUINEY'S STATION NEAR THE FRONT LINES. SOLDIERS CHEERED AS JACKSON, "HIS FACE ALL SUNSHINE AND GLADNESS," MET THE TWO PEOPLE HE MOST ADORED. YET THE SUBLIME HAPPINESS WOULD BE SHORT-LIVED.

Right, IN FEBRUARY, 1863, LT. COL. CHAMBERLAIN WENT HOME ON LEAVE FOR THE FIRST TIME. HE HAD SOME MILITARY AFFAIRS TO DISCUSS WITH THE GOVERNOR, BUT THE HOURS WITH HIS WIFE FANNY WERE THE GREATEST PLEASURE FOR THE NOW-SEASONED SOLDIER.

★ ★ ★

the coming campaign. Sometimes Hancock conducted the drill himself. His men loved his presence, for Hancock and his bull voice could turn the air blue with profanity at the slightest provocation. His division became one of the most disciplined in all the Union armies.

Chamberlain also obtained leave of absence that winter. During his visit home to Maine, he asked the governor's help in filling seventeen officer vacancies in his regiment. Chamberlain returned to the twentieth Maine and surprisingly found himself in command. Colonel Ames had transferred to the staff of General George Meade.

During those winter months of 1862-1863, the Confederate and Union armies were encamped on opposite banks of the Rappahannock River. Yet physically they were moving in different directions. "Lee's Miserables" (as many Confederates called themselves) sought to combat food shortages, lack of equipment, tattered clothing, and an increase in sickness. Horses became emaciated; accouterments were in disrepair. Lee had to weaken his army further by sending two of Longstreet's divisions to southeastern Virginia to counter Union threats and to collect supplies.

A divergent rebuilding took place in the Union army. Morale was at rock bottom when, in February, 1863, Joseph Hooker was placed in

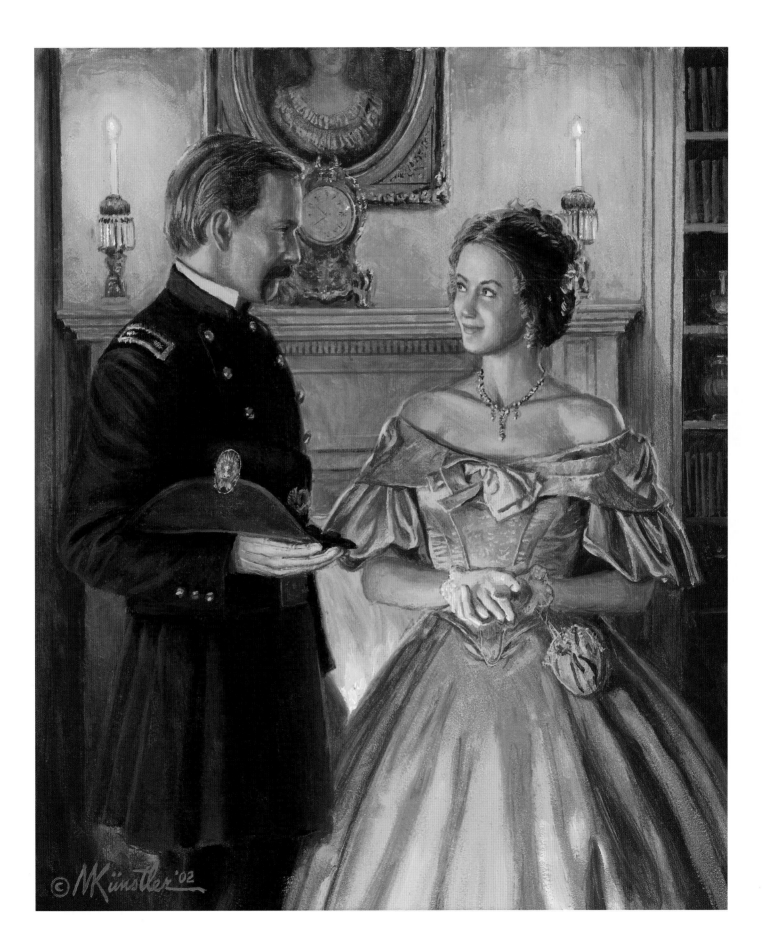

Above, FOR WEARY AND DISHEARTENED UNION SOLDIERS, GEN. HOOKER'S LIBERAL GRANTING OF FURLOUGHS IN FEBRUARY-MARCH, 1863, WAS A GODSEND. HERE A MEMBER OF THE 119TH NEW YORK ENJOYS HIS FARM, HIS PIPE, AND THE YOUNG SON NESTLED IN HIS ARM. AHEAD LAY MORE BATTLE; BUT FOR NOW, THERE WAS A MOMENT OF PEACE.

Previous pages, JANUARY 20, 1863, WAS A PARTLY CLOUDY, WINTRY DAY. THAT DID NOT DAMPEN THE PRIDE OF "JEB" STUART'S CAVALRY AS HORSEMEN SAT AT ATTENTION UNDER THE APPROVING EYES OF GENERALS JACKSON, LEE, AND STUART. THE SITE WAS MOSS NECK, THE CORBIN ESTATE DOWNRIVER FROM FREDERICKSBURG.

★ ★ ★

command. Hooker was handsome and experienced, a skilled organizer and outspoken optimist. In the space of two months he improved rations, granted liberal furloughs, found six months' back pay for all soldiers, reorganized the army's chain of command, and established identifying badges for divisions in order to build unit pride.

By late April, the Army of the Potomac numbered 130,000 men. Discipline was finely honed, morale near an all-time high. One Billy Yank stated that "under Hooker, we began to

★ ★ ★

JACKSON PRAYED OFTEN AND INTENSELY, SOMETIMES IN PRIVATE AND SOMETIMES AS STAFF OFFICERS LOOKED ON WITH A MIXTURE OF REVERENCE AND AFFECTION. AFTER THE BATTLE OF FREDERICKSBURG, JACKSON WROTE HIS WIFE: "IF I KNOW MY UNWORTHY SELF, MY DESIRE IS TO LIVE ENTIRELY AND UNRESERVEDLY TO GOD'S GLORY."

live." Hooker himself exclaimed publicly: "I have the finest army the sun ever shone on. If the enemy does not run, God help them!"

Campaigning resumed with the coming of spring. Hooker's strategy was bold and grand in scale. It bore striking similarities to Lee's movements at Second Manassas. There would not be another head-on movement against Lee at Fredericksburg. Instead, Union cavalry would first gallop around Lee's flank to sever railroads and other lines of communication. That would cut Lee adrift from his supply bases.

Next, Hooker would leave a third of his army, under General John Sedgwick, at Fredericksburg to hold Lee's attention. With the other two-thirds, Hooker would march upstream to the west. This force of 70,000 soldiers would cross the Rappahannock and its tributary, the Rapidan, then curl around Lee's unprotected left flank.

This huge flanking movement seemingly would leave Lee with but two choices. He could abandon Fredericksburg and retreat southward, in which event Hooker's army would be on his flank and could attack whenever and wherever Hooker dictated; or, Lee could stand and fight at Fredericksburg, in which event the two wings of the Federal army would close on him like a giant vise.

The Union battle plan appeared all-encompassing. Yet Hooker disregarded two vital ingredients: the daring of Lee and Jackson, and the density of the Virginia Wilderness.

Twelve miles long and six miles wide, the Wilderness was a gloomy woodland choked by second-growth timber and dense underbrush. Visibility was no more than 20 yards. Little streams cut shallow ravines and soaked

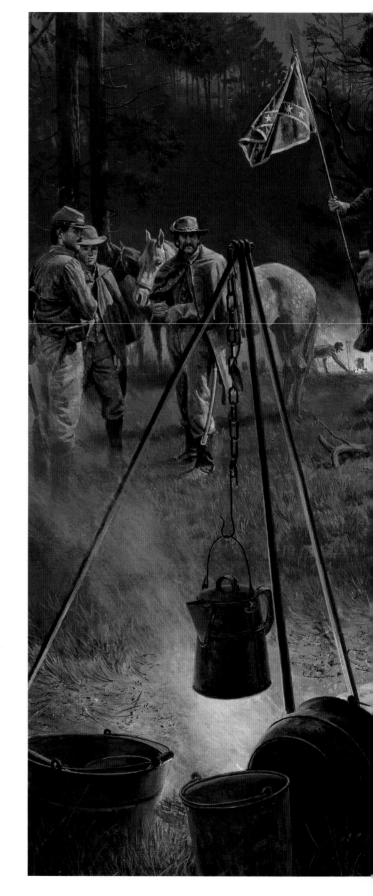

⟡⟡ ★ ★ ★ ⟡⟡

WHEN GENERAL "JEB" STUART (KNEELING) BROUGHT WORD THAT THE UNION ARMY'S WESTERN FLANK AT CHANCELLORSVILLE WAS EXPOSED, JACKSON AND LEE IMMEDIATELY BEGAN PLANNING WHAT WOULD BE ONE OF THE MOST FAMOUS FLANK MARCHES IN MILITARY HISTORY. THE MAY 1, 1863, NIGHTTIME MEETING OF THE THREE GENERALS TOOK PLACE IN THE PLAINEST OF SETTINGS.

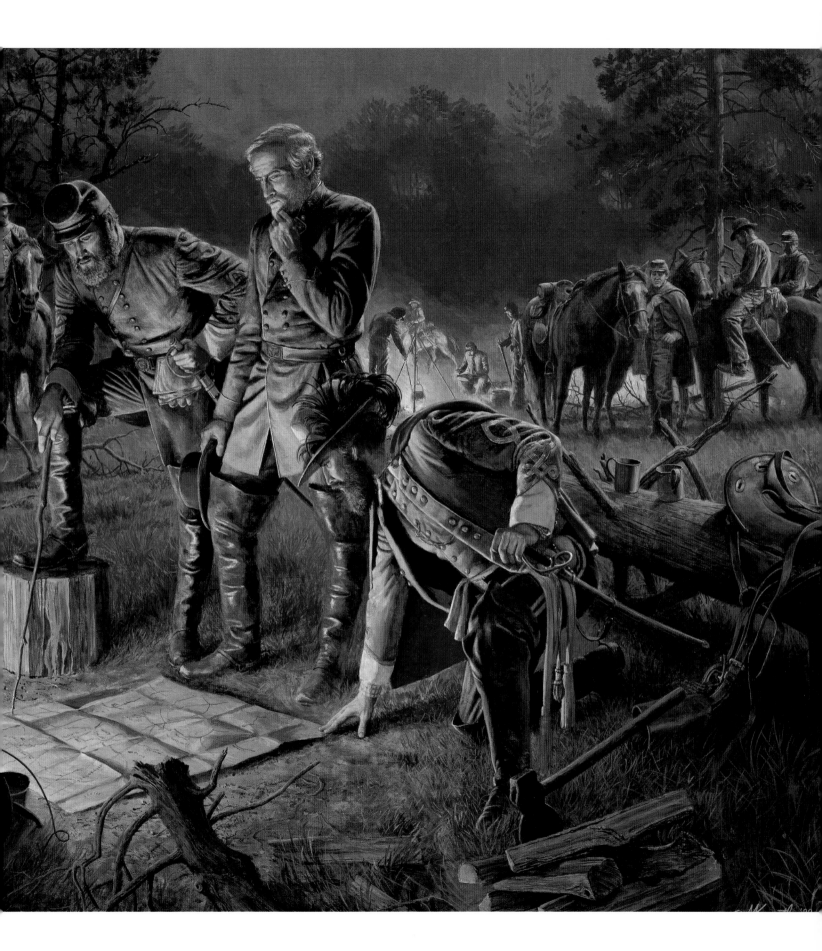

the low ground. Only a handful of clearings gave relief. The few winding roads through the Wilderness were like tracks in a jungle. The area was no place for an army to be.

By the night of April 30, Hooker was there with most of his soldiers. His headquarters was a tavern at an otherwise barren road junction known as Chancellorsville. Early on May 1, Hooker ordered his units to march east from the Wilderness and close the distance with Sedgwick. Hooker's assumption that Lee would wait in front of Fredericksburg for the executioner to come was a fatal error in judgment. Lee recognized that Hooker's portion of the enemy army was the major threat. His countermeasures were bolder than Hooker's plan.

Lee detached a lone division to parry Sedgwick while he moved west with the rest of his depleted force to engage Hooker. On the afternoon of May 1, Jackson struck the vanguard of Hooker's army with such force that the stunned Union general ordered his men not only back into the Wilderness but into a defensive posture as well. The always-audacious Lee now increased the initiative.

That evening he learned from a cavalry reconnaissance by "Jeb" Stuart that Hooker's right flank was "in the air"—neither anchored on a strong terrain feature nor bent back for protection. Lee and Jackson sat on cracker boxes by a simple campfire and planned what many writers call one of the most daring tactical actions of modern warfare. Lee decided to split his army again in the face of superior numbers. Jackson and his corps of 28,000 soldiers would embark on a twelve-mile secret march to envelop the open Federal flank. Lee would be left with 14,000

⤳⟿ ★★★ ⟿⤳

SHORTLY AFTER 8 A.M. ON SATURDAY, MAY 2, JACKSON'S COLUMNS BEGAN THEIR GREAT FLANKING MOVEMENT. JACKSON LEFT THE ROAD TO CONFER MOMENTARILY WITH LEE. THE CONVERSATION WAS BRIEF. IT WAS THE LAST TIME THE TWO MEN EVER SAW ONE ANOTHER.

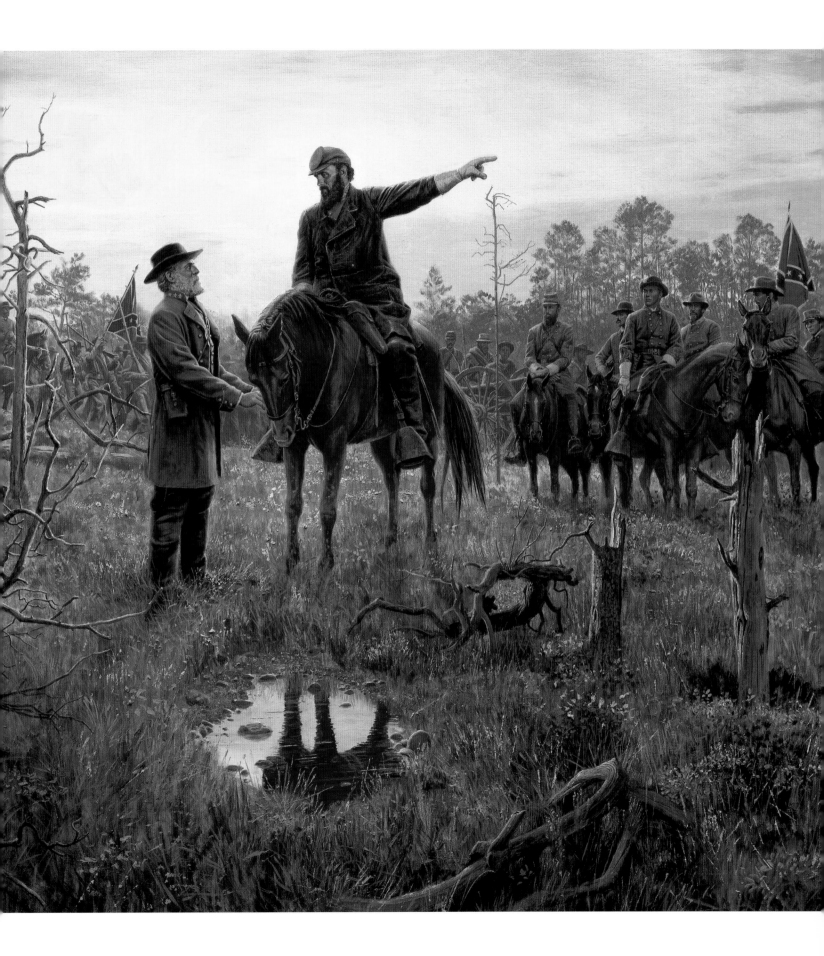

★★★

Darkness had descended over the Wilderness, but Jackson felt he was too close to total victory to stop the battle. The general made a personal reconnaissance of the Union position and was returning to his own lines when Confederates mistook Jackson and his staff for Union cavalry. A burst of gunfire exploded. The general was hit.

troops standing between Hooker's 70,000 men and the Confederate capital at Richmond. Because Lee was so outnumbered in this campaign, he could take enormous risks. And he did.

He watched after dawn on that hot May 2 as Jackson departed the bivouac area. Local guides led the "foot-cavalry" on abandoned trails, little-used wagon roads, through thick woods, and across weed fields. The march went completely undetected. Near 5:15 in the afternoon, Union soldiers had stacked their arms and were cooking supper. Two Confederate columns, each a mile in width, swept down on the Federals without warning, like an avalanche.

Hooker's right crumbled, in some places instantly and in others slowly. Jackson's battle line was so wide that any strong point could be surrounded and taken in short order. For three miles, Confederates slashed and ripped at the right and right-center of the Union position.

Over on the Federal left, Winfield Hancock's division had passed the day with other units in repulsing what were Lee's diversions to mask Jackson's movement. Chamberlain was not on the field for a unique reason. He and the Twentieth Maine were behind the lines under smallpox quarantine. They were guarding a telegraph line connecting the two wings of Hooker's army.

Darkness came that Saturday, but Jackson was not ready to stop fighting. This was Armageddon! He urged his men to continue

Three bullets struck Jackson. Two produced only minor injuries, but the third splintered bone and tendons in his upper left arm. A torturous trip to a field hospital ensued. Five hours after the wounding, surgeons amputated Jackson's arm.

pushing forward. The enemy army was on the verge of annihilation. Jackson was thinking of a night attack—an unprecedented tactic for that day. In his excitement, and to ascertain the exact location of the new Union lines, Jackson became reckless. He personally rode through the woods, gunfire, and battle smoke to reconnoiter. Jackson was returning to his own lines when Confederates understandably mistook the general and his staff for Union cavalry and opened fire.

Three bullets struck Jackson. Two produced only minor injuries, but the third splintered bone and tendons in his upper left arm. A torturous trip to a field hospital ensued. Five hours after the wounding, surgeons amputated Jackson's arm. Lee received news of Jackson's injury with the comment: "Any victory is dearly bought which deprives us of the services of General Jackson, even for a short time."

Confederates renewed the attack at dawn on May 3. Fighting was as vicious as humans could make it. A North Carolina soldier exclaimed: "The ground was covered with guns and cartridge boxes, the men were laying thick in some places. You can't find a bush but what has been hit by a shell or a bullet."

Lee soon effected the junction with his and Jackson's troops. He then pressed forward toward the Federals. Hooker's lines began yielding. The Chancellorsville crossroads were abandoned. Lee rode forward to direct the pursuit. His arrival at

the front ignited a roar of cheers as thousands of Confederate soldiers voiced their feelings for the gray-haired commander. An aide noted: "I thought it must have been from such scenes as this that men in ancient days ascended to the dignity of gods."

Hancock was in the middle of the action that day. His division was the last to relinquish its position. An officer saw the general ride "amidst a rain of shells utterly indifferent, not even ducking his head when one came close to him." One panic-stricken soldier dashed up to Hancock and asked where the road was that led to safety. A military chronicler later observed that "it is best to not put" Hancock's reply "into cold and unsympathetic type."

That night Lee received grave news. Sedgwick had crossed the Rappahannock into Fredericksburg, driven the division from Marye's Heights, and was marching to strike Lee in flank and rear. Lee calmly improvised a new strategy. He left half of his army under Cavalry Chief "Jeb" Stuart to continue pressing Hooker. With the other half, Lee moved east and met Sedgwick at Salem Church. After several hours of battle, the Federals escaped across the Rappahannock.

Lee then marched his weary soldiers back to Chancellorsville to complete the destruction of Hooker. By that time, Chamberlain at last had seen battle action. The colonel became desperate to lead his men into the contest. He told

Hooker's chief-of-staff: "If we can't do anything else, we can give the rebels smallpox!" The Twentieth Maine was not released from quarantine.

Chamberlain was undaunted. He crossed the river by himself, voluntarily joined elements of the Fifth Corps, and participated in some of the fighting. One private declared that Chamberlain was "a brave, brilliant, dashing officer who, when seen, was always remembered."

The full Confederate army was back in position by nightfall of May 5th and ready to deliver a new attack on Hooker. Yet the Union commander had had enough. Under cover of darkness, the Federal army recrossed the Rappahannock.

Chancellorsville was a smashing victory for Lee. Outnumbered more than two to one, he had inflicted 17,000 casualties while suffering fewer than 12,000 losses. Lee had literally dismembered the most forceful Union drive yet launched in Virginia. The Southern commander, forced into a battle that, on paper, he could not win, had wrenched the initiative from his opponent and turned it into his greatest triumph. Yet to Lee personally, Chancellorsville was a tragic victory.

Chancellorsville was a smashing victory for Lee. Outnumbered more than two to one, he had inflicted 17,000 casualties while suffering fewer than 12,000 losses. Lee had literally dismembered the most forceful Union drive yet launched in Virginia.

★ ★ ★ ★

FEW GRANDER MOMENTS IN HISTORY EXIST THAN WHEN LEE RODE FORWARD TO THE FRONT LINES AT THE CLIMAX OF THE BATTLE OF CHANCELLORSVILLE. HE HAD WON WHAT MANY STILL REGARD AS AN IMPOSSIBLE SUCCESS. THE BURNING CHANCELLOR TAVERN WAS BUT A BACKDROP FOR THE COMMANDER'S ARRIVAL AT THE VITAL CHANCELLORSVILLE CROSSROADS.

On May 10, "Stonewall" Jackson died of pneumonia. Lee was grief-stricken. He stated in a proclamation: "While we mourn his death, we feel that his spirit still lives, and will inspire the whole army with his indomitable courage and unshaken confidence in God as our hope and our strength." To a friend, Lee confessed: "Such an executive officer the sun never shone on…. I know not how to replace him."

The 1863 fighting at Chancellorsville had humiliated the Army of the Potomac, but it had not crippled it. Two months later, the Union army had licked its wounds, taken a deep breath, and was ready to do battle again. Soldiers like Hancock and Chamberlain were more resolved than ever to do what it took, and give what it required, to gain ultimate triumph.

For the South, Chancellorsville proved but a momentary success. The Federal army had been repulsed again, yet the war was far from being over. Lee never found a replacement for Jackson. His death deprived Lee not only of a lieutenant who thought aggressively as he did. It also removed from the army the element of mobility: the one ingredient that enabled the smaller Confederate army to keep its larger opponent off-balance. The Army of Northern Virginia was never the same again.

Neither was the Southern Confederacy.

⧢⧢⧢ ★ ★ ★ ⧢⧢⧢

IN THE LONELINESS OF YOUTH, JACKSON HAD OFTEN FOUND REFUGE IN A LEAN-TO HE CONSTRUCTED ACROSS THE WEST FORK RIVER FROM HIS UNCLE'S HOME. HIS FINAL DEATHBED STATEMENT, "LET US CROSS OVER THE RIVER AND REST UNDER THE SHADE OF THE TREES," WAS PERHAPS A WISH TO BE BACK IN THE SAFETY OF HIS CHILDHOOD SHELTER. THIS PAINTING SYMBOLICALLY CAPTURES THE GENERAL AND "LITTLE SORREL" ALONG THE RIVER BANK AND AT PEACE WITH THE WORLD.

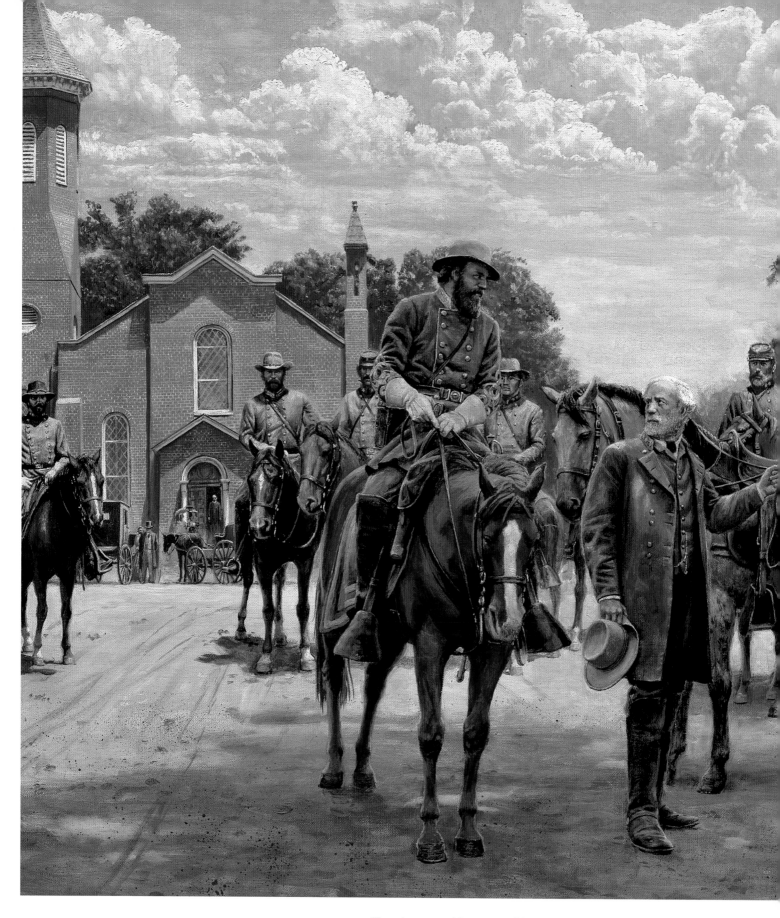

THE ARMY OF NORTHERN VIRGINIA WAS ADVANCING TOWARD A SECOND INVASION OF THE NORTH. ON SUNDAY MORNING, JUNE 21, 1863, LEE AND PART OF HIS FORCE PASSED THROUGH THE VILLAGE

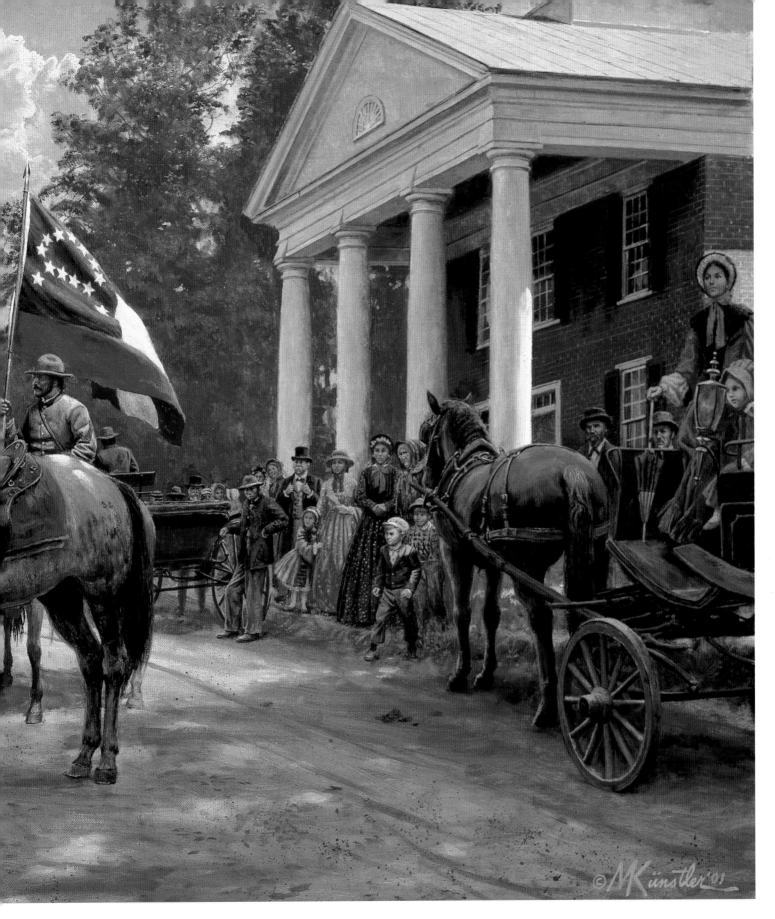

OF BERRYVILLE, VA. LEE AND GEN. JAMES LONGSTREET ATTENDED MORNING PRAYER SERVICE AT GRACE EPISCOPAL CHURCH. AFTER SERVICES, A FEW WORDS WITH "OLD PETE" FOLLOWED. THEN LEE MOUNTED HIS HORSE, TRAVELER. WITH HIS HEADQUARTERS FLAG CONSPICUOUS THAT FIRST DAY OF SUMMER, LEE RODE AWAY TOWARD A RENDEZVOUS WITH DESTINY AT GETTYSBURG, PA.

EPILOGUE

It was after Chancellorsville that Lee, Hancock, and Chamberlain attained their highest fame. The heavy 1863 fighting in the Wilderness and outside Fredericksburg was only two months in the past when the two armies collided again. That July 1-3 battle at Gettysburg, Pennsylvania, remains deeply etched in the national memory.

An outnumbered Lee attacked repeatedly in an attempt to gain victory in his second invasion of the North. In the July 2 action, Chamberlain gained national prominence. He stopped an assault on the Union left by leading the Twentieth Maine, which was out of ammunition, on a charge with nothing but yells and hopes. Such collective courage wrenched victory from the brink of defeat. Chamberlain later received the Medal of Honor for his act of gallantry.

The following day brought the final, unforgettable act in the drama of Gettysburg. It was Hancock who was largely responsible for Union success. His Second Corps repulsed Lee's last, desperate effort to break the Federal lines. In what is known as "Pickett's Charge," Hancock received a nasty thigh wound from which he never fully recovered. The injury kept him out of action for several months.

★ ★ ★

IT WAS THE SECOND DAY'S FIGHTING AT GETTYSBURG. CONFEDERATE FORCES WERE THREATENING TO BREAK THE UNION LEFT FLANK AT LITTLE ROUND TOP. THE TWENTIETH MAINE WAS BATTERED AND NEARLY OUT OF AMMUNITION WHEN COL. CHAMBERLAIN ORDERED ONE OF THE MORE DESPERATE—AND DRAMATIC—COUNTERATTACKS OF THE WAR, A BAYONET CHARGE. HERE THE ORDER HAS JUST BEEN GIVEN.

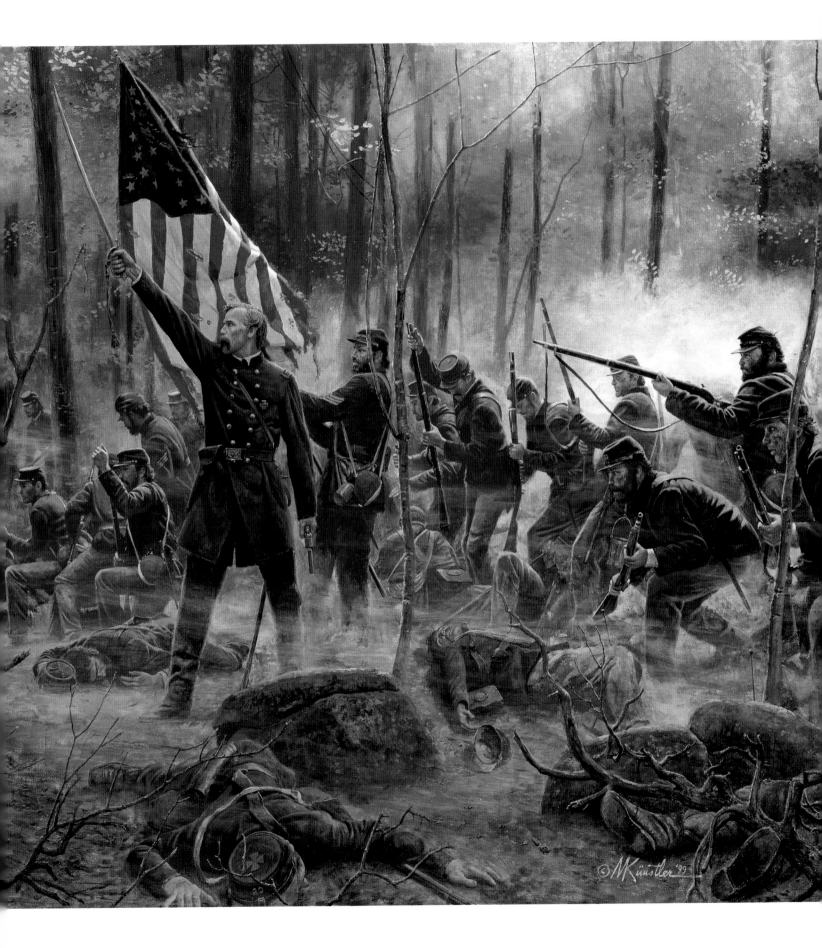

Lee was magnanimous in the hour of defeat. Exhausted, and probably ill, he accepted personal blame for the loss. He pulled what was left of his army back together and led the columns home to Virginia.

With spring, 1864, the final campaign began. Ulysses S. Grant had been appointed general-in-chief of all Union forces. Grant made his headquarters with the Army of the Potomac and gave that proud unit a strength of will at the top it had never known. Lee and his soldiers became Grant's sole objective. Where they went, the Union army would follow.

The Overland Campaign lasted 11 months and included major fighting in the Wilderness, at Spotsylvania, the North Anna River, and Cold Harbor. Grant, with a two-to-one superiority in manpower, took enormous casualties while driving Lee to the outskirts of Richmond. Then the Union general quickly transferred his army across the James River and made for Petersburg and the soft underbelly of the Richmond defenses.

Lee barely managed to counter the move in time. Nine months of siege warfare followed. Hancock was present only for the first half of the long campaign. When his Gettysburg wound re-opened, Hancock went to Washington and took command of the Veteran Reserve Corps. Chamberlain missed the opening stages of Grant's advance because of court-martial duty. Yet when he returned to the field, the Maine soldier did so spectacularly.

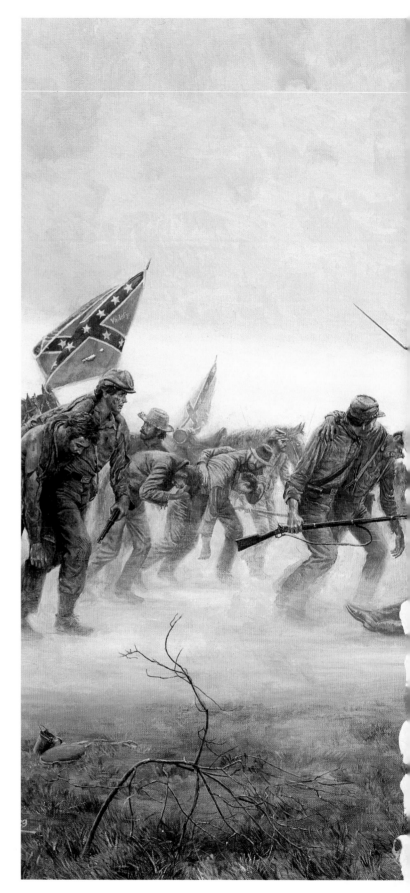

★ ★ ★

THE MOST FAMOUS CHARGE IN AMERICAN MILITARY HISTORY LASTED BUT 40 MINUTES. CONFEDERATE DIVISIONS UNDER GENERALS PICKETT AND PETTIGREW WERE SHATTERED. AS SURVIVORS STUMBLED BACK TO THE CONFEDERATE LINES, A DEJECTED LEE RODE FORWARD TO REASSURE THEM. "IT IS ALL MY FAULT," THE COMMANDER REPEATEDLY TOLD HIS SOLDIERS.

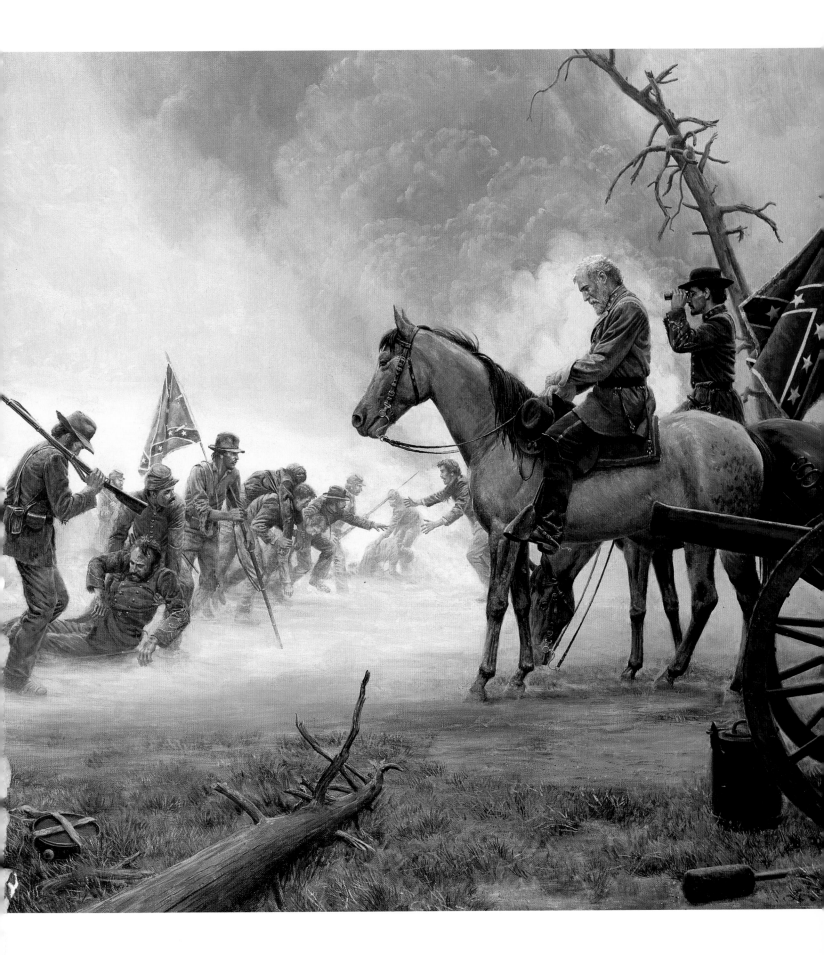

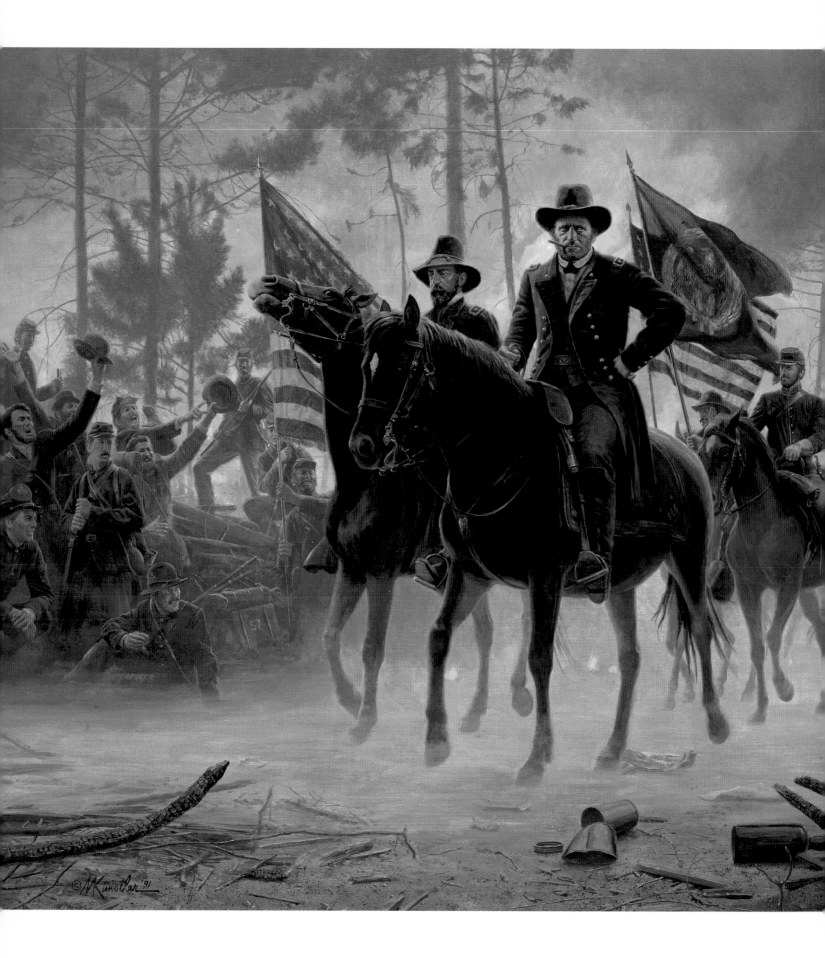

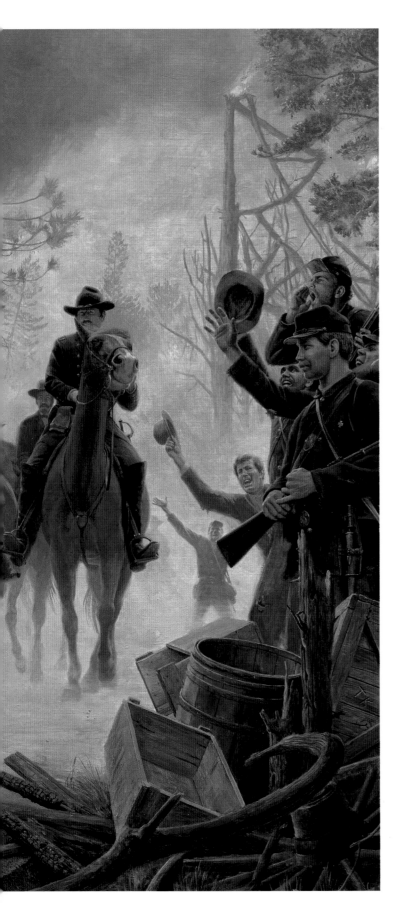

He was leading a brigade in one of the opening battles for Petersburg when he suffered a severe pelvic wound. The injury was considered fatal. This prompted Grant to promote Chamberlain on the field to brigadier general. Chamberlain recovered and, eight months later, was back with the army.

The rich, industrialized North kept Grant's forces fresh and well-supplied throughout the long siege. Lee's Confederates, locked in the Richmond-Petersburg earthworks, suffered from lack of everything but endurance. That ingredient evaporated when Grant's forces broke the Southern lines early in April, 1865, and pursued Lee for a week before encircling the pitiful remnant that was left of the Army of Northern Virginia. On Palm Sunday, April 9, Lee surrendered at Appomattox Court House. The Union officer in charge of the formal surrender of the Confederate army was General Joshua Chamberlain.

Lee overnight became the symbol of all that was good and glorious in what Southerners termed "The Lost Cause." The old soldier proved as magnanimous in peace as he was majestic in war. Late in 1865, Lee accepted the presidency of impoverished Washington College at Lexington, Virginia. For the next five years he devoted his remaining energies to training young men—and their parents—to build on the present and to look to the future.

Under Lee's direction the little school became a model for postwar higher education. Lee saw only its first stages of rebirth. In October, 1870, he died

<div align="center">⟨~⟩ ★ ★ ★ ⟨~⟩</div>

IN THE SPRING OF 1864, NEW GENERAL-IN-CHIEF ULYSSES S. GRANT JOINED GEN. GEORGE MEADE AND THE ARMY OF THE POTOMAC IN THE CAMPAIGN AGAINST LEE. TWO DAYS OF INTENSE FIGHTING OCCURRED IN THE WILDERNESS. IT WAS A STUNNING UNION DEFEAT. YET, UNLIKE HIS PREDECESSORS WHO RETREATED AFTER A SETBACK, GRANT CONTINUED TO LEAD HIS MEN SOUTHWARD TOWARD LEE, RICHMOND, AND EVENTUAL VICTORY.

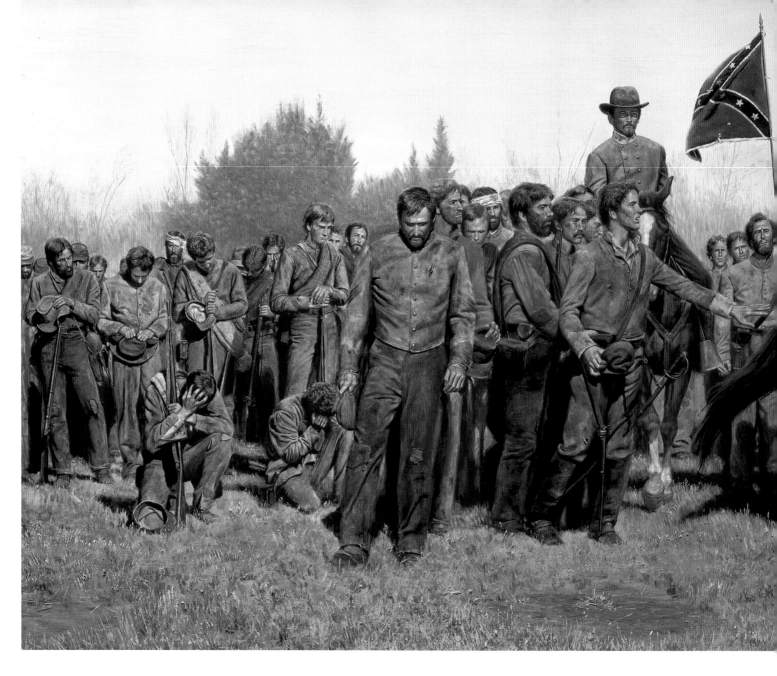

from a stroke. He is buried in the chapel on the campus of what is now Washington and Lee University. However, to many alumni, the school will always be "General Lee's College."

Hancock continued in the military to the end. He supervised the execution of the Lincoln conspirators and served as commander of one of the South's military districts during Reconstruction. Then Hancock took charge of the Department of the East. A general with a strong interest in politics, he was the 1880 Democratic presidential nominee. Hancock lost the election to James A. Garfield by a narrow margin. Six

years later, Hancock died at his Governors Island, New York, headquarters. He is buried in Norristown, Pennsylvania. A Billy Yank gave a widely hailed eulogy: "One felt safe when near him."

Chamberlain returned to Maine with six battle wounds. In 1866 he was elected governor by the largest margin of victory in the state's history. Three more one-year gubernatorial terms followed. Chamberlain was the unanimous choice in 1880 for the presidency of Bowdoin College. He held that post for twelve years. Thereafter, he engaged in a number of business ventures and veterans' organizations.

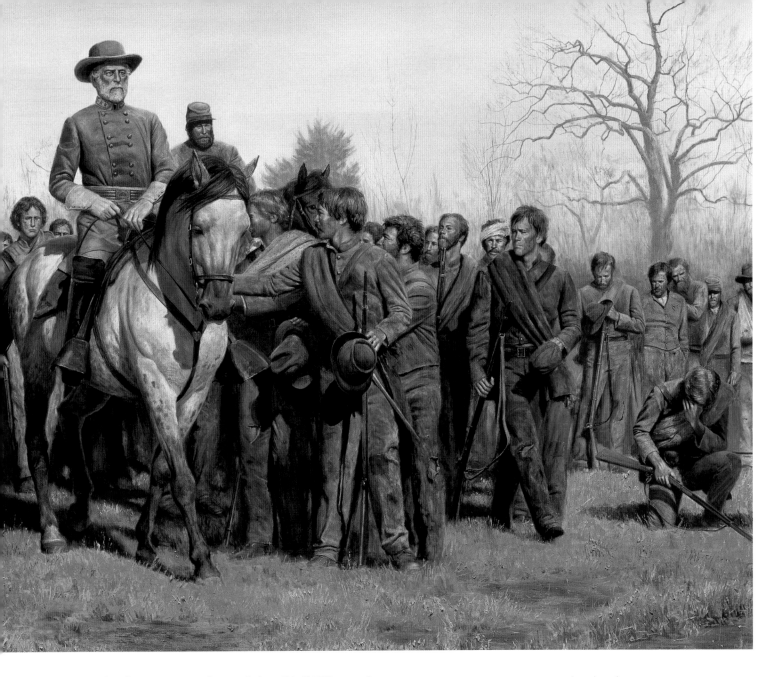

Chamberlain wrote often of the Civil War and became one of its most articulate spokesmen. He died in February, 1914, from lingering effects of his battle injuries. Chamberlain is buried in Brunswick, Maine.

The dust of Lee, Jackson, Hancock, and Chamberlain is part of the earth of Virginia, Pennsylvania, and Maine. Yet they are not as separated as distance might imply. Their graves are now part of the United States, reborn and reshaped by a war in which common gallantry forever became the essence of the American heritage.

★ ★ ★

ON PALM SUNDAY, APRIL 9, 1865, THE END CAME FOR THE ARMY OF NORTHERN VIRGINIA. SURROUNDED, AND HOPELESSLY OUTNUMBERED, LEE MET WITH GRANT AT APPOMATTOX AND ACCEPTED GENEROUS SURRENDER TERMS. WORST OF ALL FOR LEE WAS THE RETURN RIDE TO HIS FAITHFUL SOLDIERS, WHOSE "SHOUTS SANK INTO SILENCE" AND WHOSE BRONZED FACES "WERE BATHED WITH TEARS."

Following pages, TWO DAYS OF RAIN ENDED ON WEDNESDAY, APRIL 12, 1865, AND IT WAS TIME FOR THE CONFEDERATE ARMY TO GIVE UP ITS ARMS AND IDENTITY. GENERAL JOSHUA CHAMBERLAIN, IN CHARGE OF THE SURRENDER CEREMONIES, ORDERED HIS MEN TO SALUTE THEIR OPPONENTS. FOR A MOMENT, "HONOR GREETED HONOR." IT WAS "LIKE THE PASSING OF THE DEAD," CHAMBERLAIN WROTE, AS THE REMNANTS OF A ONCE-GREAT ARMY MOVED INTO HISTORY—AND LEGEND.

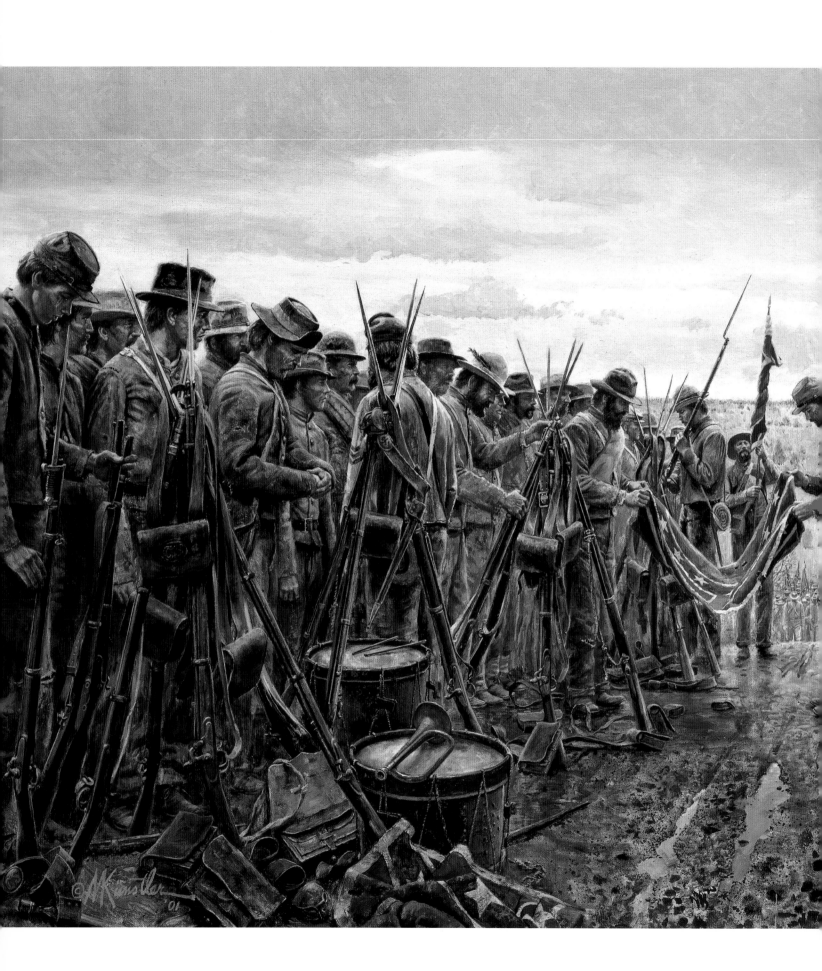

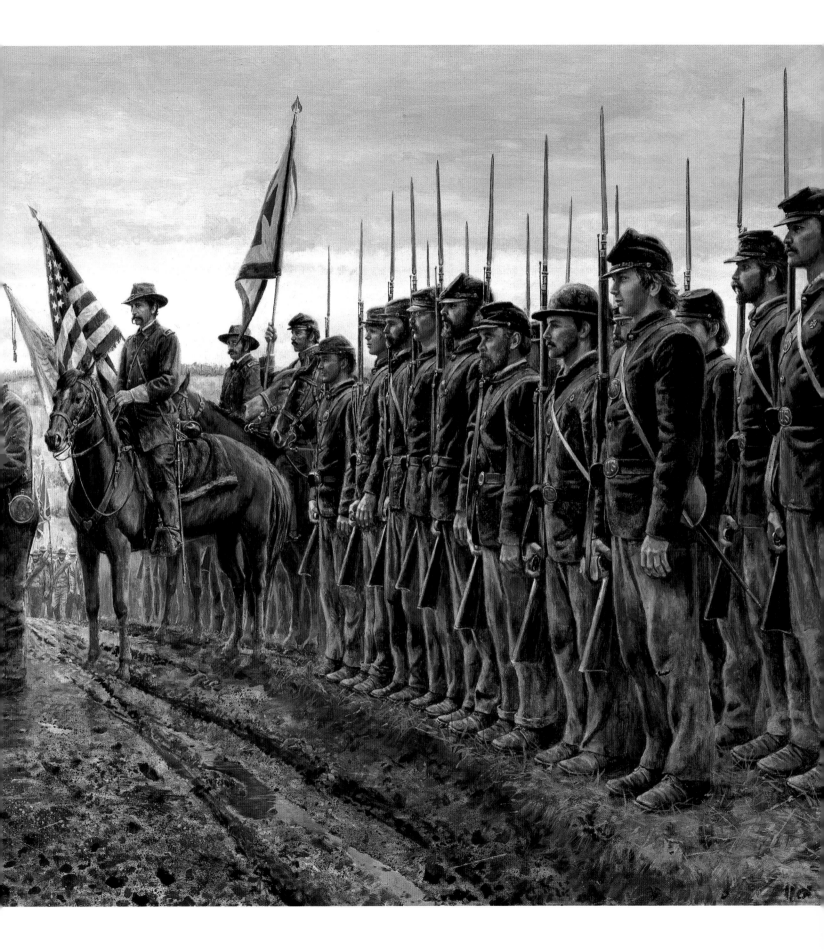

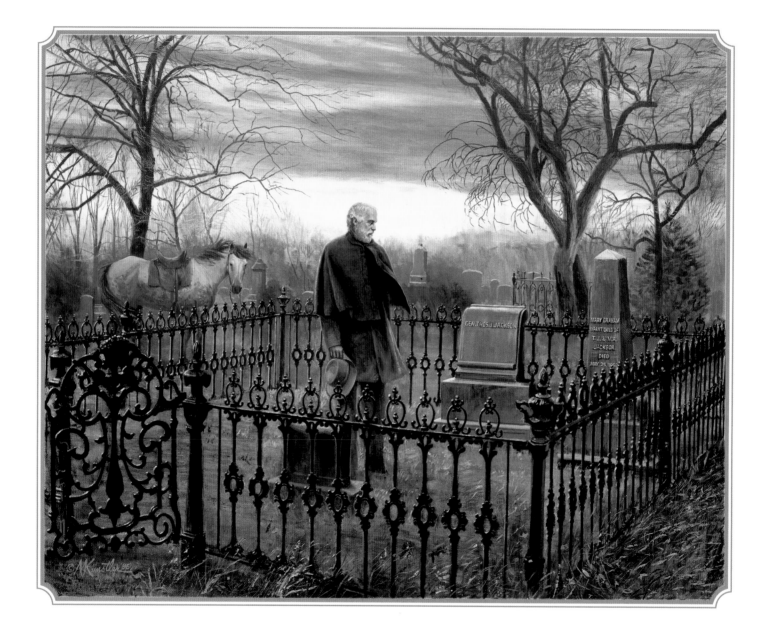

THE PAINTINGS

His Supreme Moment (pages 2, 121)
Lee at Chancellorsville, May 3, 1863
2000
Oil on canvas
27½" x 23"
Collection: Mr. and Mrs. Michael L. Sharpe

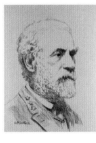

Lee (page 4)
1994
Charcoal
23" x 18½"
Collection:
Mr. and Mrs. Luther Smith

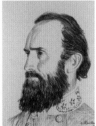

Jackson (page 5)
1994
Charcoal
23" x 18½"
Collection:
Mr. and Mrs. Luther Smith

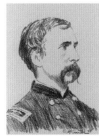

Gen. Joshua Lawrence Chamberlain (page 6)
1999
Charcoal
12½" x 9½"
Courtesy of Hammer
Galleries, New York City

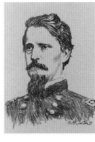

Gen. Winfield Scott Hancock (page 7)
1999
Charcoal
12½" x 9½"
Courtesy of Hammer
Galleries, New York City

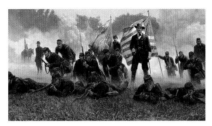

Hancock the Superb (pages 12, 86-87)
The Irish Brigade at Antietam, September 17, 1862
2002
Oil on board
12¾" x 22⅞"
Courtesy of Hammer Galleries, New York City

Fife and Drum (pages 10-11)
2001
Oil on board
9⅞" x 11⅜"
Courtesy of Hammer Galleries, New York City

Letter from Home (page 14)
2001
20" x 16"
Oil on canvas
Courtesy of Hammer Galleries, New York City

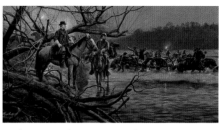

Night Crossing (pages 17, 90-91)
Lee and Jackson, September 18, 1862
1995
Oil on canvas
24" x 46"
Collection: Mr. Kenneth Rosenberg

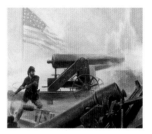

The Flag and Union Imperiled (pages 20-21)
Charleston, S.C., April 12, 1861
1985
Oil on board
16⅛" x 18"
Collection: Mr. Homer Noble

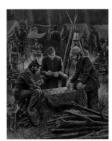

Dignity and Valor (page 22)
Gen. Robert E. Lee
2002
Oil on board
11¼" x 8"
Courtesy of Hammer Galleries,
New York City

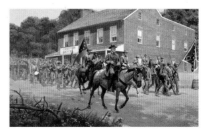

Distant Thunder (pages 24-25)
Lee at Cashtown, Va., July 1, 1863
1998
Oil on canvas
24" x 40"
Collection: Ted and Mary Sutphen

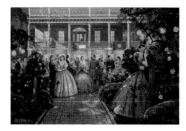

Moonlight and Magnolias (pages 26-27)
Arlington Plantation, Providence, La., April 6, 1861
1997
Oil on canvas
30" x 46"
Private Collection

The Professor from Virginia (page 33)
Thomas J. Jackson at VMI
2002
Oil on board
11" x 9¼"
Courtesy of Hammer Galleries, New York City

The Great Decision (page 39)
Robert E. Lee, April 1861
1995
Mixed media
24½" x 18"
Private Collection

Magnolia Morning (pages 28-29)
2001
Oil on canvas
26" x 36"
Courtesy of Hammer Galleries, New York City

The New General (page 35)
Winfield S. Hancock
2002
Oil on board
11½" x 8"
Courtesy of Hammer
Galleries, New York City

The Road to Glory (pages 40-41)
Jackson Leaves VMI, April 21, 1861
1997
Oil on canvas
18" x 34"
Collection: Dr. and Mrs. David Present

Stone Wall (page 31)
Gen. Thomas J. Jackson
2001
Oil on board
11⅛" x 7⅜"
Courtesy of Hammer Galleries, New York City

An American Hero (page 36)
Lt. Col. Joshua L. Chamberlain
2002
Oil on board
11½" x 8¼"
Courtesy of Hammer Galleries, New York City

The Professor from Maine (pages 42-43)
Joshua L. Chamberlain at Bowdoin College
2002
Oil on board
9¼" x 10¾"
Courtesy of Hammer Galleries, New York City

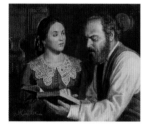

Mary Anna and Thomas J. Jackson (page 32)
Lexington, Va., April 1861
2002
Oil on board
9¼" x 10⅞"
Courtesy of Hammer Galleries, New York City

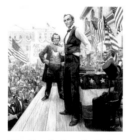

The Lincoln-Douglas Debates (detail, page 38)
Ottawa, Ill., August 21, 1858
1987
Oil on canvas
30" x 30"
Collection: Mr. José Pires

Jackson on Little Sorrel (pages 44-45)
2001
Oil on board
9⅞" x 11⅜"
Courtesy of Hammer Galleries, New York City

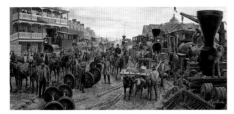

Jackson Commandeers the Railroad (pages 46-47)
Martinsburg, Va., June 20, 1861
1999
Oil on canvas
22" x 48"
Collection: Dr. and Mrs. David Present

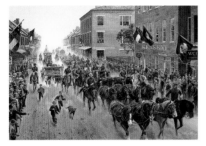

Iron Horses, Men of Steel (pages 48-49)
Winchester, Va., June 1861
2000
Oil on canvas
28" x 40"
Collection:
Feltner Community Foundation—Winchester, Va.

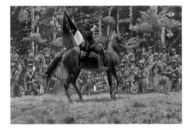

"There Stands Jackson Like a Stone Wall" (page 52)
General Thomas J. Jackson at First Manassas,
July 21, 1861
1991
Oil on canvas
24" x 36"
Collection: Dr. and Mrs. Barry George

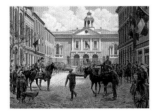

Guns of Autumn (pages 54-55)
Lee in Charleston, S.C., December 15, 1861
2000
Oil on canvas
26" x 36"
Collection: Old Exchange and Provost Dungeon,
Charleston, S.C.

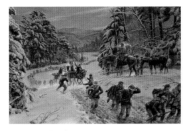

The Winds of Winter (pages 56-57)
Jackson's Romney Campaign, January 1862
2000
Oil on canvas
24" x 36"
Collection: Dr. James I. Robertson, Jr.

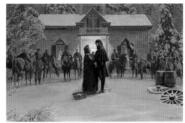

Until We Meet Again (page 58)
Jackson's Headquarters, Winchester, Va.,
Winter 1862
1990
Oil on canvas
30" x 46"
Collection:
Feltner Community Foundation—Winchester, Va.

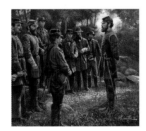

Before the Battle (page 59)
"Stonewall" Jackson and Staff
2002
Oil on board
10" x 11¼"
Courtesy of Hammer Galleries, New York City

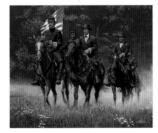

The Soldiers of Old Glory (pages 60-61)
Hancock and Staff
2002
Oil on board
11⅞" x 14⅛"
Courtesy of Hammer Galleries, New York City

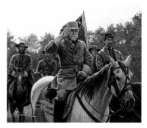

There Were Never Such Men (pages 62-63)
Lee and Staff
2002
Oil on board
9¼" x 11"
Courtesy of Hammer Galleries, New York City

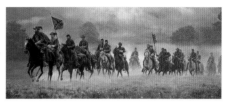

Stuart's Ride Around McClellan (pages 64-65)
June 13, 1862
1995
Gouache
17" x 38"
Private Collection

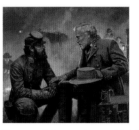

Tactics and Strategy (pages 66-67)
Jackson and Lee
2002
Oil on board
10" x 11½"
Courtesy of Hammer Galleries, New York City

The Professor and His Tutor (pages 68-69)
Lt. Col. Chamberlain and Col. Ames, 20th Maine
2002
Oil on board
11¾" x 14⅛"
Courtesy of Hammer Galleries, New York City

The High Command (page 70)
Confederate White House, July 13, 1862
2000
Oil on canvas
28" x 30"
Courtesy of Hammer Galleries, New York City

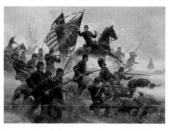

"Raise the Colors and Follow Me" (pages 82-83)
The Irish Brigade at Antietam, September 17, 1862
1991
Oil on canvas
30" x 44"
Collection: U.S. Army War College, Carlisle, Pa.

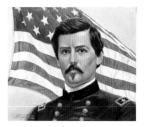

Gen. George B. McClellan (page 93)
1990
Oil on board
10" x 11½"
Courtesy of Hammer Galleries, New York City

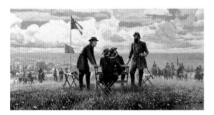

"I Will Be Moving Within the Hour" (pages 72-73)
Second Manassas, August 1862
1993
Oil on canvas
20" x 40"
Collection: Ted and Mary Sutphen

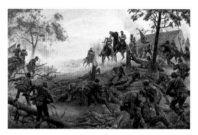

Jackson at Antietam (Sharpsburg) (pages 84-85)
Gen. "Stonewall" Jackson,
Dunker Church, September 17, 1862,
1989
Oil on canvas
32" x 50"
Collection: U.S. Army War College, Carlisle, Pa.

Lt. Col. J. L. Chamberlain and Staff (page 94)
December 1862
2002
Oil on board
11" x 9¼"
Courtesy of Hammer Galleries, New York City

The Commanders of Manassas (pages 74-75)
Gens. Lee, Longstreet, and Jackson, August 29, 1862
1996
Oil on canvas
28" x 38"
Private Collection

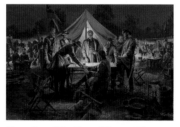

Sharpsburg War Council (page 89)
September 17, 1862
1999
Oil on canvas
28" x 42"
Collection: Mr. Samuel Blount

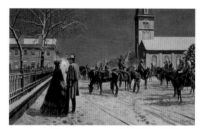

Remember Me (page 95)
Fredericksburg, Va., November 30, 1862
1997
Oil on canvas
26" x 42"
Private Collection

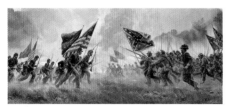

With a Rebel Yell (pages 76-81)
Second Manassas, August 29, 1862
2001
Gouache
15⅞" x 38¼"
Courtesy of Hammer Galleries, New York City

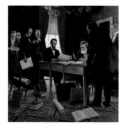

The Emancipation Proclamation (page 92)
January 1, 1863
1987
Oil on canvas
30" x 30"
Collection: Mr. and Mrs. Michael L. Sharpe

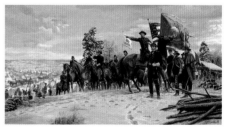

"The Fighting 69th" (pages 96-97)
Gen. Meagher and The Irish Brigade—
Fredericksburg, Va., December 2, 1862
1998
Oil on canvas
26" x 48"
Collection: Mr. Hugh O'Neill

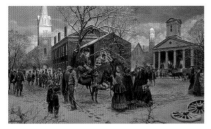

Changing of the Pickets (pages 98-99)
Fredericksburg, Va., December 6, 1862
2001
Oil on canvas
22" x 36"
Courtesy of Hammer Galleries, New York City

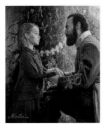

Janie Corbin and "Old Jack" (pages 106-107)
Christmas 1862
2002
Oil on board
10⅞" x 9⅛"
Courtesy of Hammer Galleries, New York City

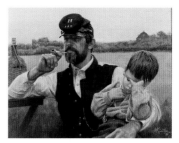

Last Leave (page 112)
1982
Oil on canvas
16" x 20"
Collection: Ms. Julianne J. Attebury

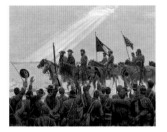

Lee's Lieutenants (pages 100-101)
Fredericksburg, Va., December 13, 1862
1997
Oil on canvas
30" x 34"
Private Collection

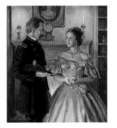

Julia (page 108)
"Stonewall" Jackson and Family, Guiney's Station,
April 20, 1863
1998
Oil on canvas
32" x 32"
Collection: Mr. Paul D. Muldowney

Divine Guidance (page 113)
"Stonewall" Jackson
2002
Oil on board
10¾" x 9¼"
Courtesy of Hammer Galleries, New York City

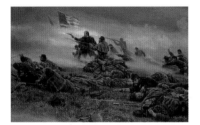

Chamberlain at Marye's Heights (pages 102-103)
Fredericksburg, Va., December 13, 1862
2002
Oil on board
14¼" x 23⅛"
Courtesy of Hammer Galleries, New York City

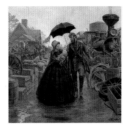

Fanny and Joshua (page 109)
Lt. Col. and Mrs. J.L. Chamberlain
2002
Oil on board
10¾" x 9¼"
Courtesy of Hammer Galleries, New York City

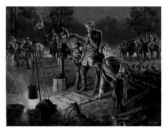

The Last Council (pages 114-115)
Jackson, Lee, and Stuart at Chancellorsville, Va.,
May 1, 1863
1990
Oil on canvas
28" x 36"
Collection: Arnold and Anne Gumowitz

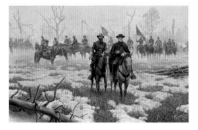

". . .War Is So Terrible" (pages 104-105)
Longstreet and Lee, December 13, 1862
1995
Oil on canvas
22" x 34"
Private Collection

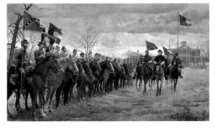

The Review at Moss Neck (pages 110-111)
Fredericksburg, Va., January 20, 1863
1995
Oil on canvas
24" x 42"
Collection: Dr. John Chandler

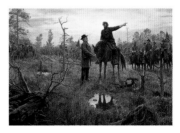

The Last Meeting (page 116-117)
Chancellorsville, Va., May 2, 1863
1994
Oil on canvas
28" x 40"
Collection: Mr. Harlan Crow

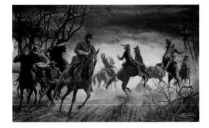

End of a Legend (page 118)
Jackson, Chancellorsville, Va., May 2, 1863
1995
Gouache
16" x 26¼"
Collection: Mr. and Mrs. Robert Gravinese

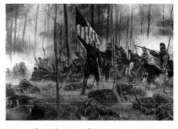

Hero of Little Round Top (pages 126-127)
Col. Joshua Chamberlain, July 2, 1863
1999
Oil on canvas
24" x 36"
Collection: Mr. Thomas Huff

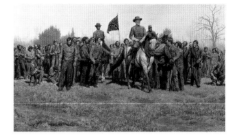

"We Still Love You, General Lee" (pages 132-133)
Appomattox, Va., April 9, 1865
1992
Oil on canvas
54" x 88"
Collection: Booth Western Art Museum, Cartersville, Ga.

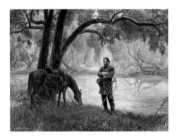

". . .Cross Over the River" (pages 122-123)
"Stonewall" Jackson
1995
Oil on canvas
24" x 32"
Collection: Mr. Billy Underwood

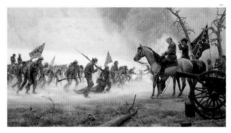

"It's All My Fault" (pages 128-129)
General Robert E. Lee at Gettysburg, July 3, 1863
1989
Oil on canvas
26" x 48"
Collection: Mr. Thorne Donnelly, Jr.

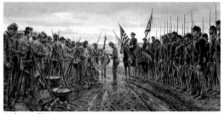

Salute of Honor (pages 134-135)
Appomattox, Va., April 12, 1865
2001
Oil on canvas
22" x 44"
Collection: Mr. John Curley

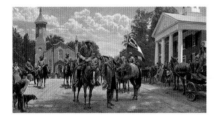

God Be With You (pages 124-125)
Lee and Longstreet, Berryville, Va., June 21, 1863
2001
Oil on canvas
20" x 36"
Courtesy of Hammer Galleries, New York City

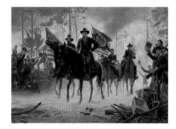

On to Richmond (pages 130-131)
Grant in The Wilderness, May 7, 1864
1991
Oil on canvas
30" x 42"
Collection: U.S. Army War College, Carlisle, Pa.

The Final Visit (page 136)
Robert E. Lee, Lexington, Va.
1995
Oil on canvas
16" x 20"
Collection: Dr. John Chandler

INDEX

Adams, Fanny, 37 *See also Chamberlain, Fanny*
Adams, John, 23
Ames, Adelbert, 69, 108
Antietam, 72, 83-84, 89, 98
Appomattox, 131, 133
Armistead, Lewis, 34, 43
Army of Northern Virginia, 63, 65, 72, 95, 101, 123-24, 131, 133
Army of the Potomac, 61, 72, 93, 112, 123, 128

Baltimore and Ohio Railroad, 45
Bangor Theological Seminary, 37
Bee, Barnard, 52
Berryville, 125
Blair, Francis Preston, 38
Bloody Lane, 83-84
Bowdoin College, 37, 43, 69, 132
Brewer, 37
Brown, John, 25, 34
Brunswick, 133
Buckner, Simon B., 34
Buell, Don Carlos, 34
Burnside, Ambrose E., 93, 95, 101, 103-04
Burnside's Bridge, 84, 89

California, 34
Canada, 21
Cedar Mountain, Battle of, 71
Cerro Gordo, 25
Chamberlain, Fanny, 108 *See also Adams, Fanny*
Chamberlain, Joshua Lawrence, 23, 34, 36-37, 43, 69, 71-72, 95, 98, 103-04, 108, 119-20, 123, 126, 128, 131-33
Chancellorsville, 114, 116, 119-20, 123, 126
Chapultepec, 25, 34
Charleston, 38, 55
Chesapeake and Ohio Canal, 45
Chickahominy River, 63
Cold Harbor, 128
Corbin, Jane, 107
Custis, Mary, 23 *See also Lee, Mary*

Davis, Jefferson, 43, 53, 63, 71
Dunker Church, 84

Emancipation Proclamation, 89, 92
Ewell, Richard S., 56

Fifth Corps (Union), 72, 120
First Brigade of Virginia, 45
Florida, 34, 53
Fort Sumter, 21, 38
Franklin, William B., 72
Frederick, 76
Fredericksburg, 55, 93, 95, 98, 104, 107, 112, 114, 116, 120, 126

Gaines' Mill, 67
Garfield, James A., 132
Georgia, 25, 53
Gettysburg, 125-26, 128
Glendale, 67
Golding's Farm, 67
Governor's Island, 132
Grace Episcopal Church, 125
Grant, Ulysses S., 93, 128, 131, 133
Guiney's Station, 108

Hagerstown, 76-77

Hancock, Winfield Scott, 23, 34-35, 40, 43, 61, 63, 67, 72, 84, 98, 103, 107-08, 119-20, 123, 126, 128, 132-33
Harpers Ferry, 25, 45, 76-77, 84
Henry House Hill, 52
Heth, Henry, 34
Hill, A.P., 84, 89
Hooker, Joseph, 104, 112, 114, 116, 119-20
Humphreys, Andrew, 103

Irish Brigade, 98

Jackson, Julia, 98, 107
Jackson, Mary Anna, 40, 58, 98, 107 *See also Morrison, Mary Anna*
Jackson, Thomas J. ("Stonewall"), 23, 30-34, 37, 40, 45-46, 50, 52, 55-56, 58-59, 61, 64-65, 67, 71-72, 76-77, 83-84, 89, 98, 101, 107-08, 112, 114, 116, 118-19, 123, 133
Jackson's Mill, 30
James River, 65, 67, 71, 128
Johnston, Albert Sidney, 34
Johnston, Joseph, 63
Junkin, Elinor, 32

Kansas, 34
Kernstown, 56

Lee, Henry ("Light Horse Harry"), 23
Lee, Mary, 107 *See also Custis, Mary*
Lee, Robert E., 22-23, 25, 34, 38, 50, 53, 55-56, 63-65, 67, 71-72, 76-77, 83-84, 89, 93, 95, 98, 101, 103-04, 107-08, 112, 114, 116, 119-20, 123-26, 128, 131, 133
Letcher, John, 40
Lewis, Jim, 45
Lexington, 30, 33, 40, 45, 59, 131
Lexington Presbyterian Church, 33
Lincoln, Abraham, 25, 38, 59, 63, 69, 89, 92, 93, 132
Little Round Top, 126
Little Sorrel, 45, 123
Longstreet, James, 72, 89, 101, 104, 108, 125
Los Angeles, 34
Louisiana, 29

Malvern Hill, 67
Manassas, (Bull Run) First Battle of, 50, 52, 69
Manassas, (Bull Run) Second Battle of, 72, 114
Manassas Junction, 50, 72
Marines, U.S., 25
Martinsburg, 46
Marye's Heights, 98, 101, 103, 120
McClellan, George B., 55-56, 59, 61, 63-65, 67, 71-72, 76, 83-84, 92-93
McDowell, Irvin, 50, 52
Meade, George, 108
Meagher, Thomas Francis, 83, 98
Mechanicsville, 67
Mexican War, 25, 30, 34, 84
Mexico, 21, 25
Mississippi River, 23
Montgomery Square, 34
Morrison, Mary Anna, 32 *See also Jackson, Mary Anna*

Ninth Corps (Union), 93
Norristown, 132
North Anna River, 128

North Carolina, 119
Pamunkey River, 64
Pennsylvania, 59, 93, 133
Petersburg, 128, 131
Pettigrew, James Johnston, 128
Pickett, George E., 103, 128
Pickett's Charge, 126
Pope, John, 71-72
Porter, Fitz John, 72
Potomac River, 23, 45, 72, 89

Rapidan, 114
Rappahannock River, 93, 95, 98, 108, 114, 120
Richmond, 40, 46, 50, 53, 55-56, 61, 64, 67, 71, 93, 119, 128, 131
Romney Campaign, 56
Russell, Almira, 34

Salem Church, 120
Savage Station, 67
Scott, Winfield, 22, 25, 38
Second Cavalry (Union), 25
Second Corps (Union), 126
Sedgwick, John, 114, 116, 120
Seven Days Campaign, 67
Seven Pines, Battle of, 63
Sharpsburg, 77, 83-84
Shenandoah River, 45
Shenandoah Valley, 30, 45, 50, 55, 71, 76
Shenandoah Valley Campaign, 55, 58
Sixth Corps (Union), 72
Sixth Infantry, 34
Sixty-ninth New York, 98
South Carolina, 25, 53, 55
South Mountain, 76-77
Spanish-American War, 84
Spotsylvania, 128
St. Louis, 23, 34
Stonewall Brigade, 52
Stradford, 23
Strasburg, 47
Stuart, J.E.B., 64-65, 98, 101, 114, 116, 120

Traveler, 125
Twentieth Maine Regiment, 69, 71-72, 102, 104, 119-20, 126

U.S. Military Academy, 23 *See also West Point*
Utah, 34

Valley of Virginia, 55-56
Veteran Reserve Corps, 128
Virginia, 23, 30, 38, 43, 45, 50, 53, 55-56, 71, 84, 89, 108, 120, 128, 133
Virginia Military Institute (VMI), 30, 33-34, 40, 45
Virginia Wilderness, 114, 116, 118, 126, 128, 131

War of 1812, 84
Washburn, Israel, 69
Washington, D.C., 52, 61, 71-72, 95, 128
Washington and Lee University, 132
Washington College, 131
Washington, George, 23
West Fort River, 123
West Point, 25, 30, 34, 37, 69 *See also U.S. Military Academy*
Williamsburg, 61, 63
Winchester, 47, 56, 59

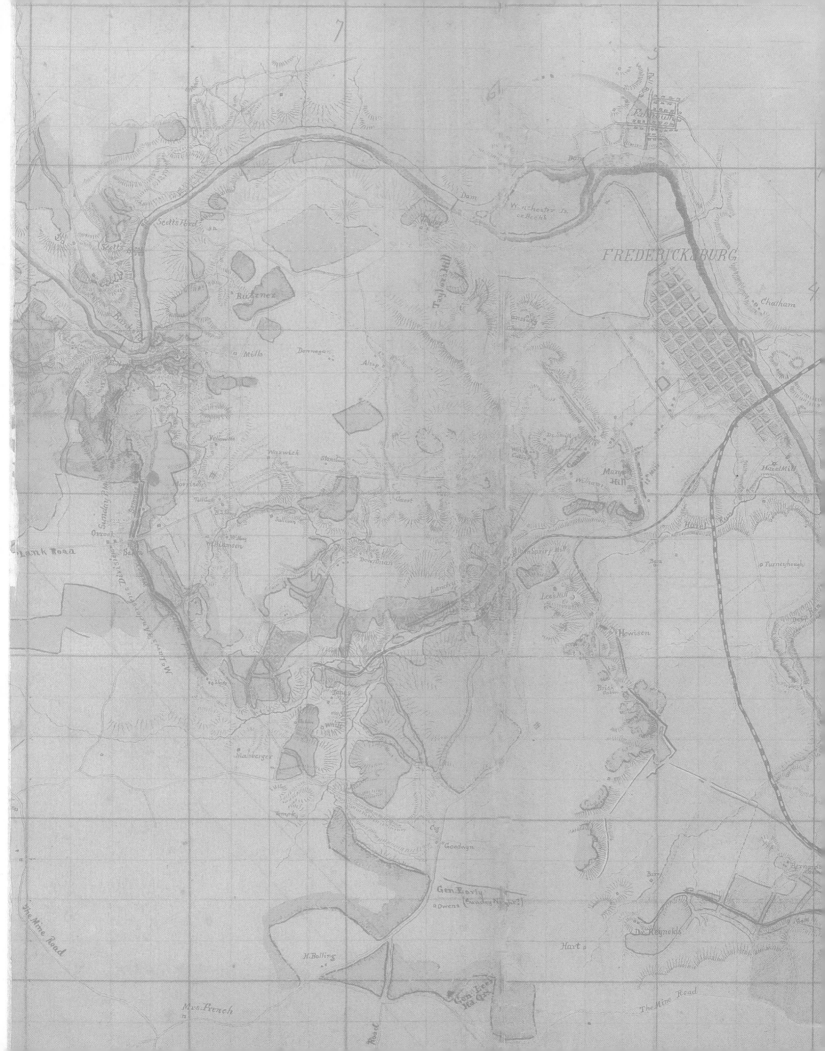

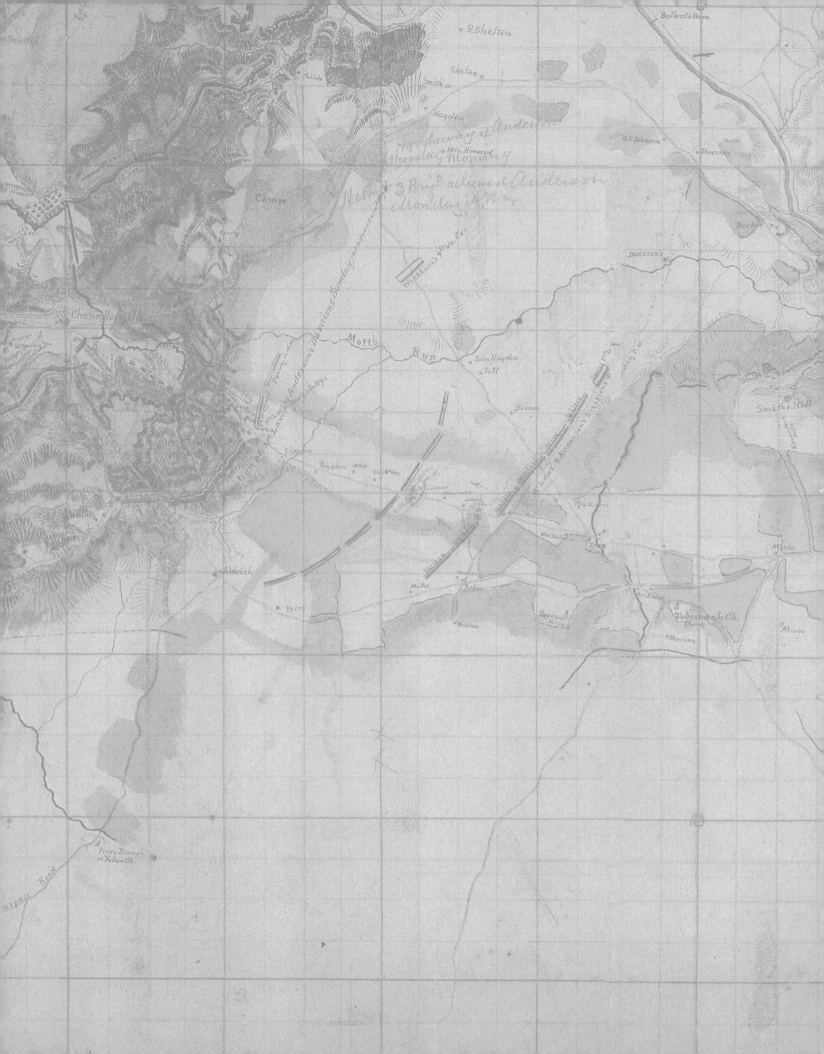